STEAM RAILWAYS

BRITAIN IN PICTURES

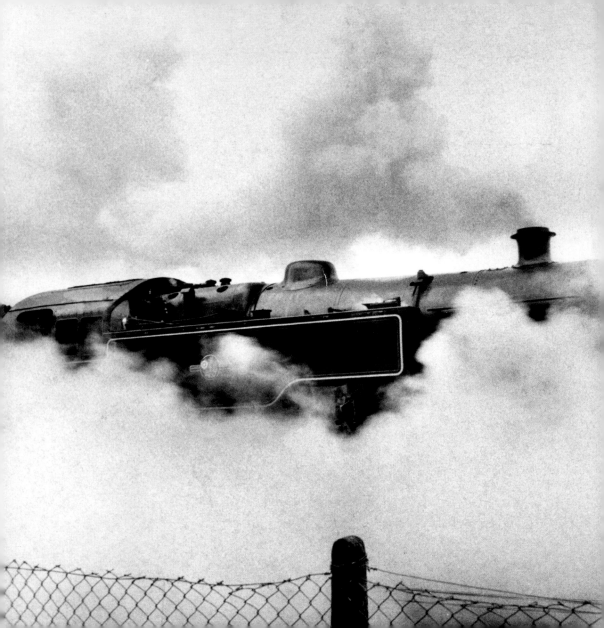

STEAM RAILWAYS

BRITAIN IN PICTURES

AMMONITE
PRESS

First published 2013 by
Ammonite Press
an imprint of AE Publications Ltd,
166 High Street, Lewes, East Sussex, BN7 IXU

Text © AE Publications Ltd, 2013
Images © Mirrorpix, 2013
Copyright © in the work AE Publications Ltd, 2013

ISBN 978-1-90770-891-6

British Cataloguing in Publication Data. A catalogue record of
this book is available from the British Library.

Editor: George Lewis
Series Editor: Richard Wiles
Designer: Robin Shields
Picture research: Mirrorpix

Colour reproduction by GMC Reprographics
Printed and in China

Page 2: BR 2-6-4 Standard
tank No. 80079 on the first
day of the Severn Valley
Railway's new season.
18th March, 1989

Right: Birmingham New
Street was officially
opened in 1854 but had
already been in operation
for three years. The station
was operated jointly by
the London and North
Western Railway (LNWR)
and the Midland Railway.
The overall roof – at the
time of its construction
the longest iron and glass
structure of its type in
the world – was heavily
damaged during the Blitz
and demolished after the
Second World War.
c.1890

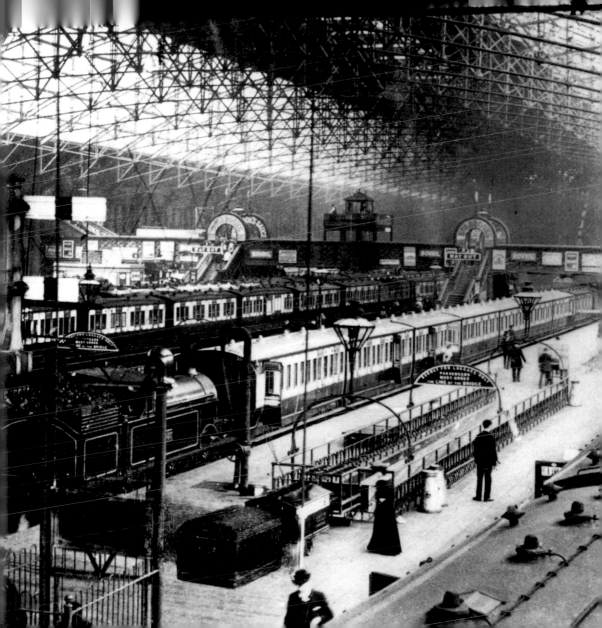

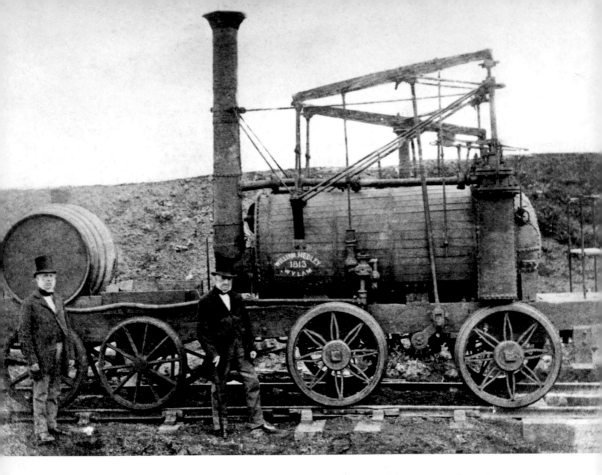

This is by common consent the first commercially successful steam railway locomotive. Designed by William Hedley (1779–1843), it entered service on 1st July, 1813 pulling coal trucks over a five-mile (8km) line between Wylam, Northumberland and the docks at Lemington-on-Tyne. Although it had no official name – i.e., unlike many of its descendants, it had no plate on its boiler – it became known universally as 'Puffing Billy'. c.1865

INTRODUCTION

Perhaps the most amazing feature of this book – apart, of course, from the marvellous images by Mirror Group photographers – is that although it is set out in chronological order, the reader may often feel impelled to check the caption dates to confirm that.

The reason for this seeming time warp is that trains have been going back and forth throughout their history – not only from one end of the line to the other, but also from ancient to modern to ancient to modern.

This is nowhere better illustrated than in the years following the end of the Second World War in 1945, when diesel and electric traction were taking over while steam locomotives were being decommissioned with breathtaking speed and lined up in their thousands for destruction. Yet British Railways (BR) went on building new steam locomotives for the next decade and a half: the last one, No. 9000 *Evening Star*, entered service in 1960. (The cause of this anomaly was that construction of diesel and electric locos was not fulfilling the required quotas; the shortfall led some people to wonder why the government had been so keen to scrap steam before its replacements were ready.)

One might expect this book to end at the time of the last BR steam journey in 1969. But not a bit of it: steam remained, on preserved railways and also on main lines, where enthusiasts' specials and other excursions began to spin money with which the ever cash-strapped national rail operators could well have done – and indeed which they could have had if they'd had the foresight to acknowledge and accommodate the undying love so many people feel for what is now sometimes known as 'heritage transport'. If only they hadn't been so keen to kill it off; if only they'd realised they were messing with immortals… *Mallard, Flying Scotsman* and *King George V* are just a few of the locos that were withdrawn in the 1960s, but which reappear in steam again and again thereafter.

In 2008, the wheel came full circle again on the completion of *Tornado*, a brand new steam Pacific with authentic 1930s' looks but internal workings that are up to the exacting safety standards of the 21st century and thus enable it to go anywhere on the national standard gauge network.

Steam trains are not as prevalent now as they were a century ago, but they are still alive and well and plying their trade somewhere in the United Kingdom on most days of every year.

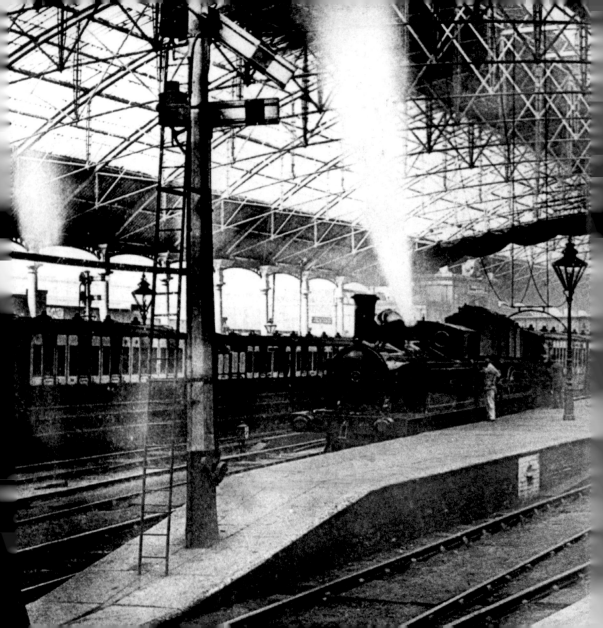

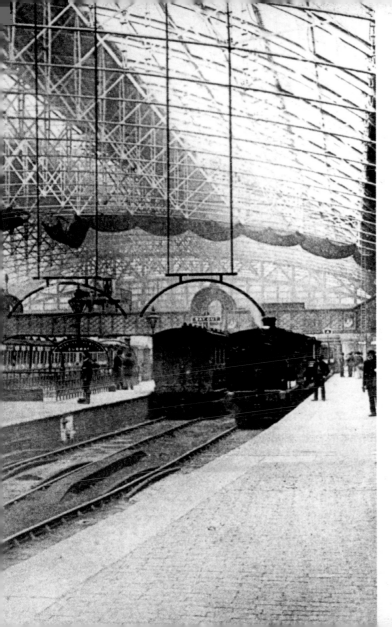

An LNWR tank lets off steam at Birmingham New Street. The sole surviving member of this once numerous class now operates on the Keighley and Worth Valley Railway in Yorkshire.
c.1890

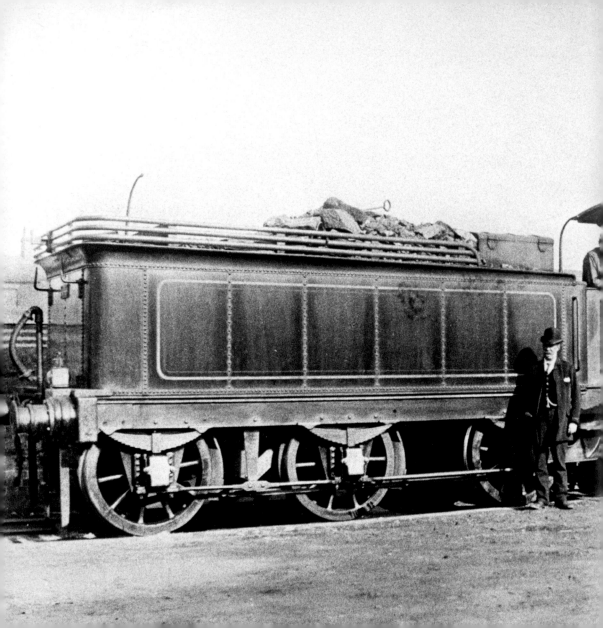

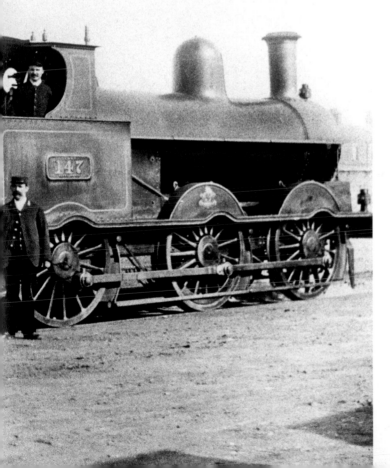

LNWR No. 147, stationed at Crewe, was used mainly for express goods but also headed passenger trains. Note the open cab and the company crest on the central wheel splasher. c.1896

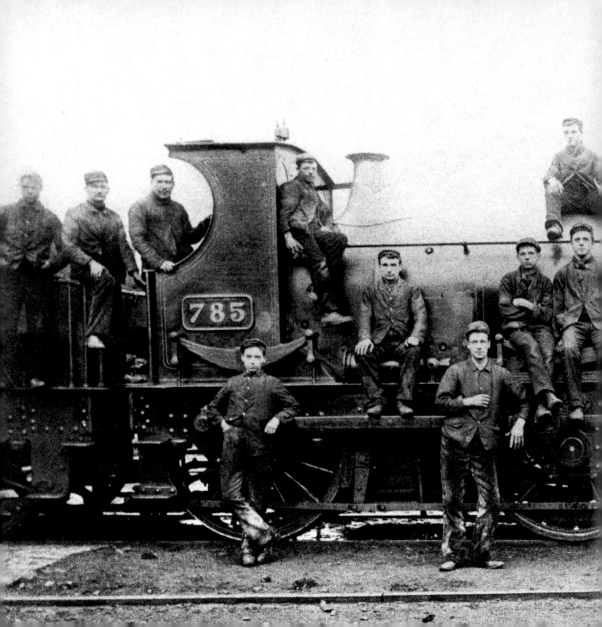

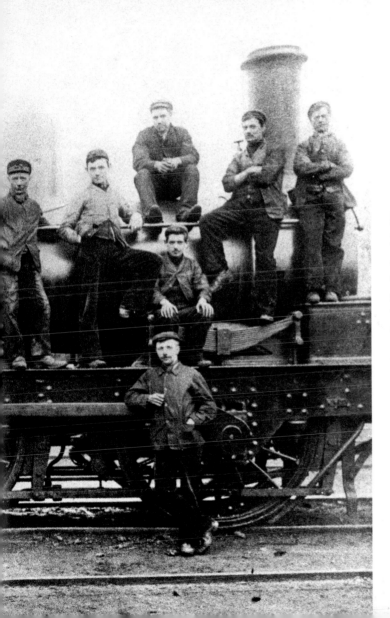

LNWR train crews pose proudly on a loco outside Stafford Road sheds. These once extensive works closed in 1965 and the land on which they stood is now part of a trading estate.
c.1900

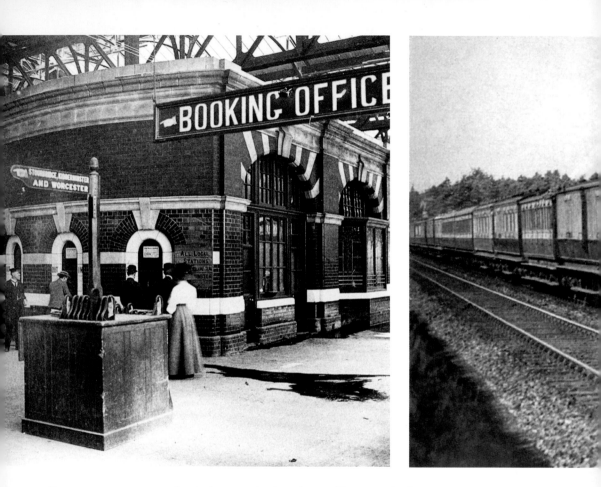

Passengers queuing for tickets at the booking office on Platform One at Snow Hill Station, the Birmingham terminus for Great Western Railway services from London Paddington via Wolverhampton Low Level. Closed in the 1970s but reopened in the 1980s, Snow Hill is today linked to London Marylebone.
1912

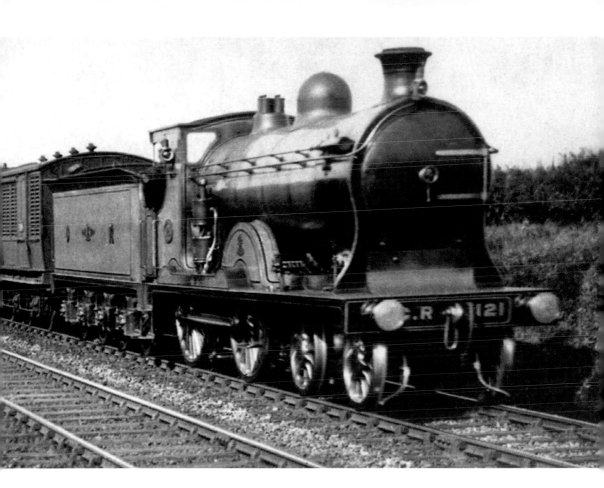

Resplendent in Caledonian Railway livery, this 721 (Dunalastair) Class 4-4-0 was designed by John F. McIntosh. A year after the photograph was taken, the locomotive was destroyed in the Quintishill rail disaster (see overleaf).
c.1914

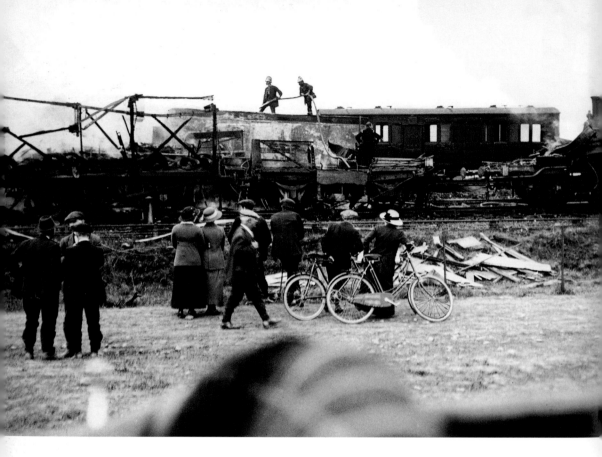

Early on the morning of 22nd May, 1915 five trains collided at Quintishill Junction near Gretna Green, Scotland. One of them, hauled by CR No. 721 *(see previous page)*, was carrying around 500 soldiers of the 7th Battalion of the Royal Scots Guards bound for Gallipoli. Around 230 people were killed – the exact number of fatalities is unknown because the army roll list was destroyed in the ensuing fire.
24th May, 1915

The exterior of Curzon Street Station, the Birmingham terminus of the London & Birmingham Railway and the Grand Junction Railway between 1838 and 1846, when both companies were taken over by the LNWR, whose owners preferred New Street (*see pages 7, 8–9*). Curzon Street was downgraded, first to holiday excursions and later to goods only. It was closed in 1966 and used as an occasional concert venue.
c.1920

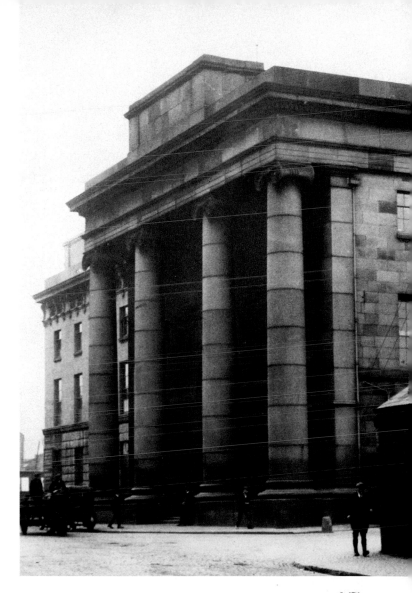

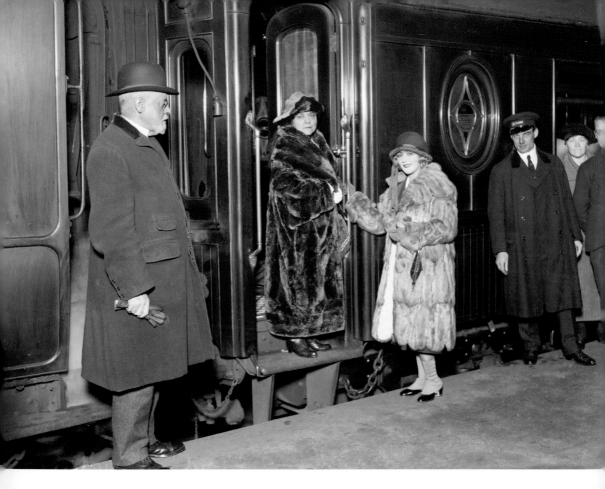

Long established as the fastest and most efficient method of overland transport, by the end of the First World War railways had become luxurious enough to attract celebrities. Here Mary Pickford, Canadian film star and co-founder of United Artists, takes a photo opportunity with her mother at London Victoria Station.
2nd October, 1921

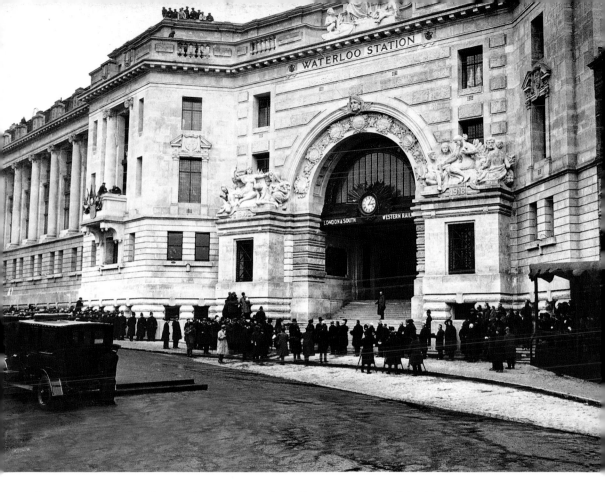

Queen Mary, wife of King George V, at the official opening of the Victory Arch at Waterloo. The station had been in use since 1848, but the completion of this grand new entrance got royal treatment.
21st March, 1922

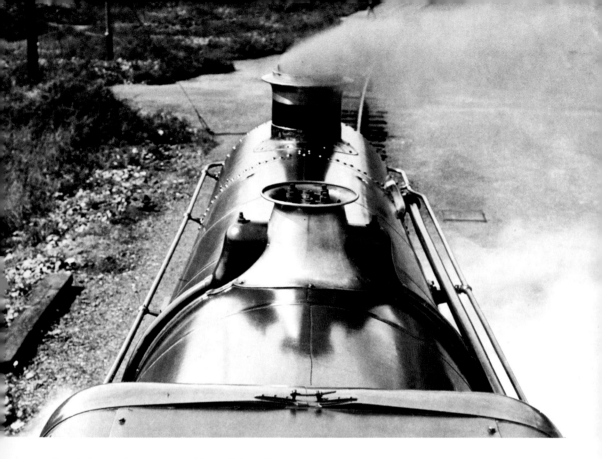

Fresh from the works, with polished brass and copper-capped chimney shining in the autumn sun, *Caerphilly Castle* was the first new steam locomotive to be built by the GWR after the First World War. Over the next 17 years, a total of 171 Castles were built at Swindon.
5th September, 1923

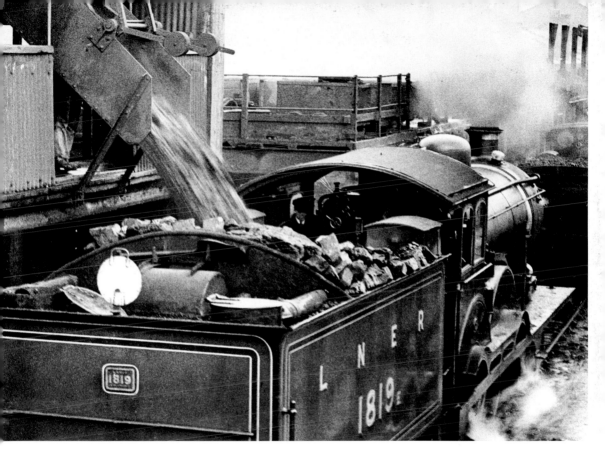

Coal roars down a new mechanical tipping chute, filling
the tender of Holden 'Claud Hamilton' Class D16 No.
1819 in 20 seconds in preparation for its next journey out
of London Liverpool Street. Originally built for the Great
Eastern Railway (GER), the locomotive was repainted
after Grouping in LNER apple-green livery.
5th December, 1924

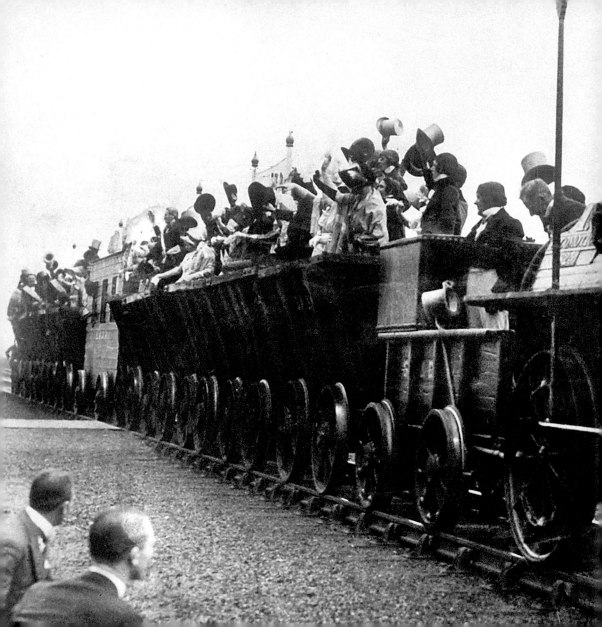

Nostalgia is still what it used to be: enthusiasts in period costume celebrate the centenary of the Stockton & Darlington Railway, the world's first line for paying passengers, aboard the original Stephenson loco, No. 1 *Locomotion*, which has been on static display in Darlington Station since 1892.

25th March, 1925

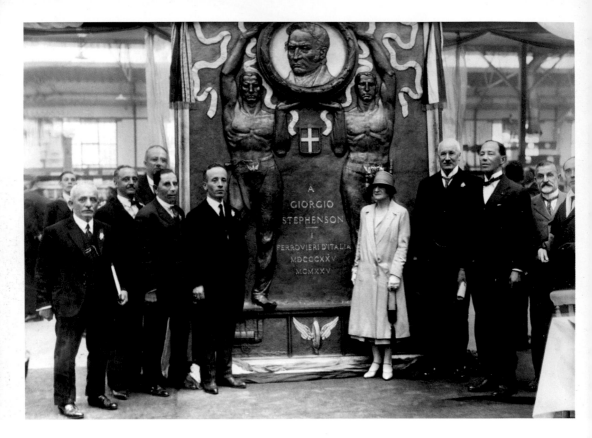

In recognition of George Stephenson's contribution to the development of steam, Italy presented a memorial plaque at Britain's Railway Centenary Celebrations. The Italian delegation is on the left of the photograph; on the right are LNER chairman William Whitelaw (fourth R) and general manager Ralph Wedgwood (third R).
4th July, 1925

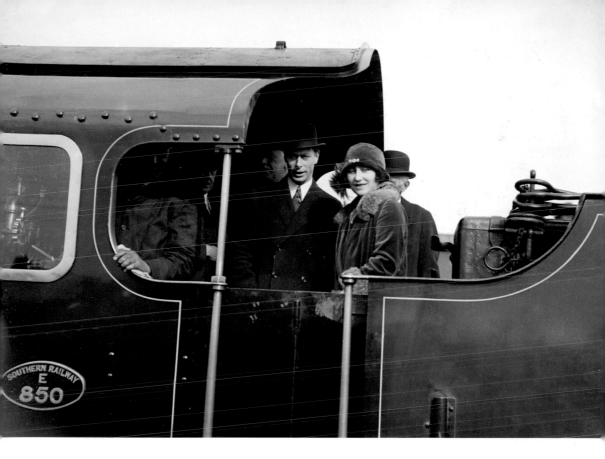

Prince Albert (later King George VI) and Princess Elizabeth inspect the Southern Railway's crack new express locomotive, No. 850 *Lord Nelson*, at Ashford Works in Kent. The loco is still in operation on the Watercress Line between Alton and Alresford, Hampshire.
21st October, 1926

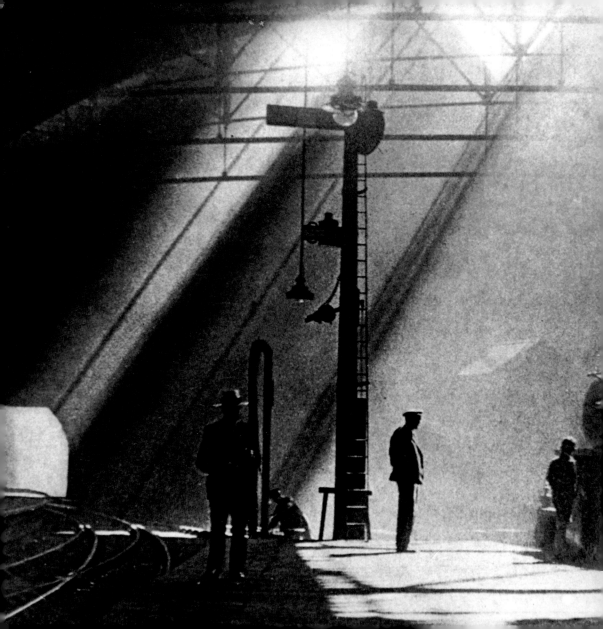

The interior of Birmingham New Street: not for nothing were the great railway stations of Britain known as 'cathedrals of steam'. Note the young enthusiast by the locomotive and the railway worker attending to the water crane on the left of the photograph.
1927

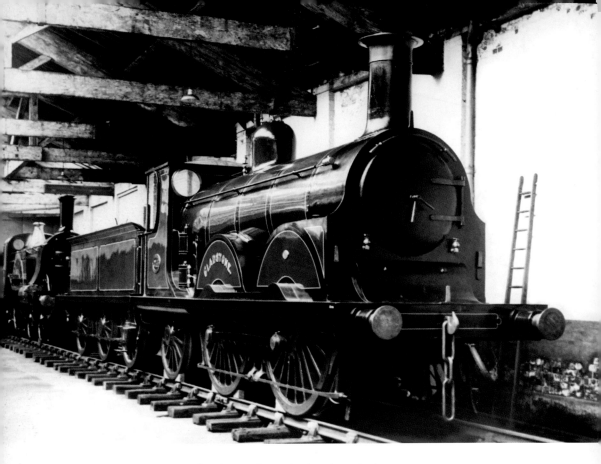

In 1927, *Gladstone*, one of a class of 0-4-2s that headed expresses on the London Brighton & South Coast Railway (LBSCR), was withdrawn from service and preserved here in York, where it formed the foundation of the National Railway Museum, which now has one of the finest collections of railwayana in the world.
1st June, 1927

The aftermath of a crash on the GWR line through the Vale of Llangollen, Wales, when a goods locomotive failed on the Cefn Viaduct and was hit in the rear by a following train. The lead train, shown here, caught fire, and the driver and fireman escaped death only by jumping out of the cab and hanging on to the parapet 150 feet (50m) above the River Taff. The accident happened in the early hours of 25th January, 1928; the wreckage took more than six weeks to clear.
6th March, 1928

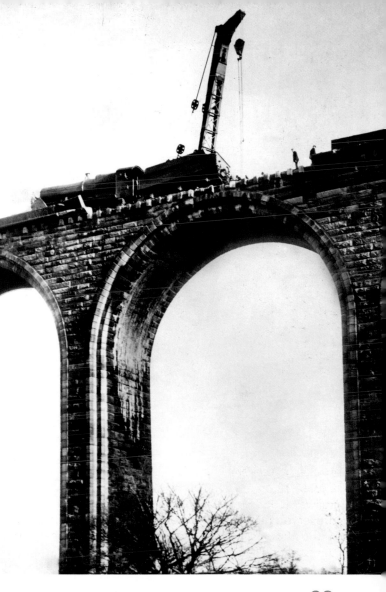

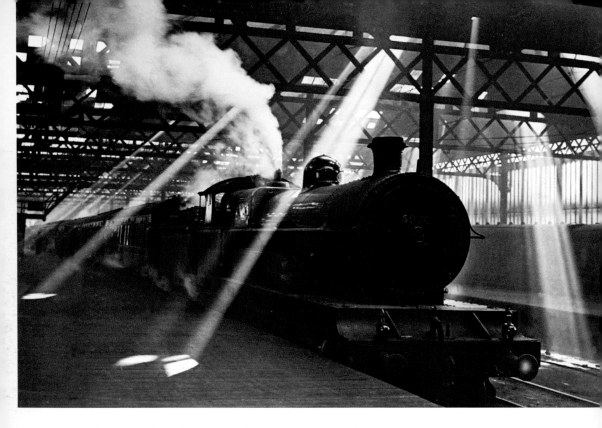

Through the murk and latticework roof, a pyramid of light shafts surround an ex-LNWR Claughton class 4-6-0 No. 5970 *Patience* as it starts a northbound express out of the old Euston Station, the London terminus of the LMS.
April 1928

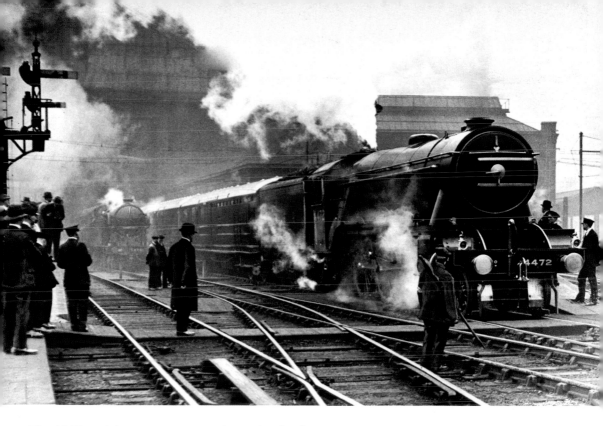

The LMS and the LNER constantly vied to be faster between London and Scotland. In 1928, the latter company took the lead with the introduction of A3 Class No. 4472, *Flying Scotsman*, seen here leaving London King's Cross on its inaugural non-stop journey to Edinburgh at the head of the express of the same name.
1st May, 1928

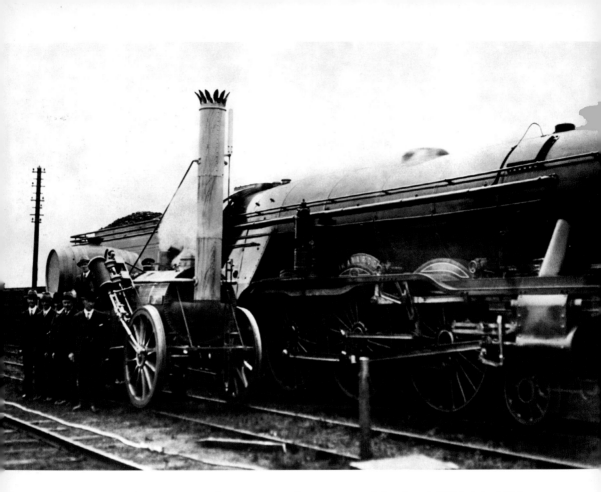

This replica of George Stephenson's *Rocket*, winner of the Rainhill Trials in 1829, was built at Darlington to order by US motor magnate Henry Ford. It is now on static display at the Henry Ford Museum in Dearborn, Michigan, USA.
24th May, 1929

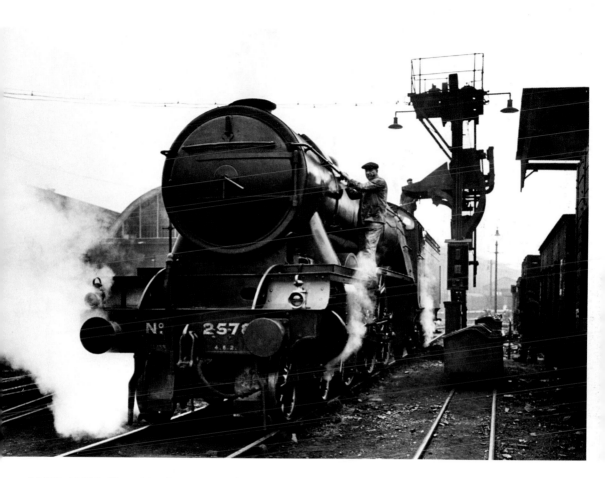

LNER A1/A3 Class No. 2578 *Bayardo* stands over the inspection pit at London King's Cross. The driver and fireman clean the locomotive's boiler while the tender is refueled by an electric coaling machine.
2nd September, 1929

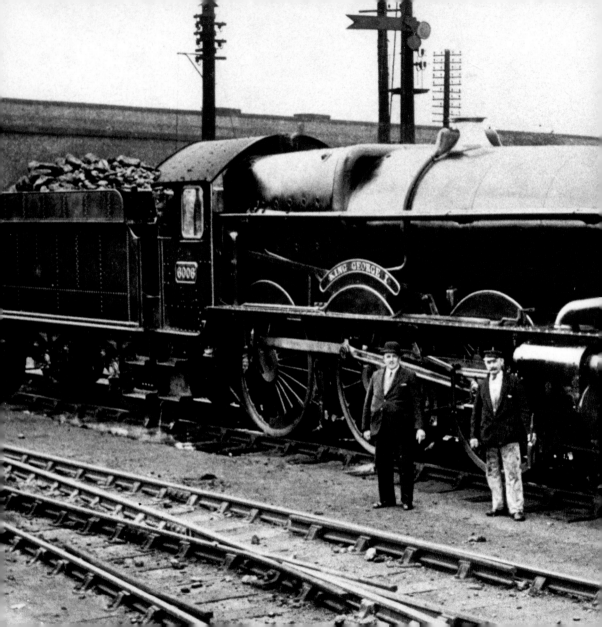

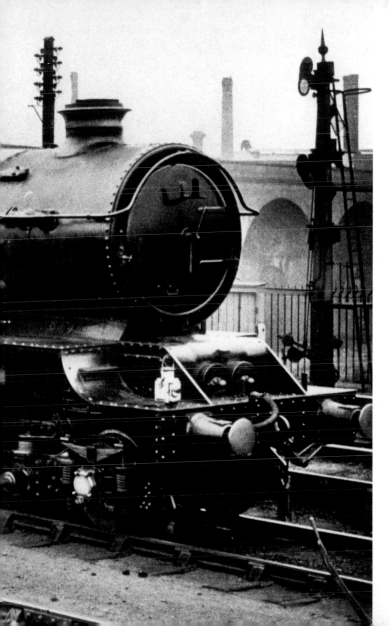

GWR 6000 Class *King George I* at Stafford Road Sheds, Wolverhampton. Designed by C.B. Collett, the Kings were more powerful versions of his older Castles, which were themselves a development of G.J. Churchward's Star class. Three Kings are preserved, and two of them – *King Edward I* and *King Edward II* – are still in working order.
c.1930

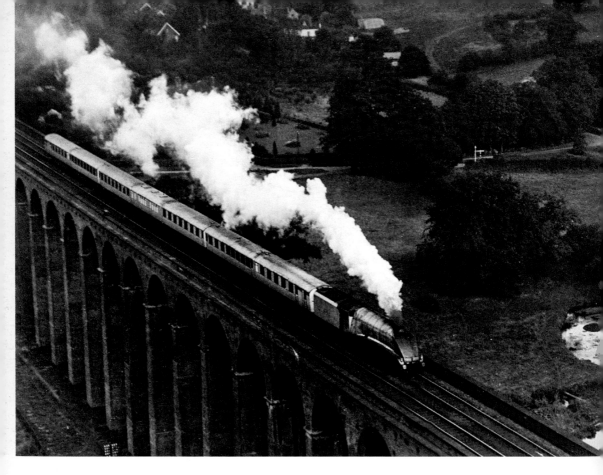

A streamlined LNER A4 Class locomotive heads the *Silver Jubilee* London-Edinburgh express over Welwyn Viaduct in Hertfordshire. This service was inaugurated in 1935 to commemorate the 25th anniversary of the accession of King George V. Note the silver carriages to match the silver locomotive.
c.1930

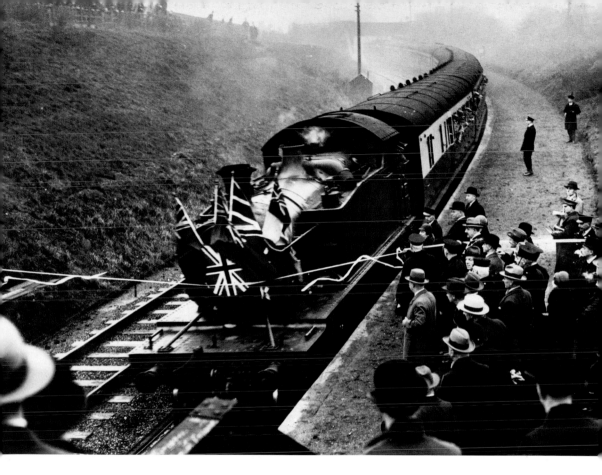

A GWR Prairie tank hauls the first passenger train into Hawthorns Station, which was built on the Paddington–Birkenhead line principally to serve football fans attending matches at West Bromwich Albion's nearby ground.
26th December, 1931

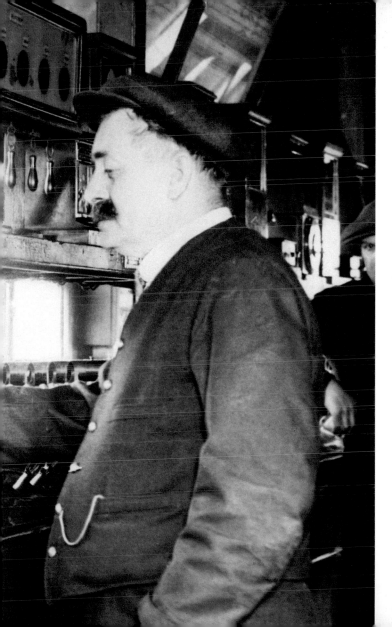

A signalman at work in
the box at Snow Hill,
Birmingham.
June 1932

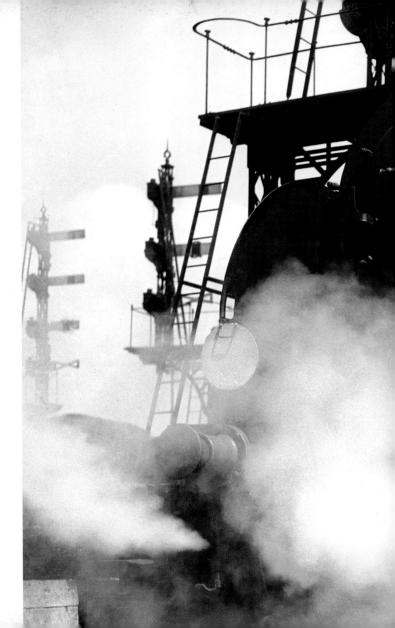

Southern Railways N15
King Arthur Class 4-6-0
No. 752 *Linette* leaving
London Waterloo Station.
The circular boards above
the front buffers indicate
that it is heading an
express passenger train.
2nd July, 1932

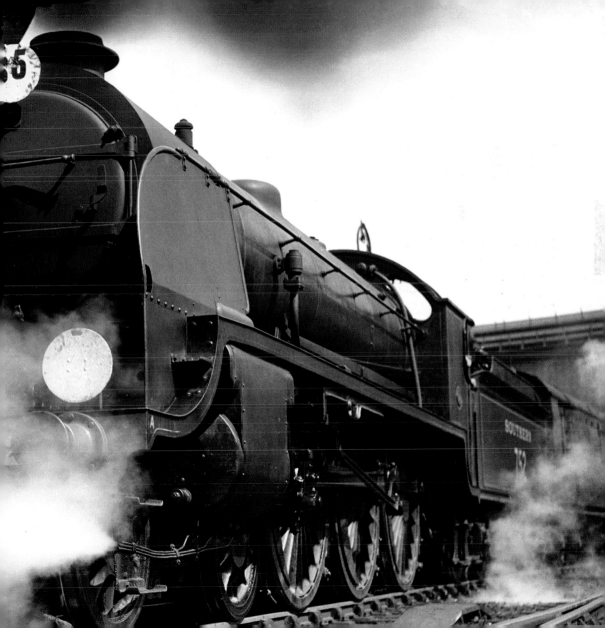

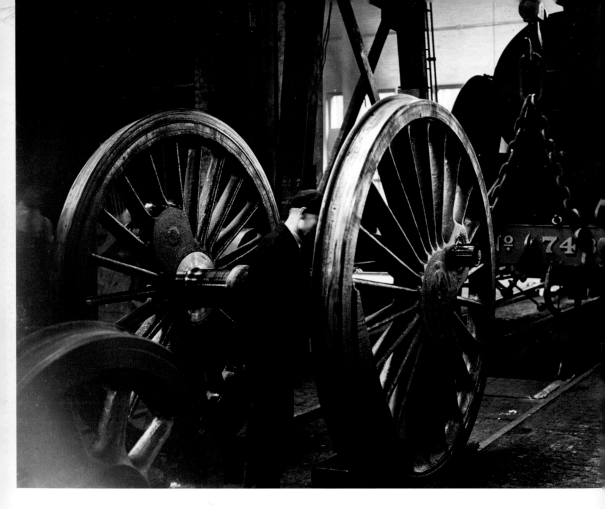

Locomotive wheels undergoing maintenance at the
Southern Railways engine shed at Nine Elms, London.
2nd July, 1932

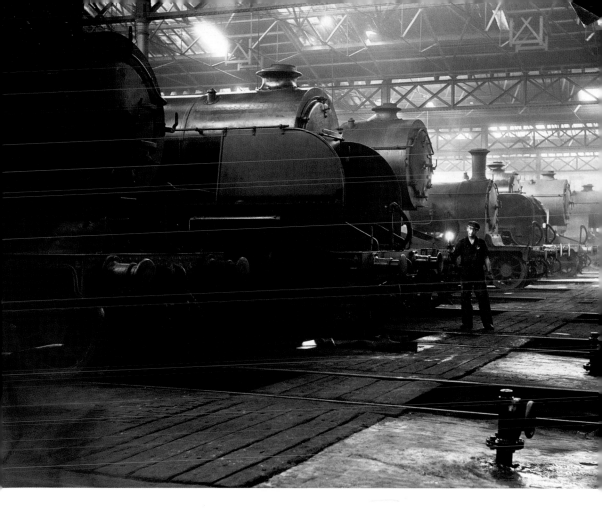

Nine Elms shed line-up.
2nd July, 1932

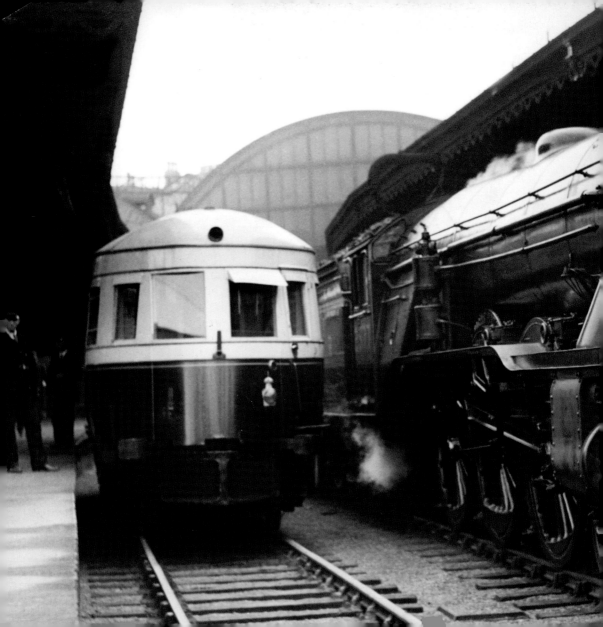

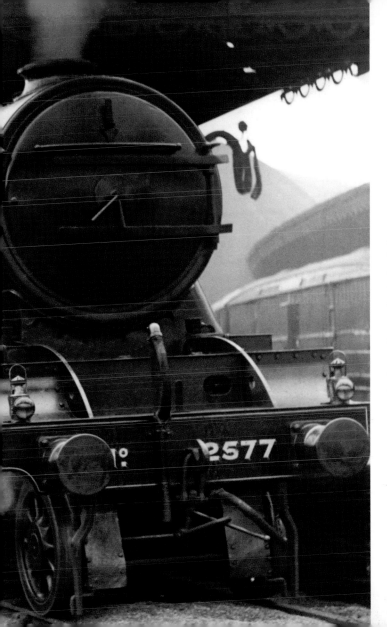

Britain's first railbus, a 60-seater Armstrong Whitworth, waits for the road at Newcastle Central Station. This new-fangled diesel-electric is dwarfed by the adjacent steam locomotive, Gresley A1 Pacific No. 2577 *Night Hawk*.
26th September, 1933

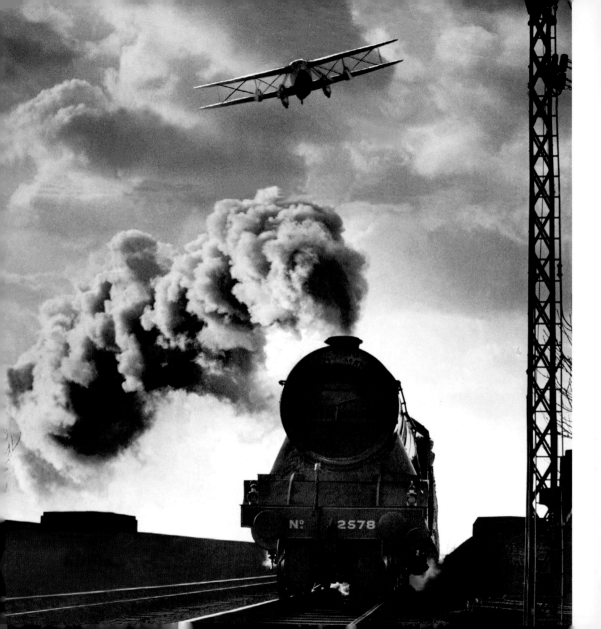

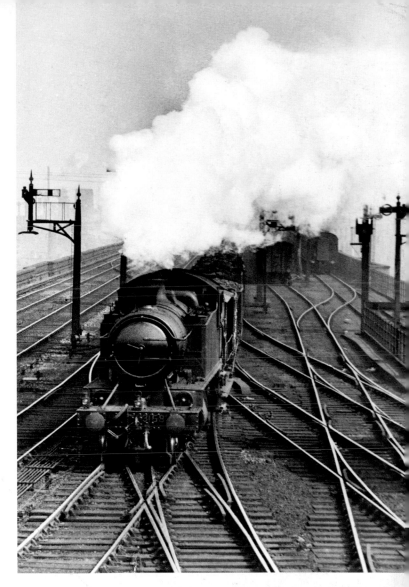

Left: An Imperial Airways plane flies over *The Flying Scotsman* at Welwyn, Hertfordshire.
At the head of the express is LNER A1/A3 Class No. 2578 *Bayardo*.
13th February, 1934

A GWR Prairie tank hauls an iron ore train from Banbury, Oxfordshire to the steel works at Bilston, Staffordshire.
May 1934

Crash inspectors survey the damage the morning after two passenger trains collided on a diamond crossing at Port Eglinton Junction near Cumberland Street Station, Glasgow. Nine people were killed and 11 seriously injured in the accident.
7th September, 1934

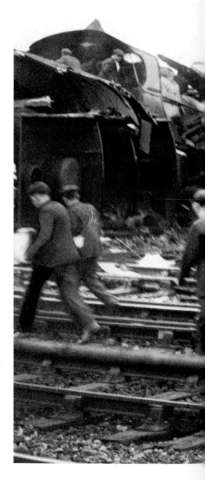

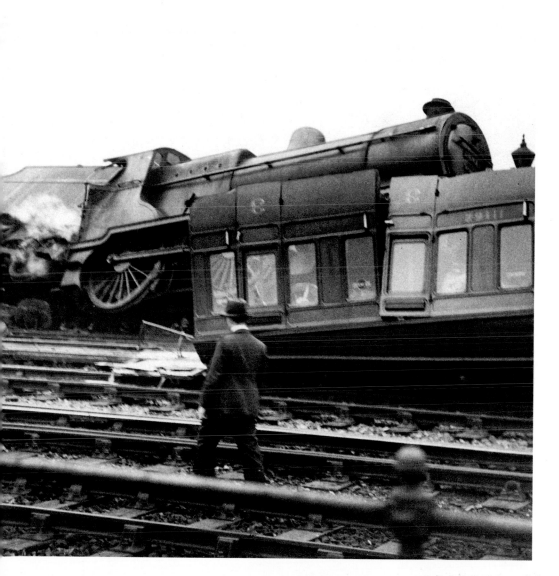

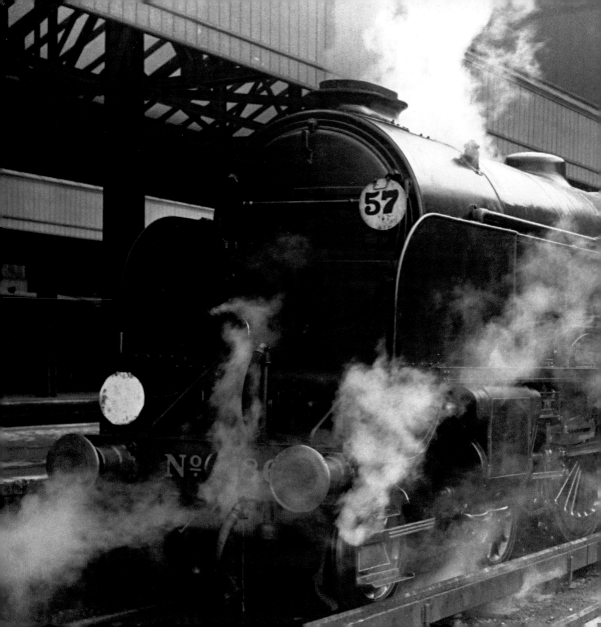

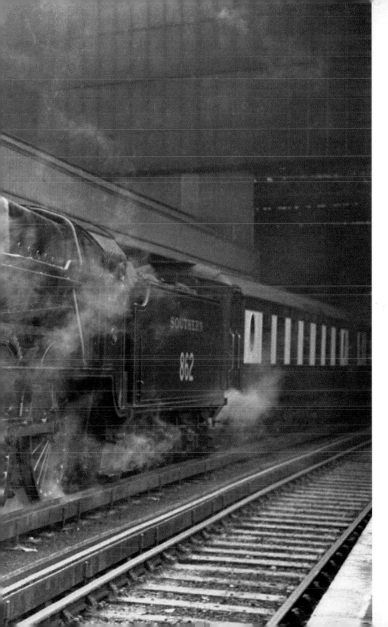

Southern Railway (SR) Lord Nelson Class 4-6-0 No. 862 *Lord Collingwood* at Waterloo. The Pullman coaches indicate that the train's destination was either Bournemouth (*The Bournemouth Belle*) or Ilfracombe (*The Devon Belle*), the only services from this station that operated this luxurious form of passenger rolling stock.
c.1935

The approaches to
Waterloo Station.
Although the locos in the
photograph are steam,
the third rail reveals
that by this time electric
trains were already
well established on the
Southern Railway.
c.1935

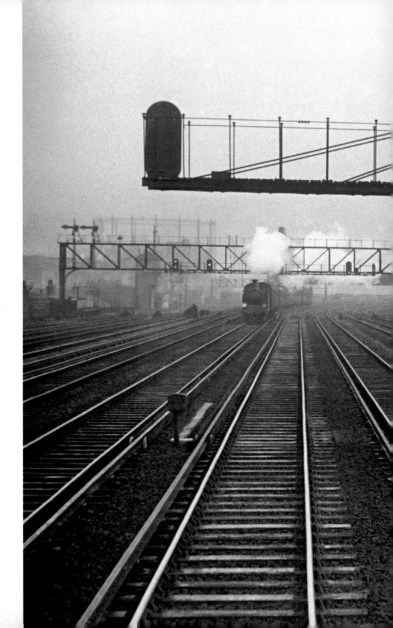

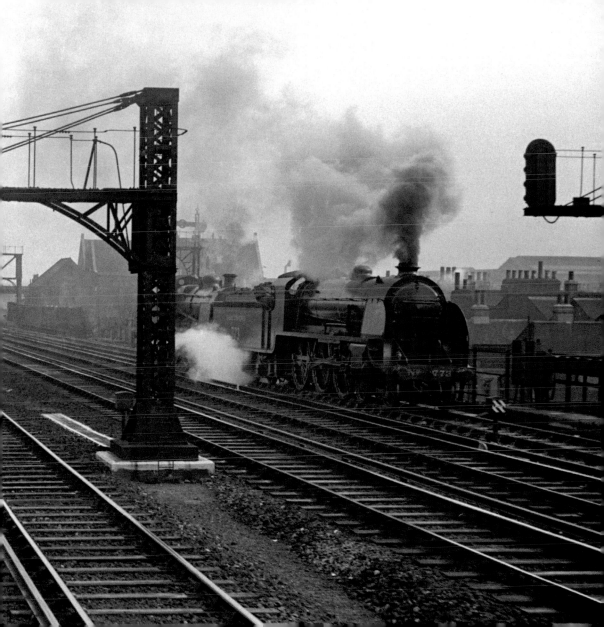

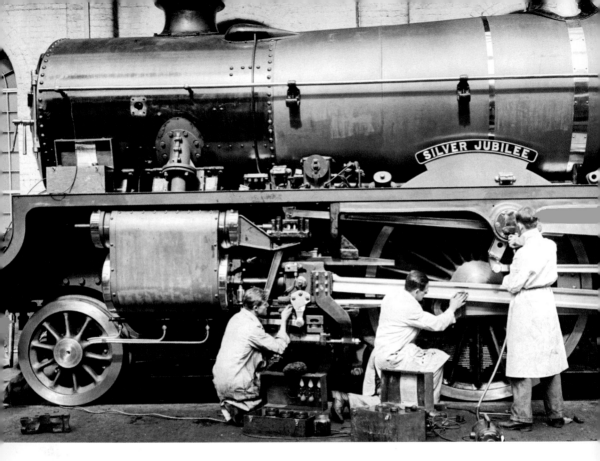

While the LNER gave one of its express passenger services the *Silver Jubilee* name *(see page 36)*, the LMS applied it to both a class of locomotive and its first member. Here No. 5552 is being finished out at Crewe Works, where it was painted in a special high-gloss black livery with chromium trim to distinguish it from other LMS passenger locos, which were traditionally finished in crimson lake.
April 1935

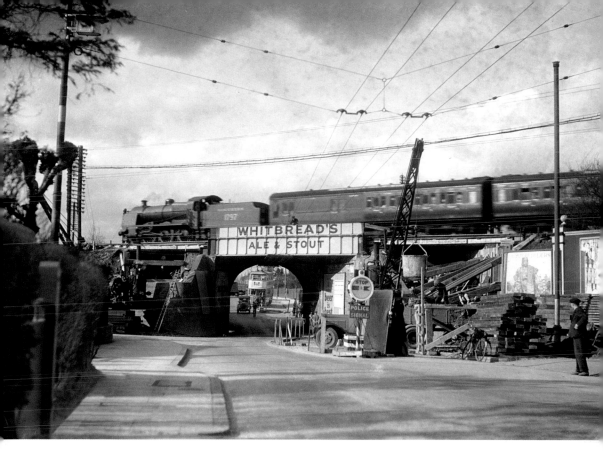

A Southern Railway U Class 2-6-0 passes over Malden railway bridge, which was then being repaired. Note the trolley bus wires, the absence of road markings and the dearth of road traffic: the 1930s were still in the Age of the Train.
April 1935

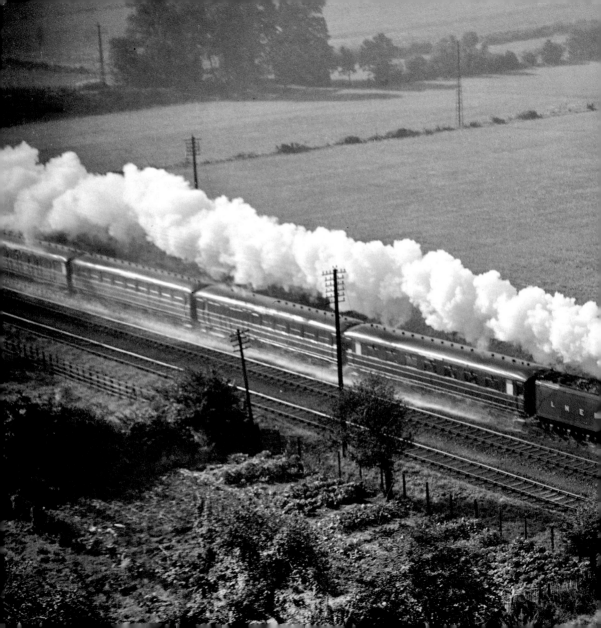

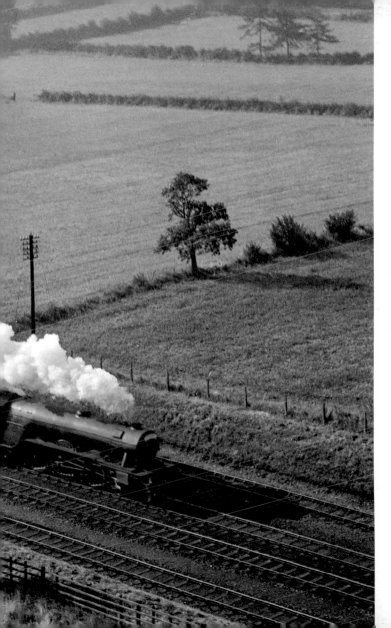

An LNER A1/A3 Pacific leaves a trail of smoke in its wake as it thunders through the Hertfordshire countryside on one of the fast tracks of a four-line route.
1936

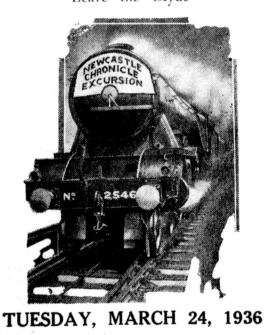

**"Newcastle Evening Chronicle"
and "North Mail"
EXCURSION
to see the Cunard White Star Liner
QUEEN MARY
Leave the Clyde**

Nº 2546

TUESDAY, MARCH 24, 1936

Your TRAIN SEAT No. is _____

In COACH _____

Left: A ticket for the *Newcastle Evening Chronicle and North Mail* excursion to see the Cunard White Star Liner RMS *Queen Mary* leave Glasgow after its completion at the John Brown Shipyard on the River Clyde.
March 1936

LNER A4 No. 4491 *Commonwealth of Australia* snakes its way out of Newcastle Central Station en route to Edinburgh. Note the rear-working tank engines double-heading carriages in the right of the photograph.
2nd July, 1937

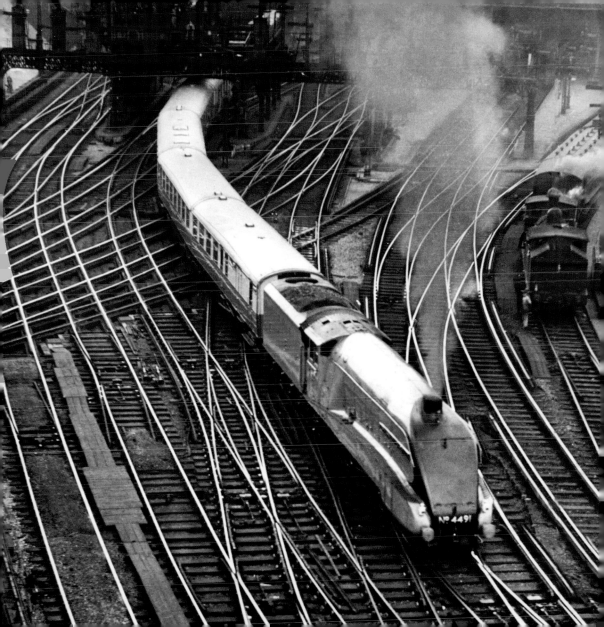

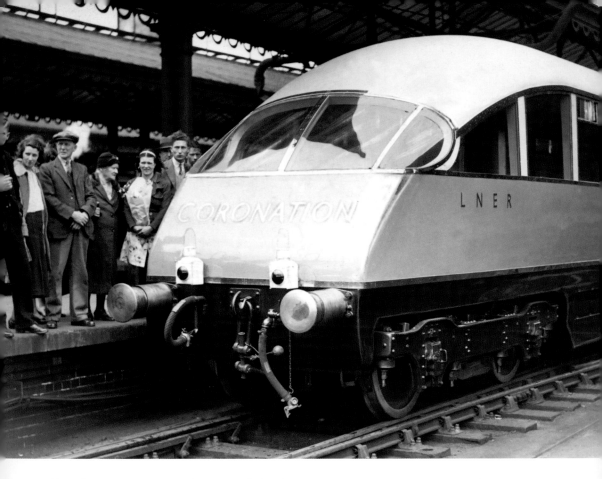

The observation car at the rear of *The Coronation*, a passenger express between London King's Cross and Edinburgh Waverley introduced by the LNER to celebrate the accession of King George VI. This photograph was taken at Newcastle Central at the end of a test run on the eve of the official launch of the service.
3rd July, 1937

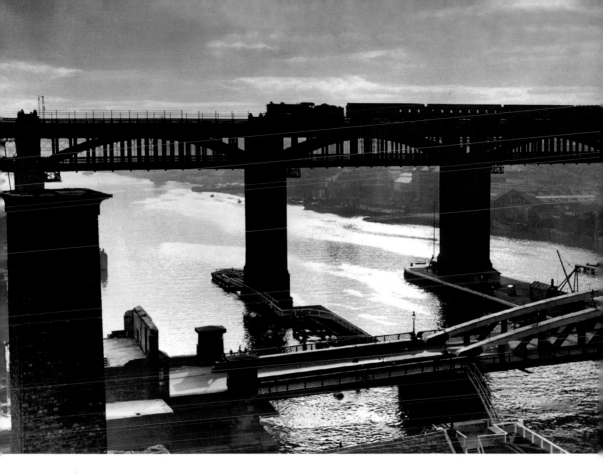

There's no fog on the Tyne, but still plenty of atmosphere in this sunset view over the river from Gateshead as a passenger train steams over Robert Stephenson's 1849 wrought iron High Level Bridge, a bravura double-decker structure carrying a road beneath the railway level. William Armstrong's Swing Bridge is partially visible in the right of the photograph.

14th January, 1938

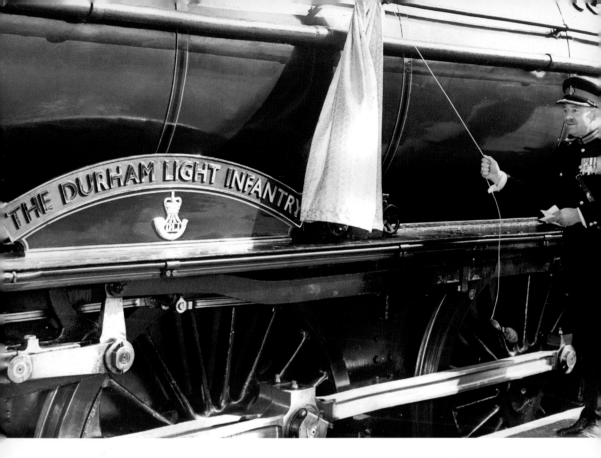

The V2s were a class of 2-6-2 locomotives that entered service on the LNER between 1936 and 1944. One hundred and eighty-four of them were built but at first only seven of them were given names. Later it was decided to ennoble an eighth in honour of one of Britain's most distinguished army regiments.
29th April, 1938

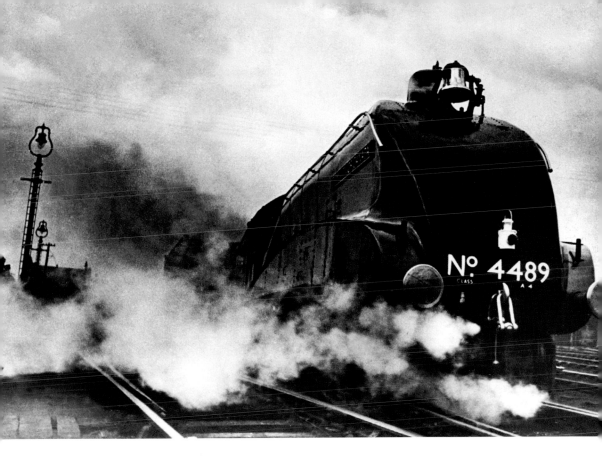

LNER A4 Pacific *Dominion of Canada* leaving London
King's Cross for Edinburgh on the East Coast main line.
The bell on the front, mounted in imitation of Canadian
Pacific Railway practice, was removed in 1949 and
replaced with a standard chime whistle.
22nd June, 1938

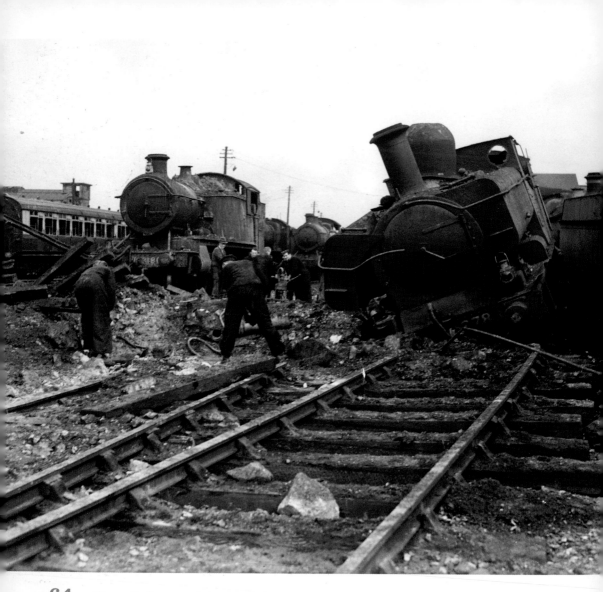

Left: A German air raid on Newton Abbot hit the GWR railway station with six bombs. Although one of them failed to explode, the others killed 14 people and destroyed both the southbound platform and this 0-6-0 pannier tank.
20th August, 1940

A team of girl painters employed by the Southern Division of the Southern Railway have painted their way up and down the line from Dorset to Basingstoke. The leader in this picture is Doris Heal whose entire family is here putting Southampton Central Station to rights after the bombing. Her mother is at the end of the line.
c.1940

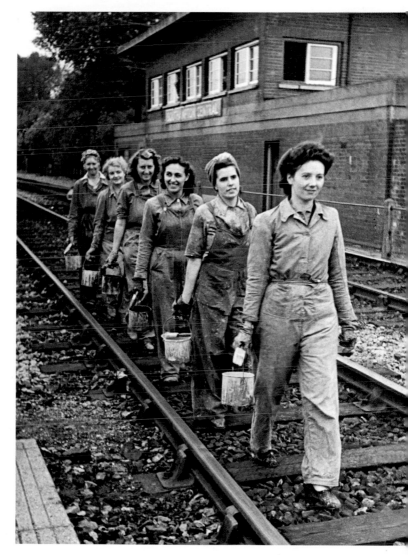

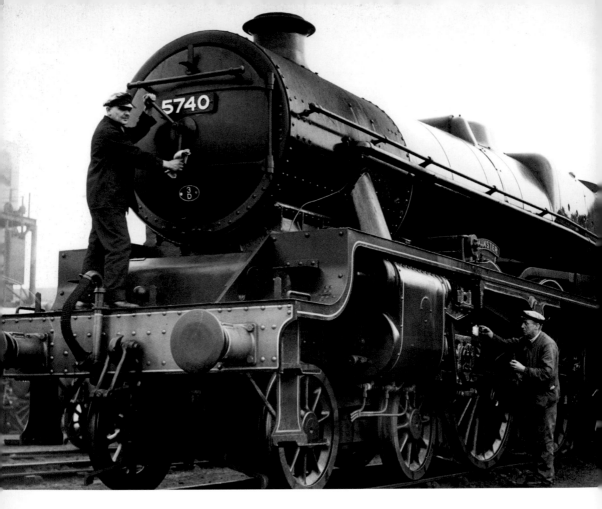

The crew of LMS Jubilee Class 4-6-0 No. 5740 *Munster* prepare the locomotive for a night run. Wartime rail services in Britain were severely disrupted by Luftwaffe bombing raids, but railway workers did all they could to maintain services as normal. 2nd April, 1940

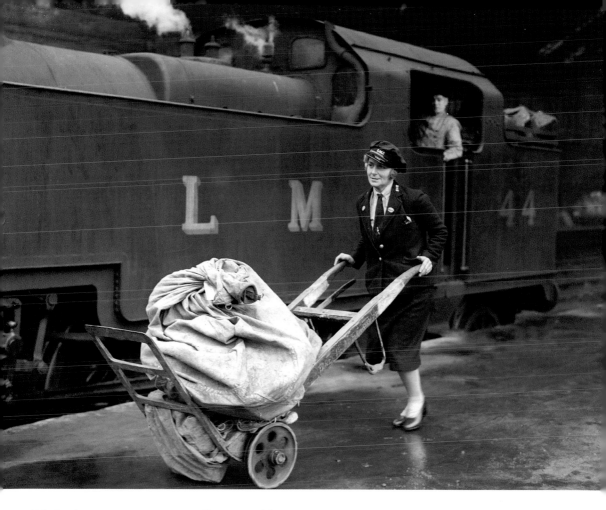

While the men were away in the armed forces, women took over many essential services on the home front: before the Second World War female porters were unheard of; at the height of the conflict, they were an everyday sight.
1941

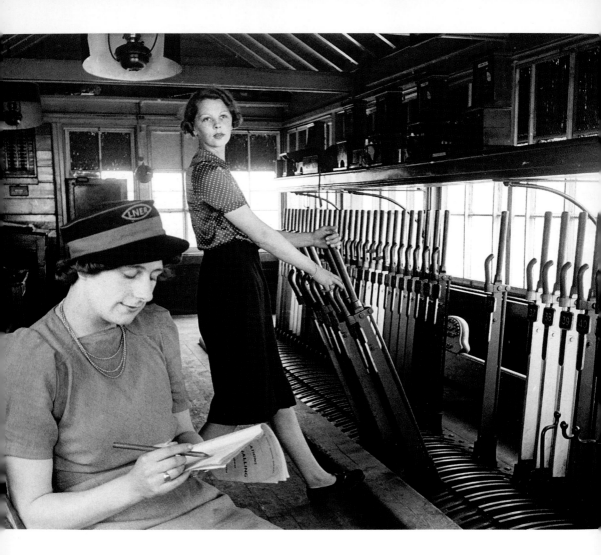

Left: Women work the signal box at Warmsworth near Doncaster, Yorkshire on the East Coast main line. The men they replaced would have been issued with uniforms, but wartime restrictions meant that female staff had to work in their own clothes, apart from the optional extra of an LNER cap.
1941

During the Second World War blackout, a driver shines a torch to check lineside signals from the footplate of an LNER locomotive heading a Night Scotsman service between London and Edinburgh.
6th February, 1941

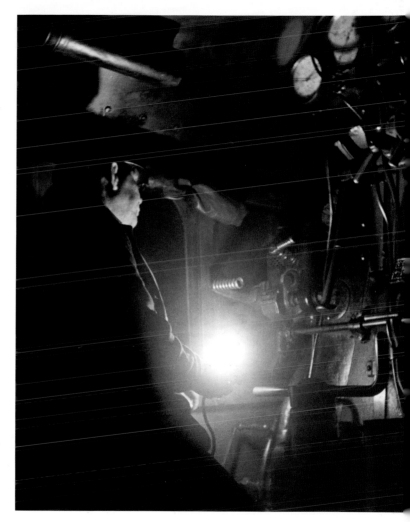

Holidaymakers throng the platforms at London Paddington Station as they head to the West Country. During the Second World War many traditional seaside resorts in Southeast England, such as Brighton, Margate and Southend, were closed to visitors because they were in the front line of German air attacks.
2nd August, 1941

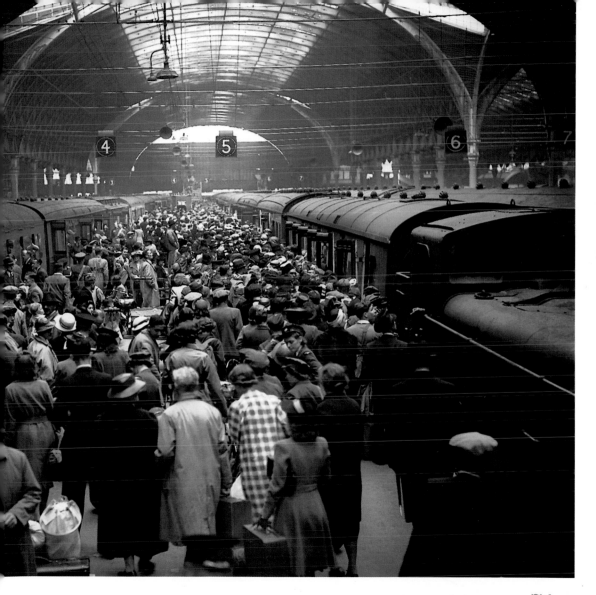

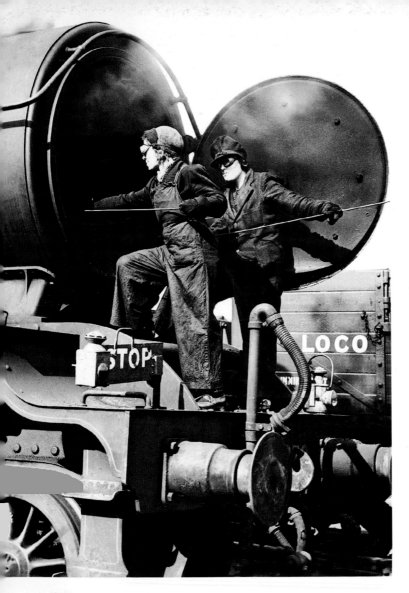

Female railway workers clean out a locomotive boiler. Having shown what they were capable of during Britain's hour of need, many women were reluctant to return to housework after the conflict, paving the way for major postwar changes in society.
1942

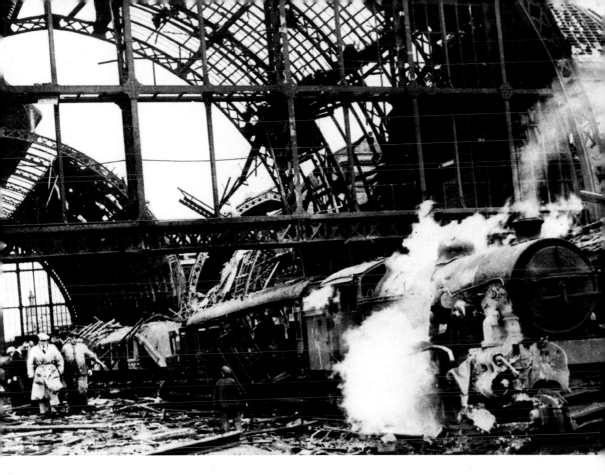

A fine August day ended in terror at Middlesbrough Station after a German daylight air raid scored a direct hit on the overall roof, causing it to partially collapse on a passenger train beneath. Seven people were killed. In spite of the vast damage, salvage workers and volunteers immediately set to work to clear the track. Normal rail services resumed just 40 hours later.

6th August, 1942

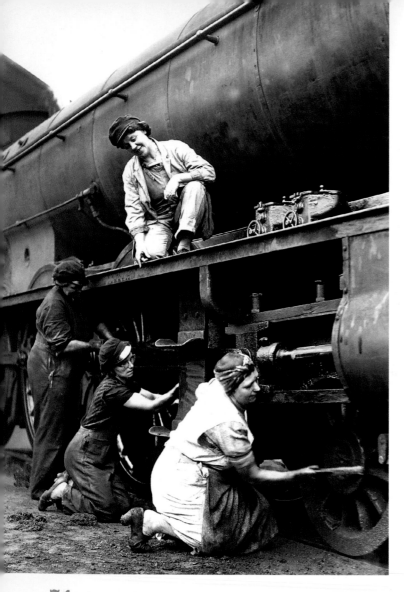

Women cleaning the wheels and valve gear of an LNER freight locomotive: before the Second World War, many people believed that women were incapable of heavy manual labour; after the conflict they were compelled to reconsider their sexist attitudes.
27th August, 1942

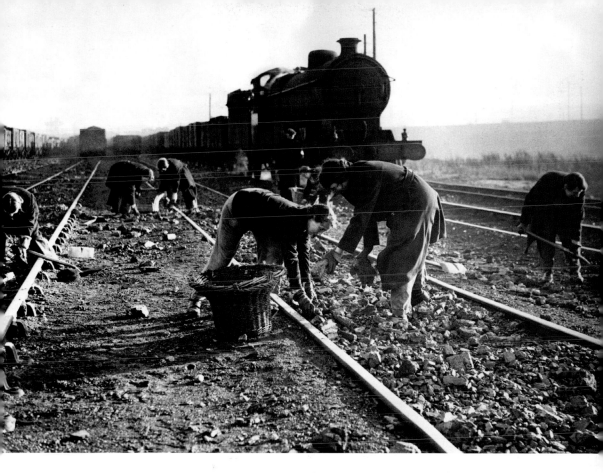

With fuel supplies at a premium throughout the Second
World War, every piece of coal was valuable and the
railways hired women to recover it after it had been
dropped between the railway lines by passing trains.
20th January, 1943

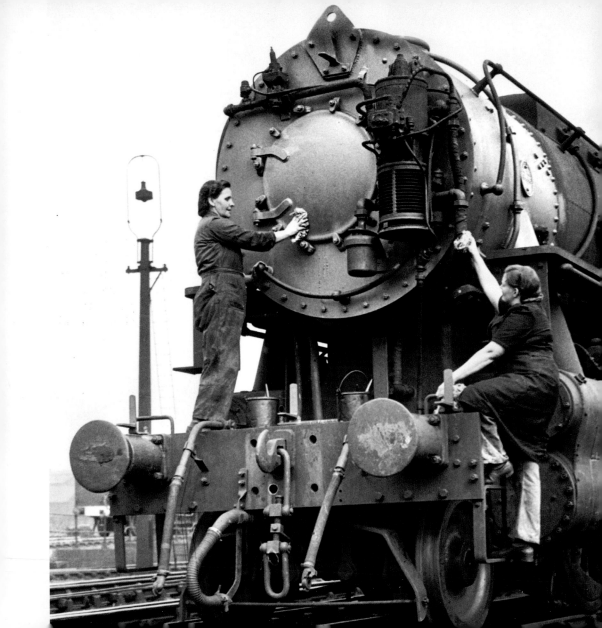

After the Japanese attack on Pearl Harbor on 7th December, 1941, the United States joined the Second World War and began supplying Britain with badly needed supplies including powerful steam locomotives such as this US Army Transportation Corps (USATC) S160 Class 2-8-0, here being cleaned by female LNER workers.
14th April, 1943

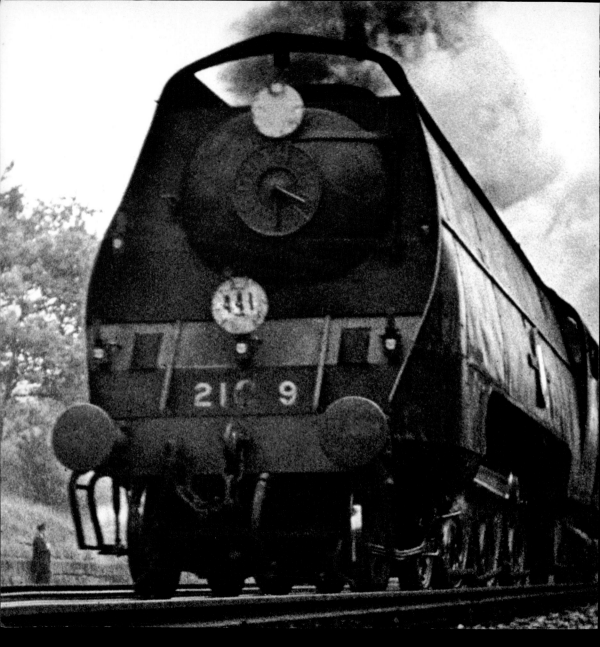

The Southern Railway's chief mechanical engineer Oliver Bulleid introduced his spectacular Merchant Navy Class 4-6-2 Pacifics in 1941. The deluxe appearance attracted adverse criticism but gained government approval because it was classified as a mixed traffic design – the locomotives were declared suitable for hauling freight as well as passenger trains. Seen here near Surbiton, No. 21C9 *Shaw Savill* makes light work of the longest train ever to leave London Waterloo.

5th May, 1943

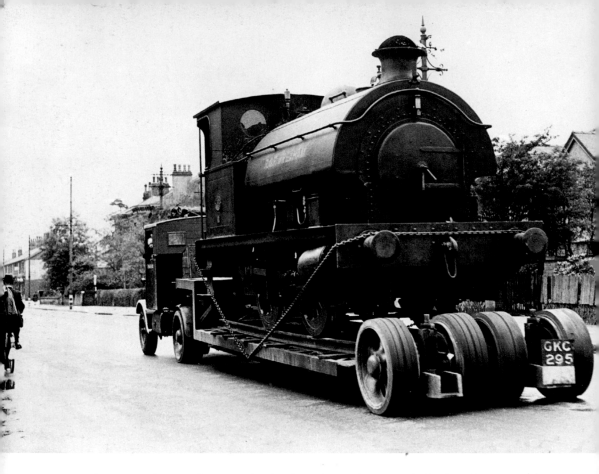

Many of Britain's largest factories had railway lines that were linked to the national system but operated by the companies' own tank engines. Here one such locomotive is taken for repair on a low-loader through the streets of Stretford, Manchester. **June 1943**

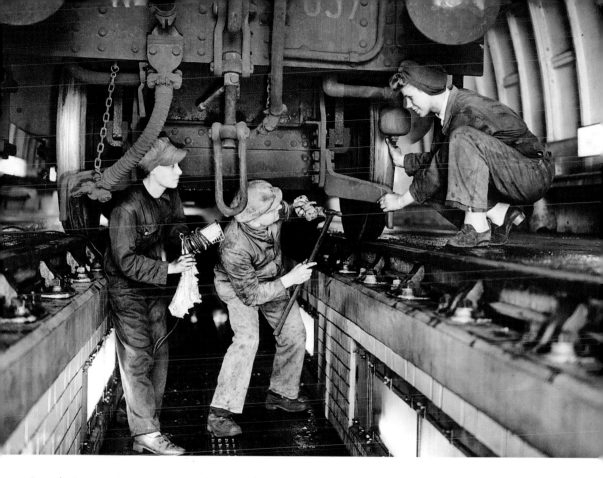

A male inspector supervises women cleaners working on the underside of a locomotive in the floodlit pit of an engine shed.
1944

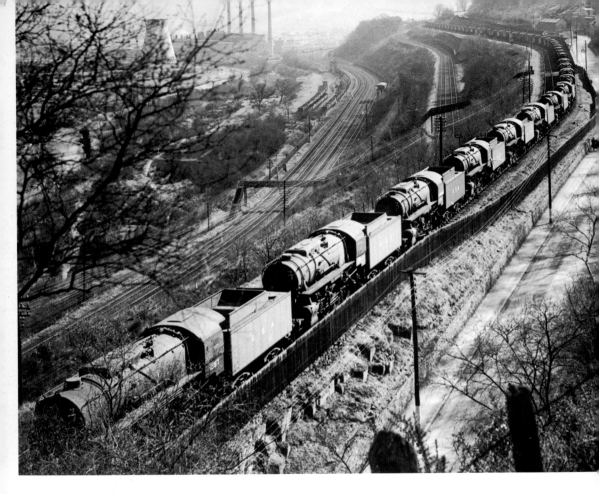

As D-Day approached and the Allies prepared for their invasion of mainland Europe, the United States' supplies of material grew from a trickle into a flood. Here a long line of USATC S160s await deployment on an English siding.
1944

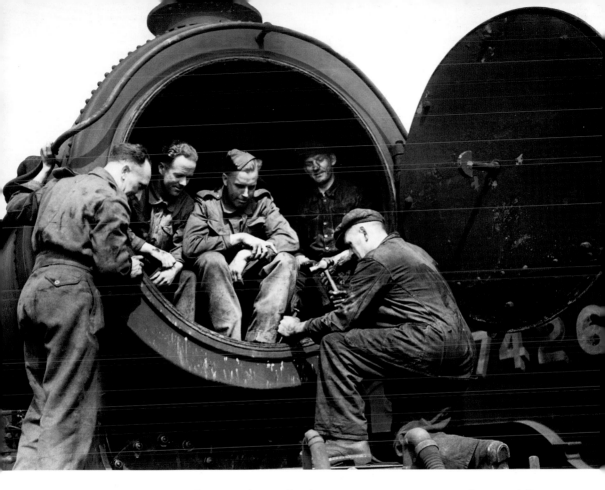

Perhaps learning a new trade in readiness for their return to civvy street, these soldiers observe an experienced practitioner removing scale from the smoke box of an LNER Thompson Class B1.
July 1944

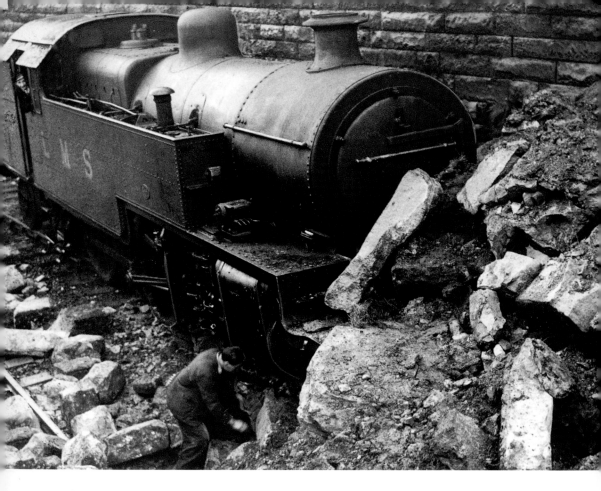

As if bombing raids were not enough to deal with, this LMS Fowler Class 4MT 2-6-4 tank engine gets caught in a large landslide at Greenock, Clydeside. The driver inspects the damage while the fireman stays safely in the cab.
1st December, 1944

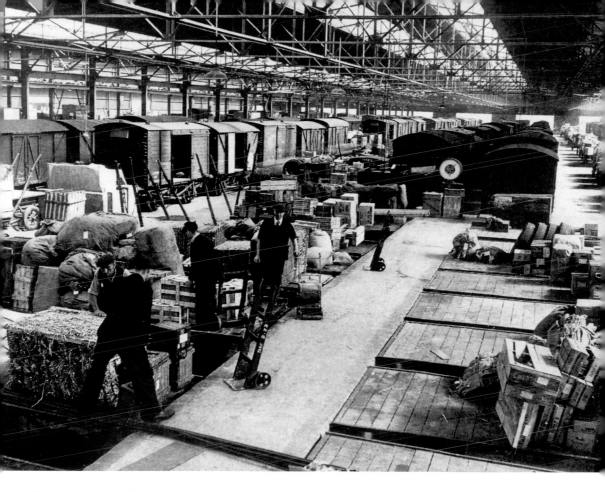

The rebuilt goods depot at Lawley Street, Birmingham,
not long after it reopened at the end of the Second
World War.
1945

The first steam
locomotives to be built
after the end of the
Second World War
featured several modern
additions, including
electric front lights, which
henceforth replaced the
traditional but now old-
fashioned oil lamps.
2nd June, 1946

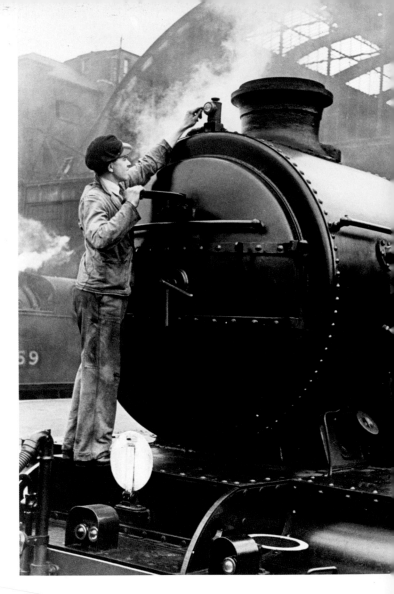

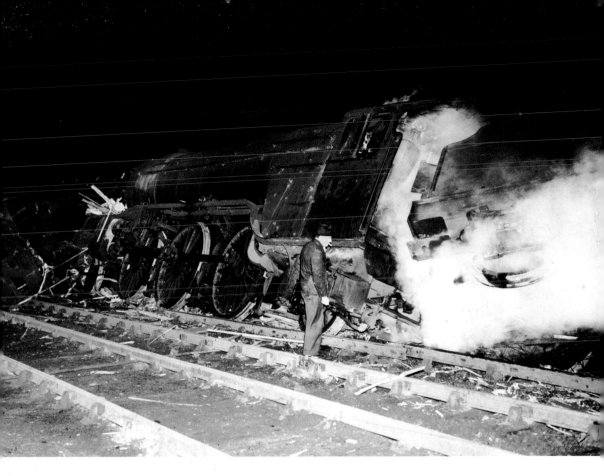

A Gresley Class V2 locomotive lies on its side in the aftermath of a crash at Potters Bar. A local train travelling towards London King's Cross was derailed when a signalman changed the points as it was passing over them. Its derailed coaches fouled the mainline and were shortly afterwards hit in quick succession by two northbound expresses. Two passengers were killed and 17 injured.
10th February, 1946

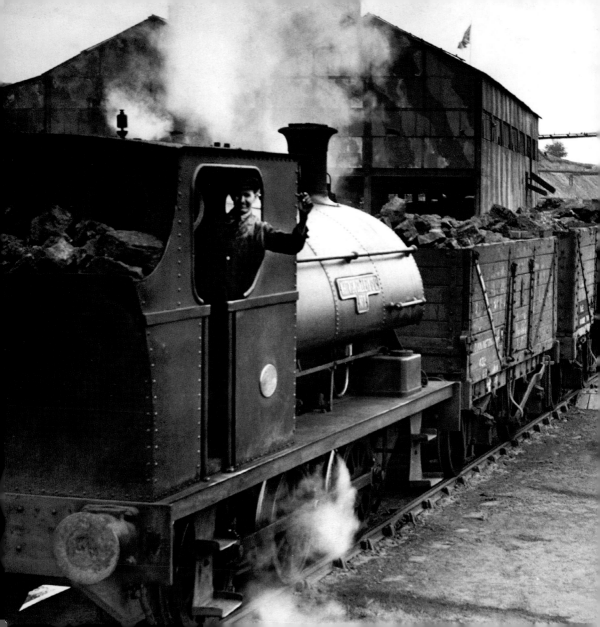

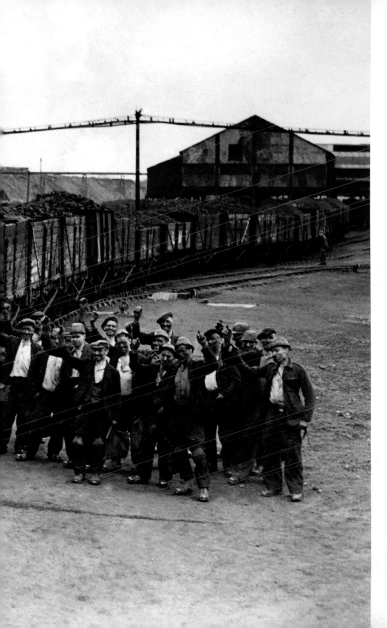

After the Second World War, British people worked extra hard to help the nation recover economically. It took these 16 men only one working day to load this coal train at the Hitwick Colliery in Coalville, Leicestershire. **3rd May, 1946**

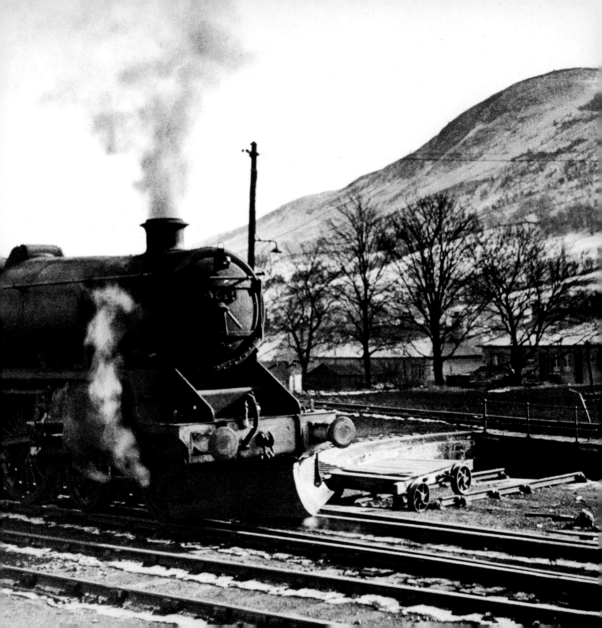

An unidentified steam locomotive passes the turntable outside Blair Atholl Station on its way from Perth to Forres in Morayshire, Scotland, a route that passes through the imposing Grampian mountain range.
c.1947

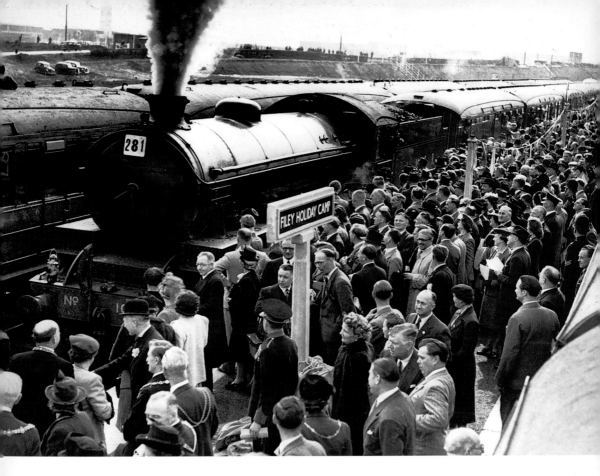

One of the most striking early changes in postwar Britain was the increasing popularity of holiday camps. This photograph shows the opening of a new station at the end of a branch line built specially to serve one of the leading sites, Butlin's at Filey, Yorkshire.
10th May, 1947

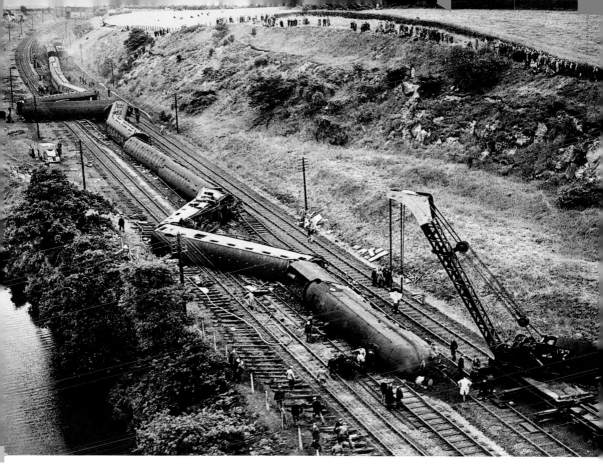

The 8.30 am express passenger train from London Euston to Liverpool, comprising 14 L6 screw-coupled bogie vehicles, hauled by a Pacific type loco, became derailed, blocking four lines. The train was crowded with about 800 passengers, of whom 130 were standing; four were killed outright and one died later in hospital. 22nd July, 1947

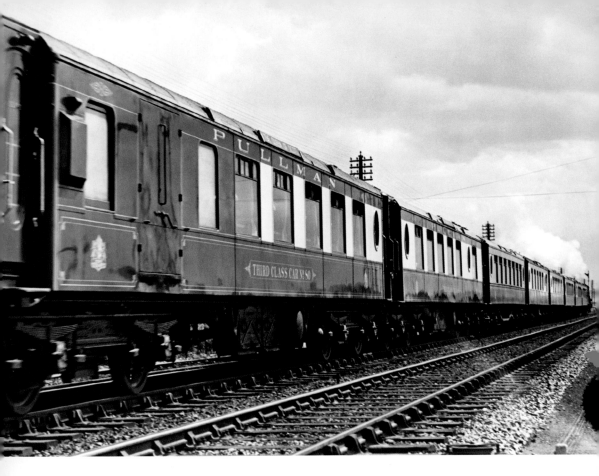

After years of austerity, the return of luxury rail services was a welcome sign that Britain was returning to normal. Here the first postwar Pullman passes through Low Fell en route for London King's Cross after leaving Glasgow. 9th July, 1948

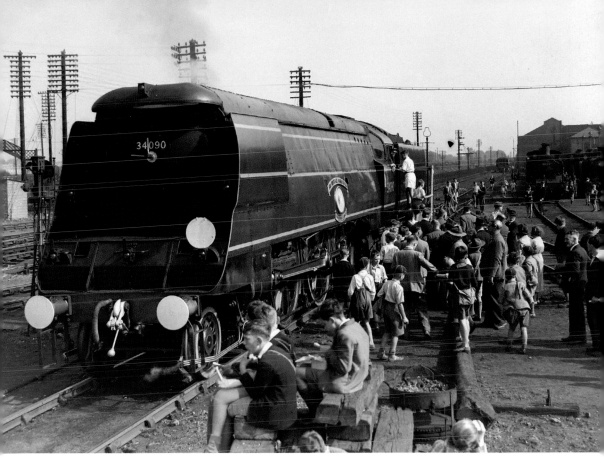

Railway enthusiasts swarm around the Southern Railway Bulleid West Country Class Pacific No. 34090 *Sir Eustace Missenden*, during an open day at Ashford Railway Works, Kent. This locomotive, named after the last chairman of the SR and the first chairman of British Railways' Railway Executive, was at the time only nine months old. **20th August, 1949**

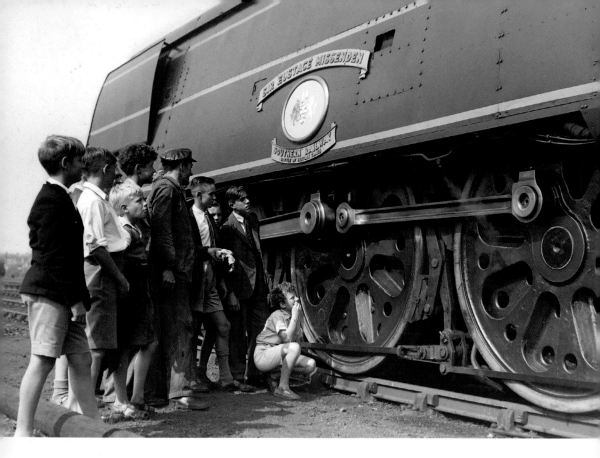

Under the watchful eye of a footplateman, small boys scrutinise the Battle of Britain class steam locomotive at close quarters during an open day at Ashford Works. They seem particularly impressed by the 6 feet 2 inch (1.88m) driving wheels.

20th August, 1949

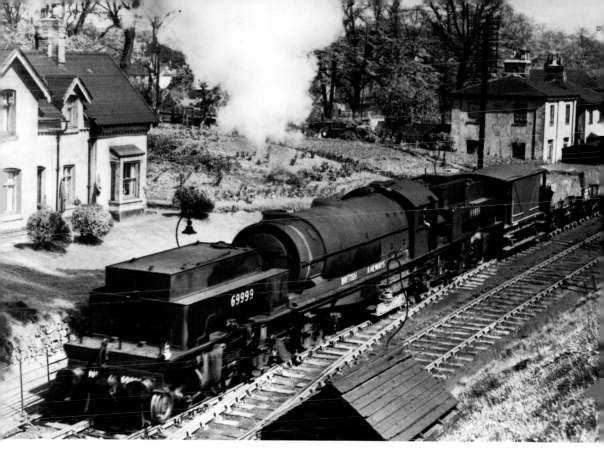

The only articulated locomotive ever to run on British standard gauge railways, this 4-8-0+0-8-2 Beyer-Garratt Class U1 was used to bank heavy coal trains up steep inclines on the LNER. It was in service between 1925 and 1955. 29th April, 1949

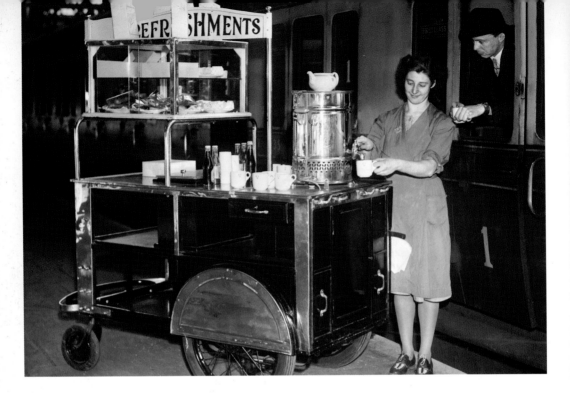

Refreshment trolleys were introduced by the Western Region of British Railways to compensate for any lack of on-board facilities. Here a female worker at Birmingham Snow Hill Station serves a cup of tea to a passenger at the window of his train carriage.
31st May, 1949

Right: The sheer excitement of a steam express train running at speed is encapsulated in this magical evening photo of ex-GWR Castle Class No. 7001 *Denbigh Castle* racing at dusk through the London suburbs on the 7.10 pm from Paddington to Birkenhead Woodside. In accordance with GWR practice, the driver, Reg Deacon, is on the right-hand side (other railways' locos were left-hand drive); fireman Fred Phillips shovels coal into the firebox.
20th May, 1950

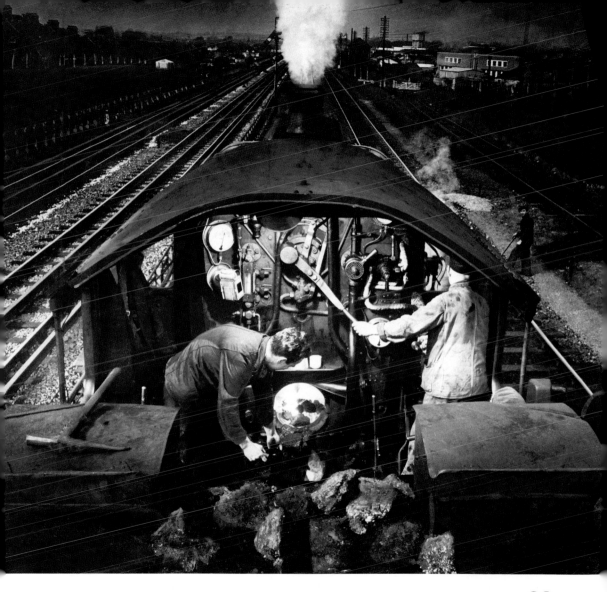

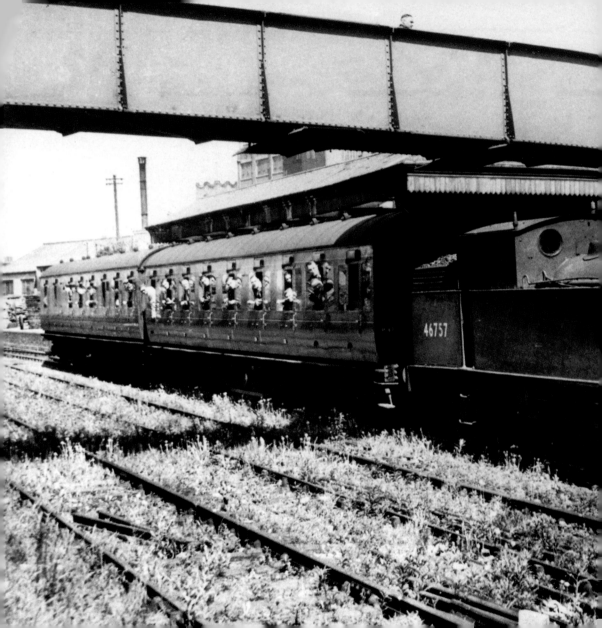

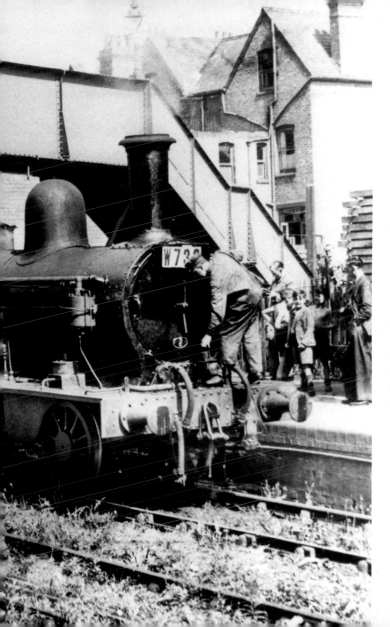

A Stephenson Locomotive Society special stops at Harborne, a suburb of Birmingham. The station had been closed to passengers since 1934, but that hardly explains the weeds on the tracks, which have grown wild for lack of financial and manpower resources.
June 1950

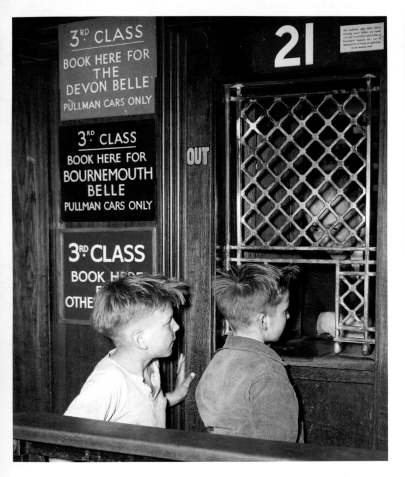

Two boys buying tickets from the booking office at London's Waterloo Station. Third class was not abolished on British Railways until June 1956.
June 1950

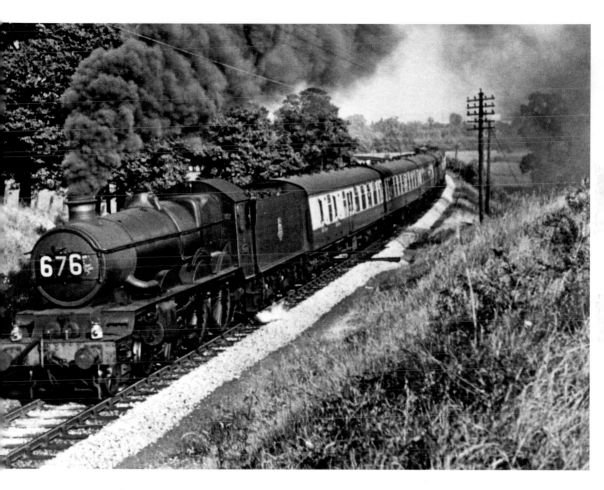

A 4-6-0 steam locomotive hauls its train through the picturesque Warwickshire countryside.
c.1950

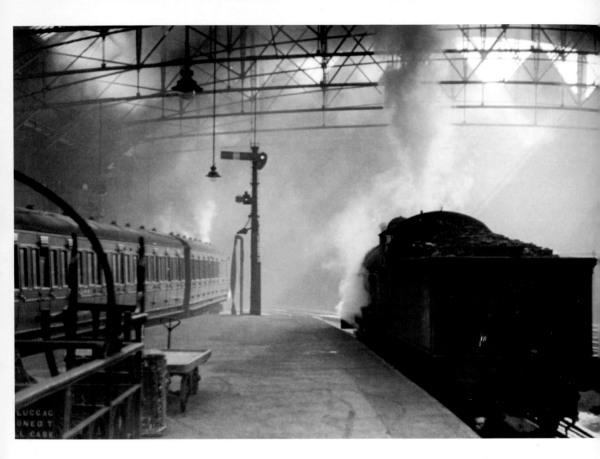

A locomotive backing down onto its train at Liverpool
Street. This was London's darkest station, because
the platforms curve at the outer end and the tracks
do not run into the open until they have passed under
Shoreditch High Street.
c.1950

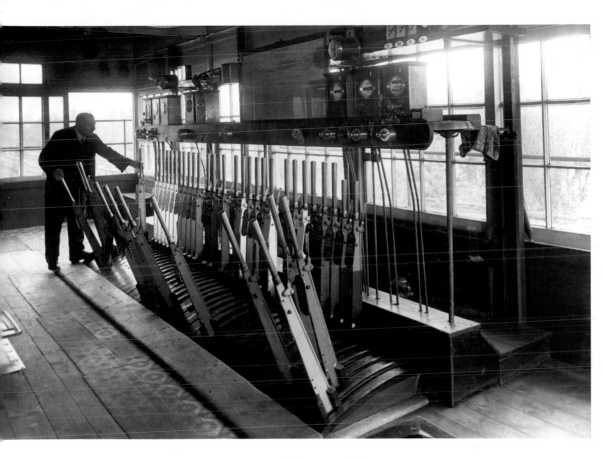

Signal boxes were highly pressurised workplaces: staff were responsible for safety and punctuality and needed physical strength to switch the heavy levers.
c.1950

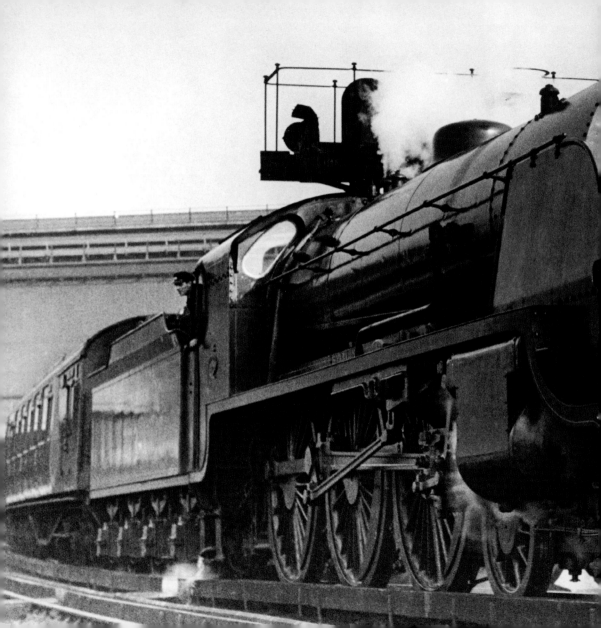

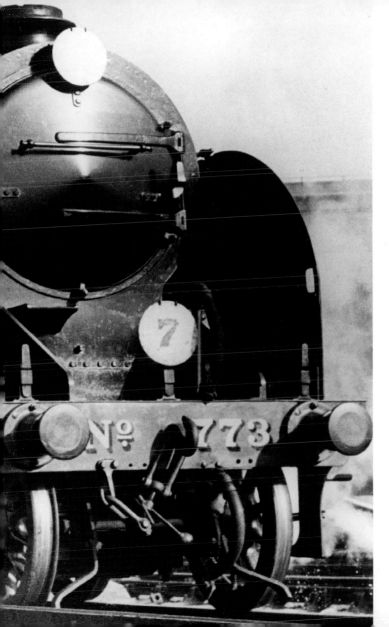

SR Class N15 4-6-0 No. 773 approaches London Waterloo Station with an express passenger train. In design and performance, this locomotive was no different from locomotives of the King Arthur Class, but unlike them it had no name.
c.1950

An unidentified King Arthur Class locomotive powers through a cutting. Note again the electrified outside third rail, one of the most easily recognizable features of the Southern network. c.1950

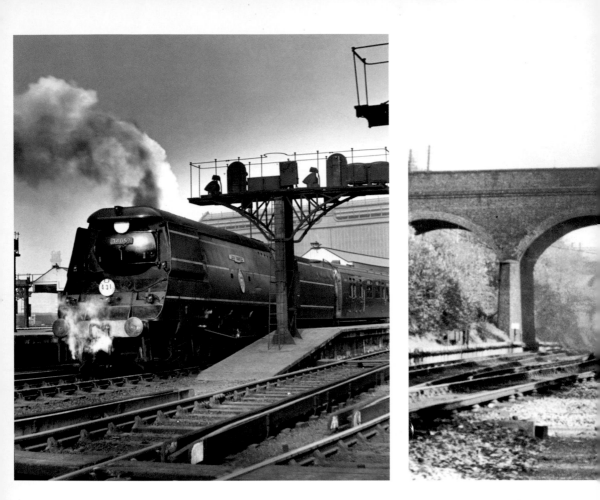

Southern Region Battle of Britain Class No. 34052 was named *Lord Dowding* after Air Chief Marshall Hugh Dowding, who headed RAF Fighter Command during what Winston Churchill famously called 'their finest hour'.
c.1950

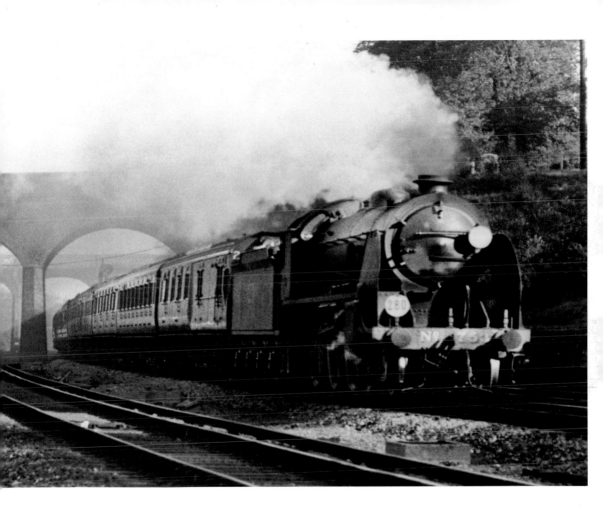

No. 753 *Melisande* was one of 74 King Arthur Class 4-6-0s designed by Robert W. Urie and built for the London & South Western Railway between 1919 and 1926. c.1950

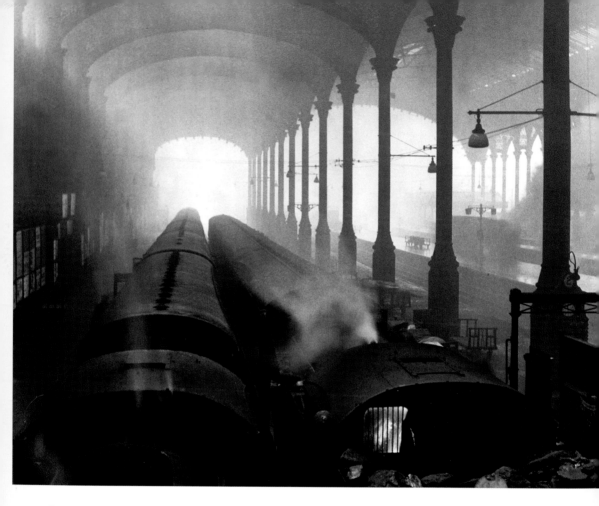

Commuter trains in and out of Liverpool Street linked the City of London with dormitory and new towns in Essex and parts of Hertfordshire. Expresses from this station served the whole of East Anglia.
c.1950

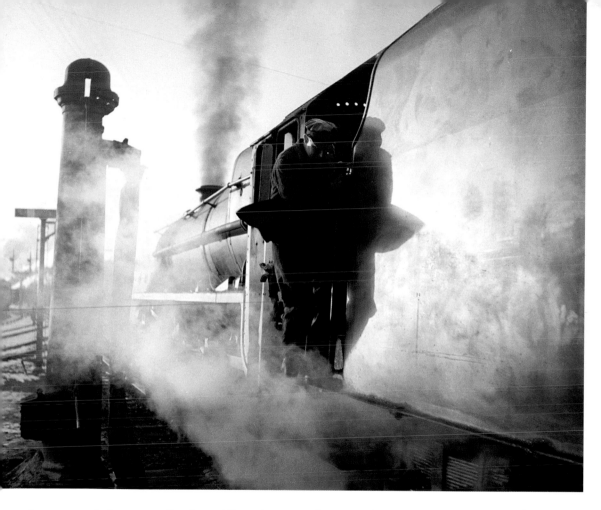

A steam train between Perth and Forres, Morayshire on a line that cuts across
the northeast end of the Grampian Mountains, the traditional boundary between
Scotland's Highlands and Lowlands.
c.1950

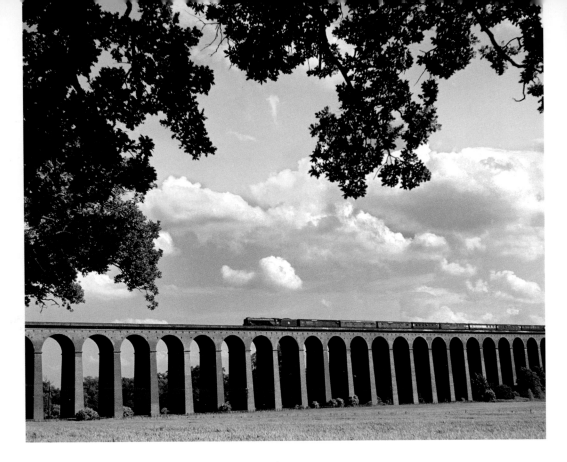

Digswell Viaduct, on the East Coast main line near
Welwyn North, Hertfordshire. At the head of the express
is *A.H. Peppercorn*, an LNER A2 Class Pacific, named
after its designer.
c.1950

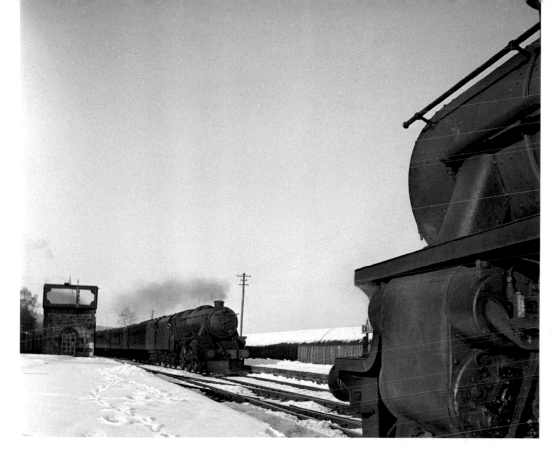

A Black Five on the Highland line between Perth and Aviemore. Locomotives of this class were built for the LMS by William Stanier. They were real workhorses, equally adept at heavy goods trains and passenger expresses. Note the snow plough.
c.1950

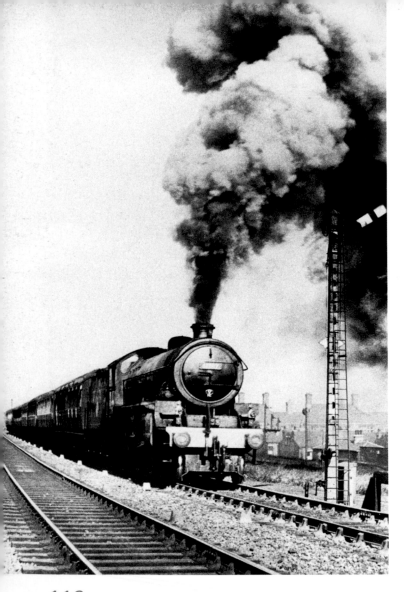

Ex-LNER B1 Class 4-6-0 No. 61387 attacks the 1-in-50 incline from Holbeck up to Copley Hill with a Leeds-Cleethorpes train. **1951**

Before the advent of electronic notice boards, station staff had to keep changing the times and destinations of passenger trains on indicators like these at Manchester Victoria.
24th February, 1951

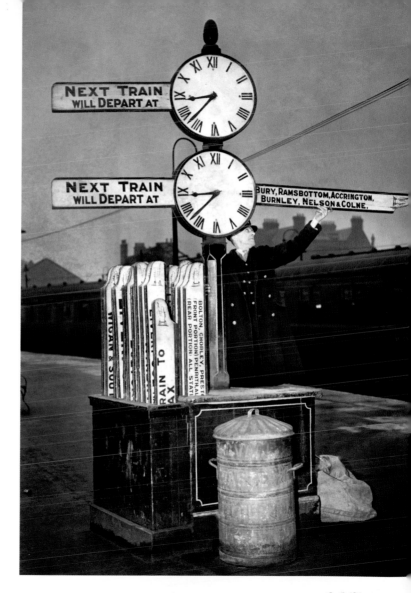

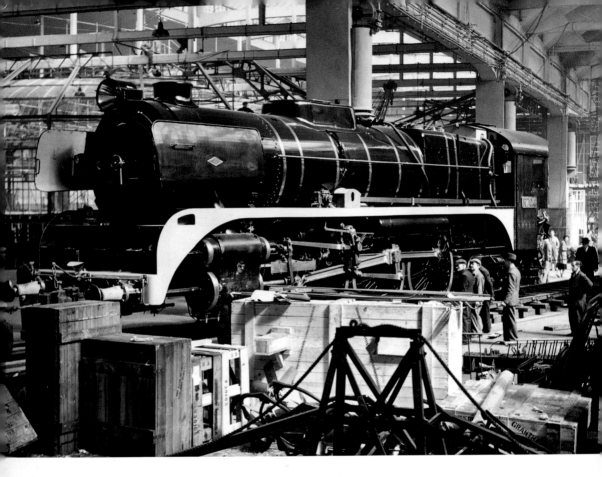

As part of the Festival of Britain, an Exhibition of
Industrial Power was held at Kelvin Hall in Glasgow.
Among the displays was this locomotive, built at the
nearby Springburn Works and bound for Melbourne,
Australia to work on the Victorian Railways.
22nd April, 1951

Mrs Lemon is exasperated by the uninvited arrival in her yard of the 57-ton Southern Region No. 32493 E4 0-6-2T tank engine, and a gawping crowd. The locomotive, built in 1899 at the Brighton Works, worked as mixed traffic out of the London's Nine Elms shed until withdrawn from service and cut up in 1958.
1st October, 1951

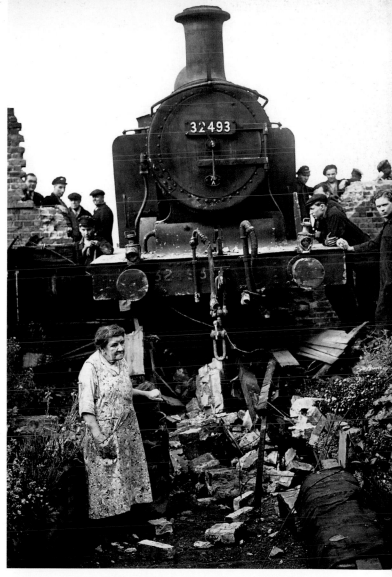

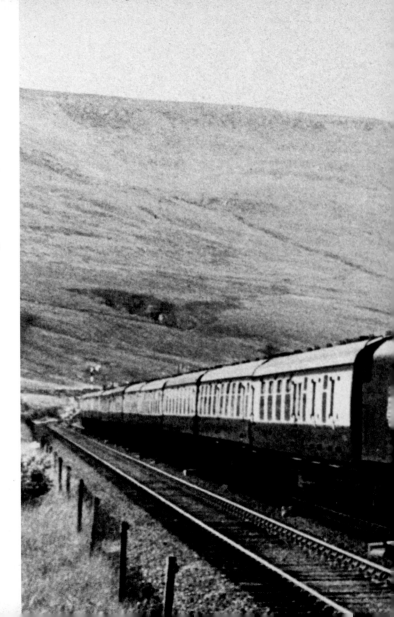

Ex-LMS Jubilee Class
4-6-0 No. 45573
Newfoundland beneath
Wild Boar Fell on the climb
to Ais Gill summit with
an Edinburgh–St Pancras
through train.
c.1952

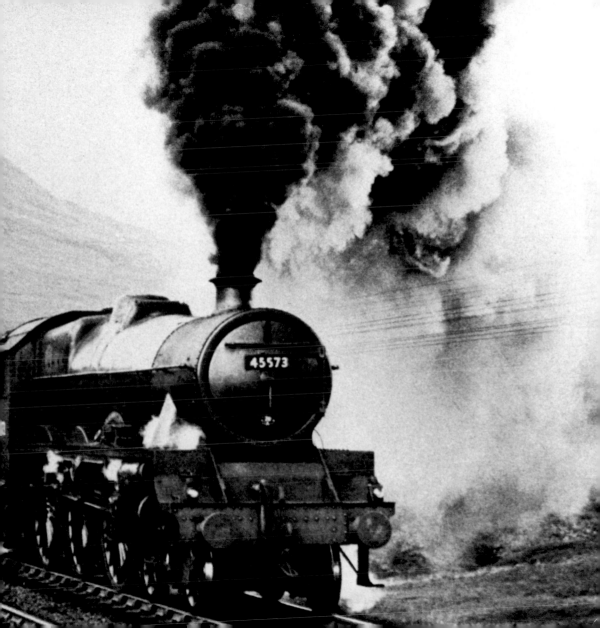

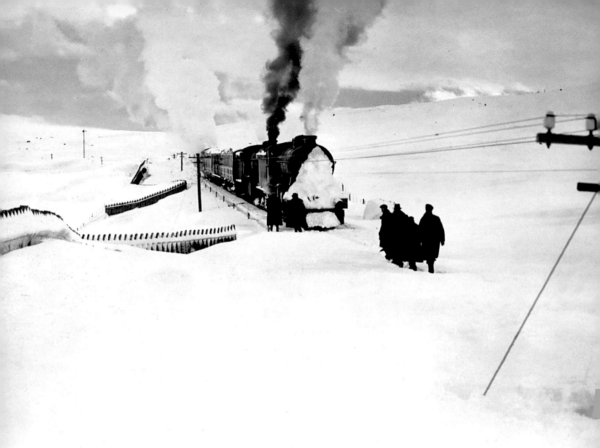

A relief train – double-headed and with a banker at the rear – is brought to a halt by snowdrifts on the West Highland line just short of Corrour, the highest mainland railway station in the United Kingdom.
3rd January, 1952

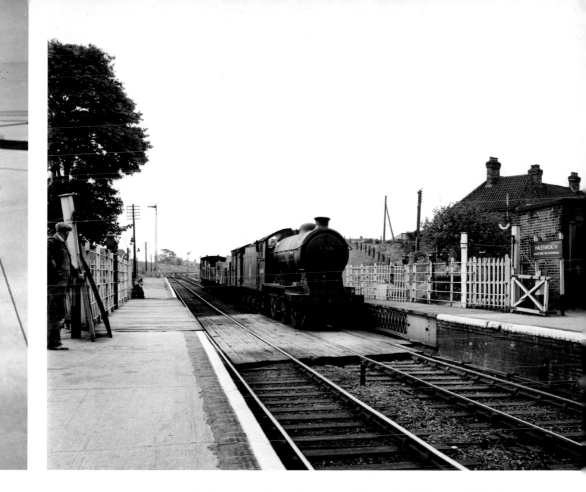

A short goods train passes through Halesworth Station on the Ipswich–Lowestoft line.
21st June, 1952

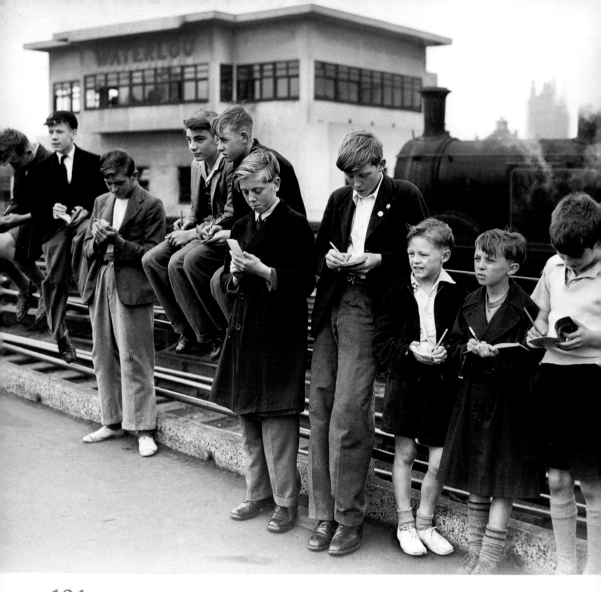

Left: Young trainspotters gather at the end of the platform at London Waterloo Station.
August 1952

A Class K2 2-6-0 No. 61787 *Loch Quoich* leaves Fort William with a train for Mallaig on the former LNER West Highland line.
c.1952

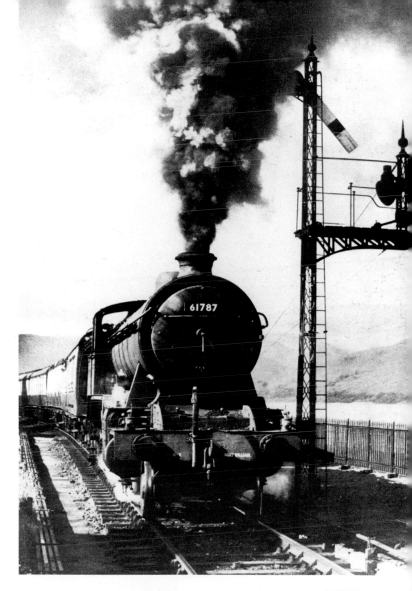

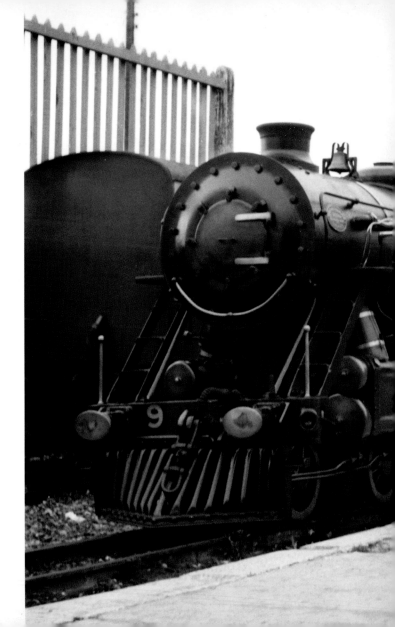

The Romney, Hythe & Dymchurch is a 15-inch (381mm) gauge light railway that runs for 13½ miles (22km) along the coast of Kent. Here is the pride of the RHDR's motive power stud, No. 9 *Winston Churchill.*
12th August, 1952

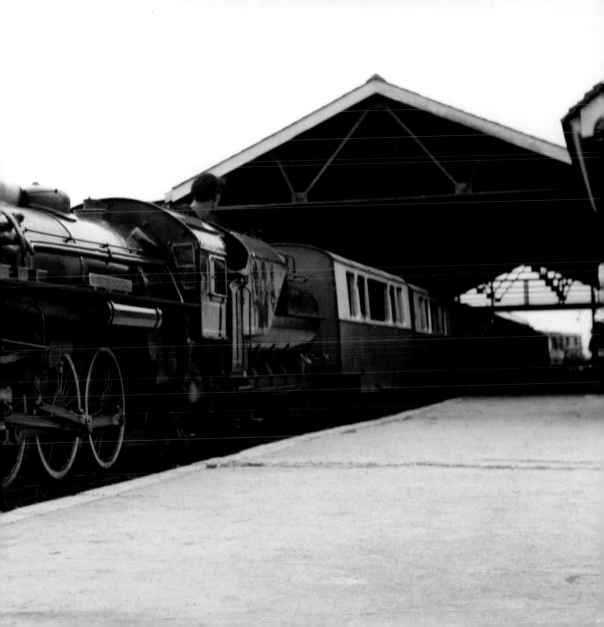

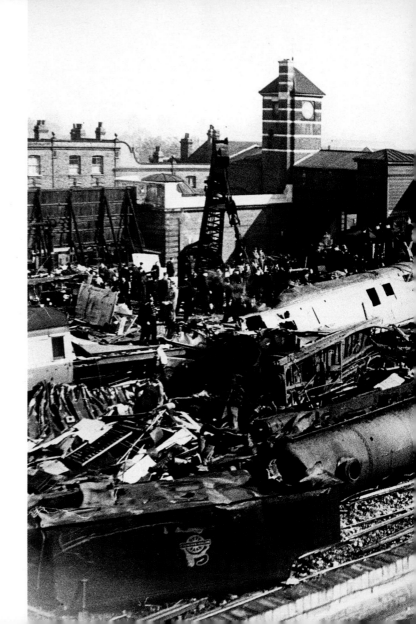

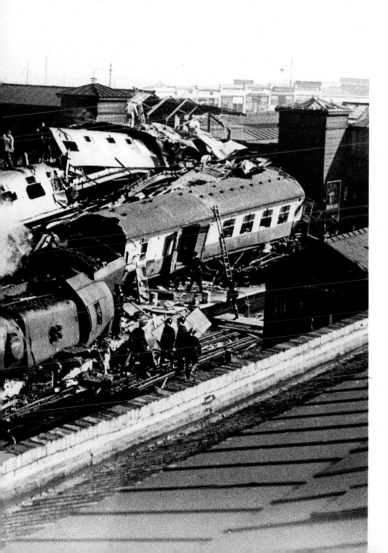

On an autumn morning a Euston-bound express sleeper train from Perth, Scotland crashed into the rear of a local passenger train that had stopped at Harrow and Wealdstone Station. A few seconds after the impact, a double-headed express passenger train travelling north in the opposite direction ploughed into the derailed coaches.
8th October, 1952

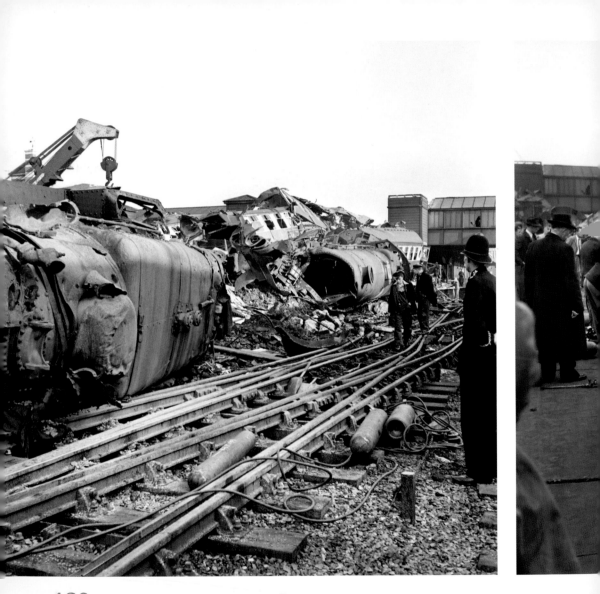

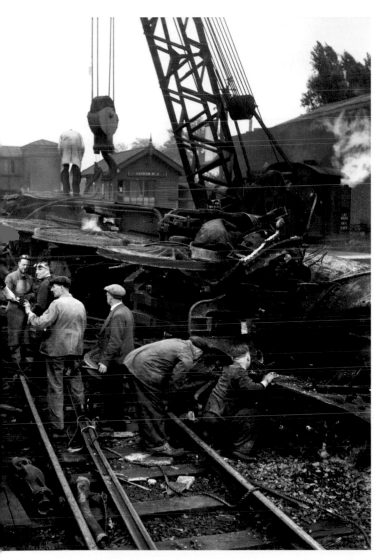

Clearing the wreckage: the Harrow and Wealdstone disaster was the worst peacetime rail crash in British history: 112 people were killed and 340 were injured.
9th October, 1952

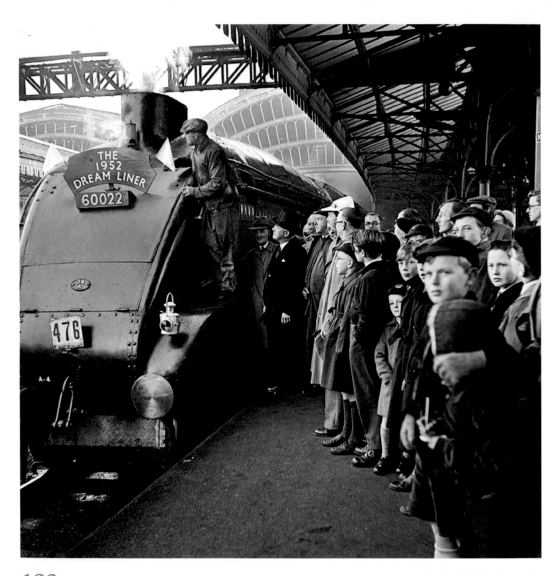

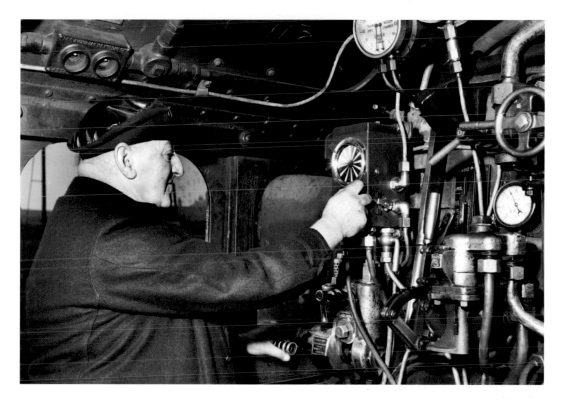

Left: *The Dream Liner* was a special excursion that took enthusiasts to Doncaster for the 99th anniversary of the town's famous railway works. Here the driver mounts the headboard on the streamlined front of *Mallard*, which in 1938 became the fastest steam locomotive in history, a record that it retains to this day.
14th October, 1952

On the footplate of an LNER locomotive between London and Newcastle. The driver keeps his hand on the Automatic Safety Device, otherwise known as the Dead Man's Handle.
18th October, 1952

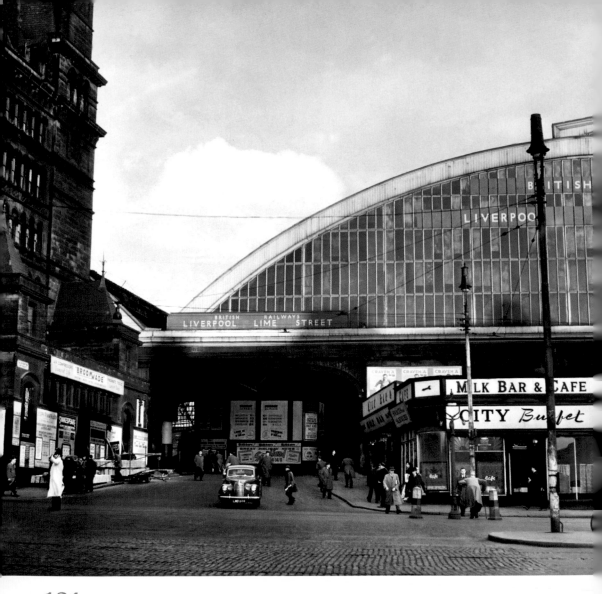

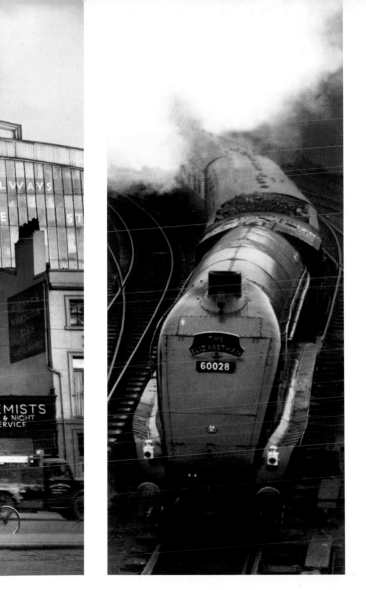

Far left: The exterior of Liverpool Lime Street. The original plan to make the station the image of London Euston was eventually abandoned in favour of this single curve roof, which was completed in 1849.
23rd February, 1953

The Elizabethan express passes through Newcastle Central Station non-stop en route between London and Edinburgh. The A4 Pacific at its head was originally *Sea Eagle* but renamed *Walter K. Whigham* in 1947 after the deputy chairman of the LNER.
30th June, 1953

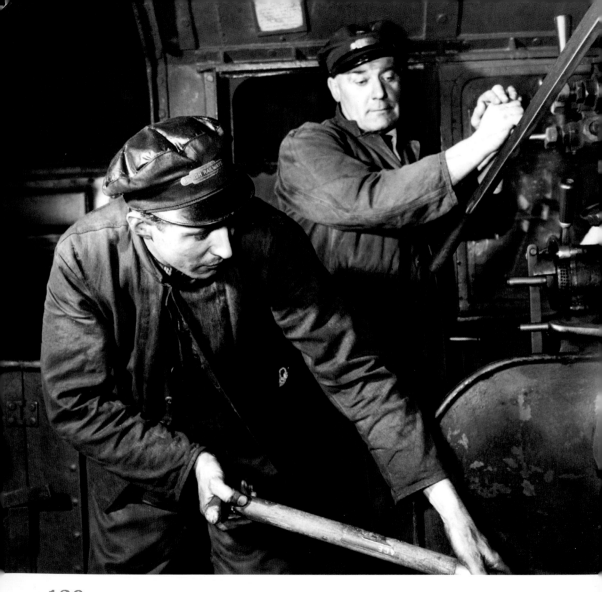

Left: An engine driver and fireman at work on a British Railways locomotive.
February 1954

Driver Alfred Demaszure (L) and fireman André Devos on the footplate of the *Golden Arrow* on the French leg of its journey between London Victoria and Paris Gare du Nord. (In these pre-Tunnel days, the Channel crossing was made by ferry.)
2nd April, 1954

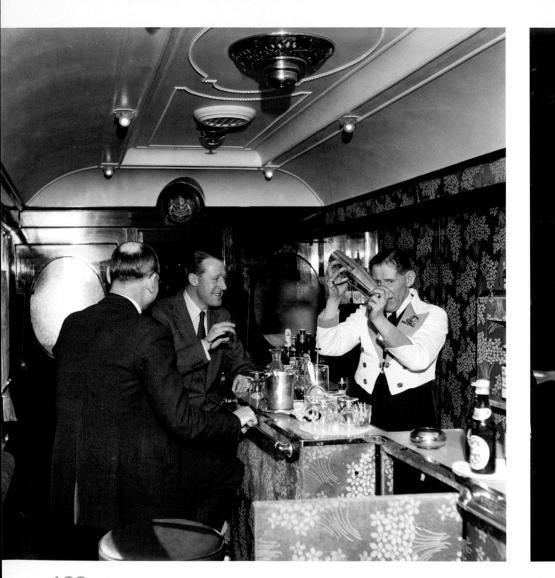

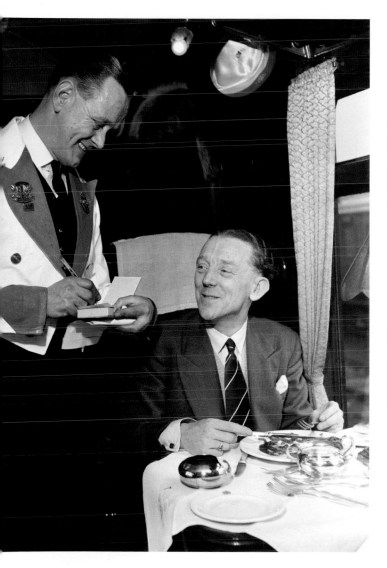

Far left: The cocktail bar on 'Pegasus', one of the Pullman coaches on *The Golden Arrow* between London and Paris.
5th April, 1954

Acting conductor Billy Williams writes a ticket out for a *Golden Arrow* passenger who didn't have time to book his seat.
5th April, 1954

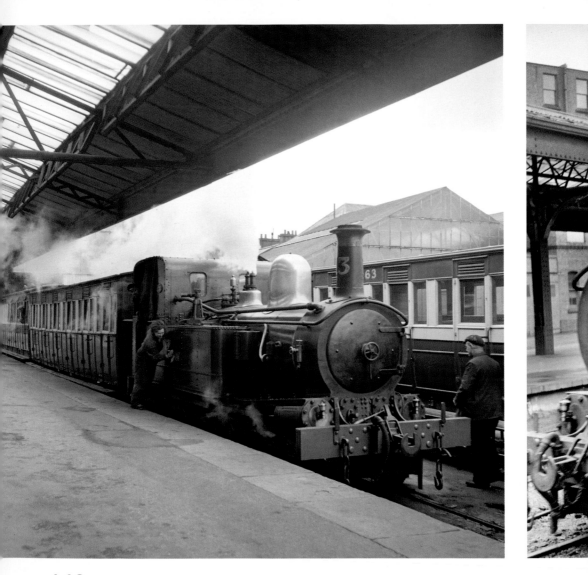

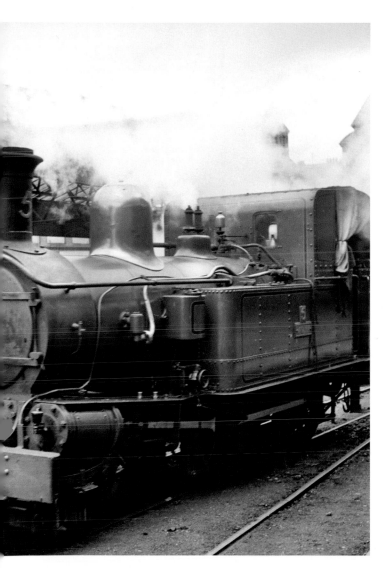

The Isle of Man Steam Railway had an extensive network, with three lines spreading out from the capital, Douglas, and 16 steam locomotives, all but one of which were Beyer-Peacock 2-4-0 tanks. The photographs show two of them: No. 3 *Pender* (far L) and No. 5 *Mona* (L).
13th May, 1954

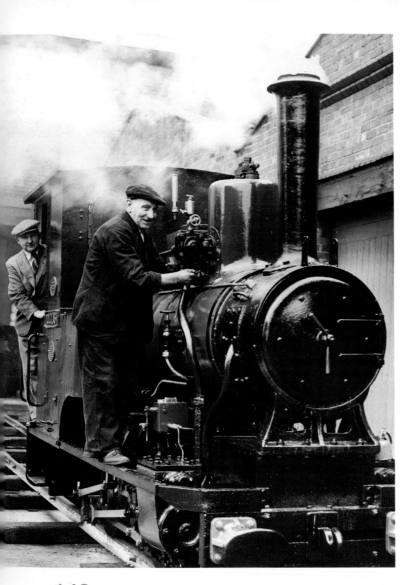

In 1951, the Talyllyn – a 2 feet 3 inch (686mm) gauge line between Tywyn and Nant Gwernol in Wales – became the world's first preserved railway. Within three years it was so popular that it needed more motive power to supplement the two original locomotives. This is *Douglas*, one of the new boys.
July 1954

British Railways cashed in on the popularity of rail excursions with specials like the *Northern Venturer*, a four-day round-trip from Newcastle to Morecambe, then Harrogate, then Edinburgh and finally Scarborough.
26th July, 1954

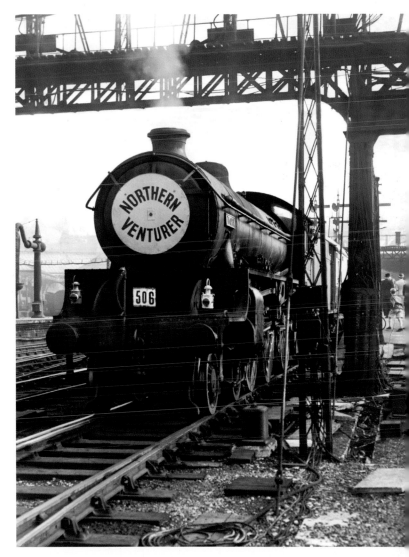

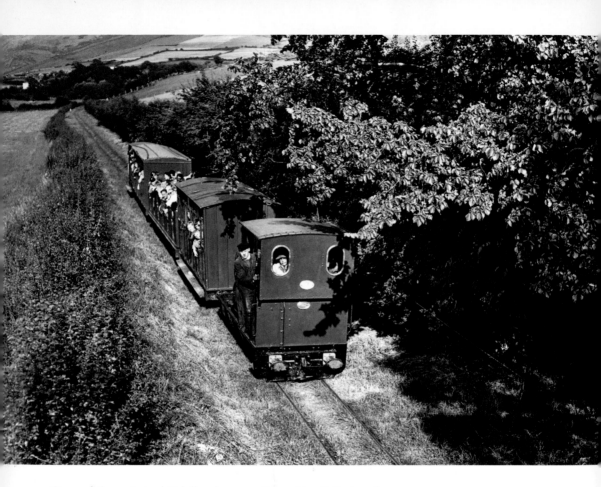

One of the original Talyllyn locomotives, No. 2 *Dolgoch*, runs backwards on a Tywyn-bound train in the shadow of Cader Idris Mountain.
1st August, 1954

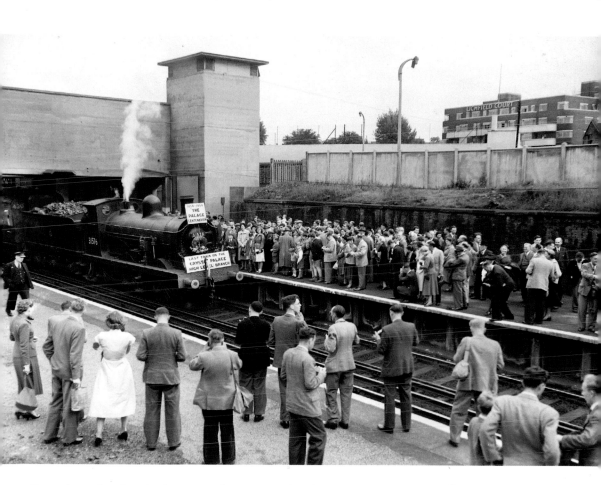

Crowds gather for the last train from Crystal Palace to
Richmond, a line that was closed to passengers because
of lack of demand.
September 1954

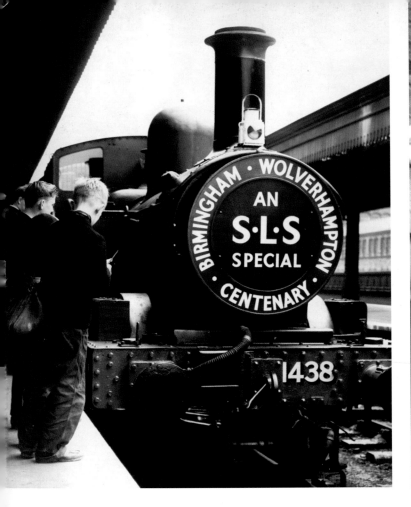

A Stephenson Locomotive Society special to mark the centenary of the opening of the Great Western line between Birmingham and Wolverhampton.
November 1954

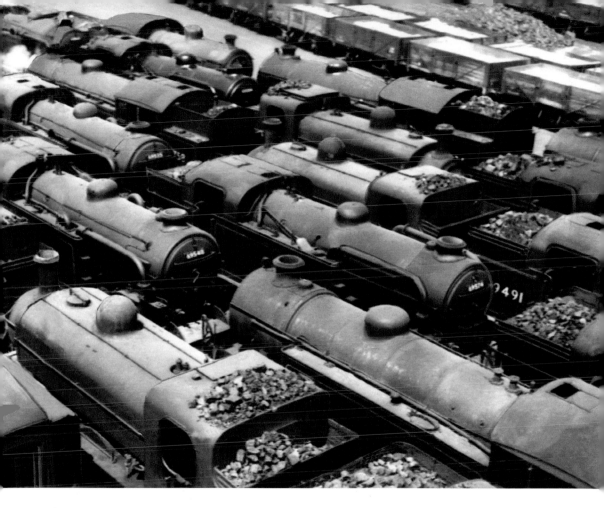

Tank engines huddle together outside the engine sheds at London King's Cross during one of the not infrequent rail strikes that caused inconvenience and annoyance to passengers.
1st June, 1955

Bulleid West Country Class No. 21C134 *Honiton*, hauling the *Golden Arrow* service, simmers at London Victoria while awaiting the green light to head for the Channel coast at either Dover or Folkestone. Note the Union flag and the French tricolore.
28th September, 1955

Far right: Oblivious to the *Golden Arrow* Pullman car's exquisite bespoke marquetry and spacious luxury, this lady in her tailored suit gets on with the important task of powdering her nose.
28th September, 1955

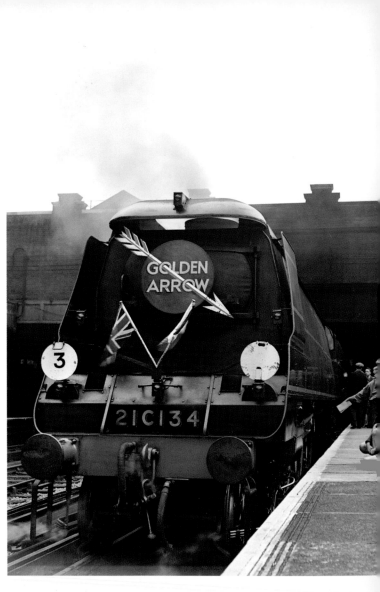

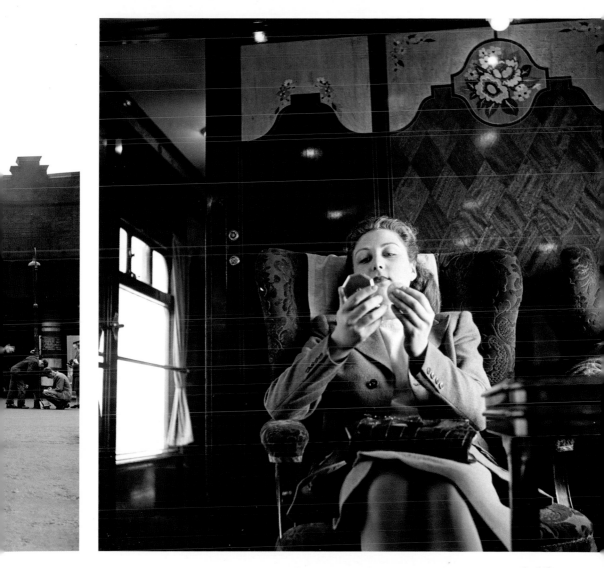

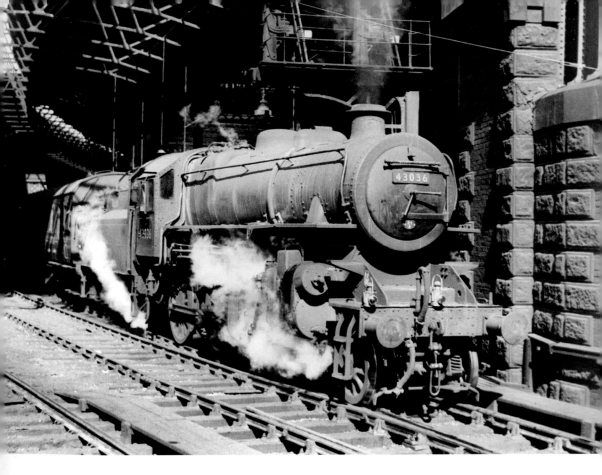

LMS Class 4F Ivatt No. 43036 at Birmingham New Street.
These 2-6-0s were originally intended for light goods
traffic but were in practice also used extensively for
secondary passenger trains.
c.1955

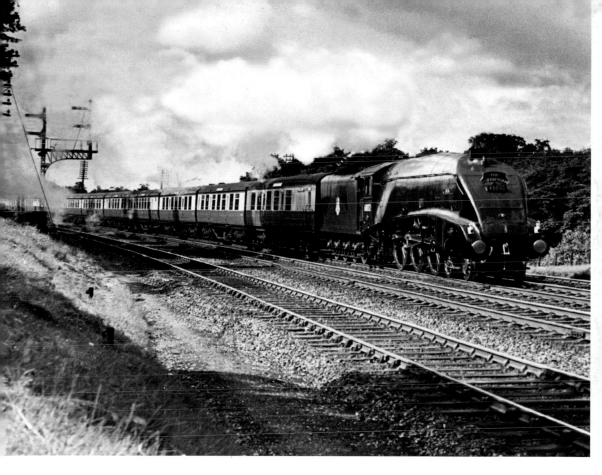

A4 Class No. 60032 *Gannet* heads *The Elizabethan*
express on the longest non-stop run in the world from
London to Edinburgh.
10th January, 1956

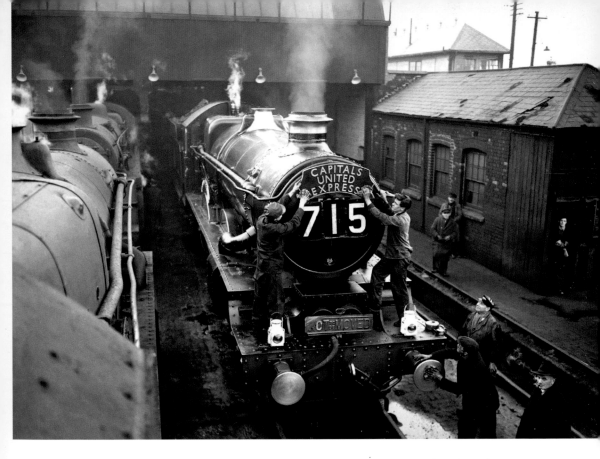

To mark the official acknowledgement of Cardiff as the capital of Wales, the Western Region of British Railways gave the express that linked the city with London a fitting name. Here a Castle Class 4-6-0 is given a final polish at Cardiff Canton Shed before hauling the inaugural up service to Paddington.
5th February, 1956

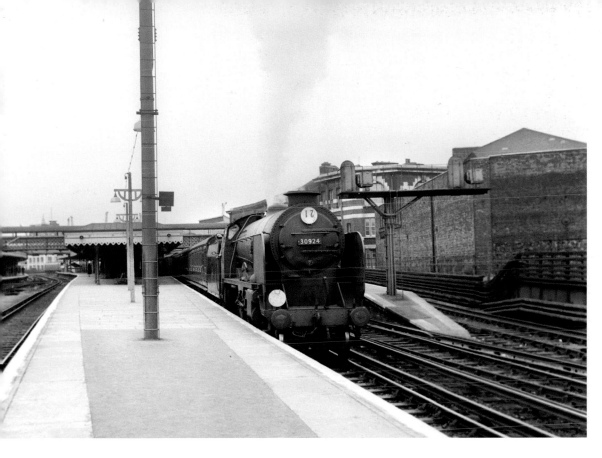

SR No. 30924 *Haileybury* pulls into Hastings Station. This locomotive was one of Maunsell's Schools Class, the most powerful 4-4-0s ever to operate in Europe.
May 1957

Chronological order.
Stephenson's *Rocket*
heads a streamlined
LMS Coronation Class
locomotive, but only for a
photo call: the later loco
had clocked a speed of
114mph (183km/h); the
winner of the Rainhill Trials
could do no more than
28mph (45km/h).
1st May, 1957

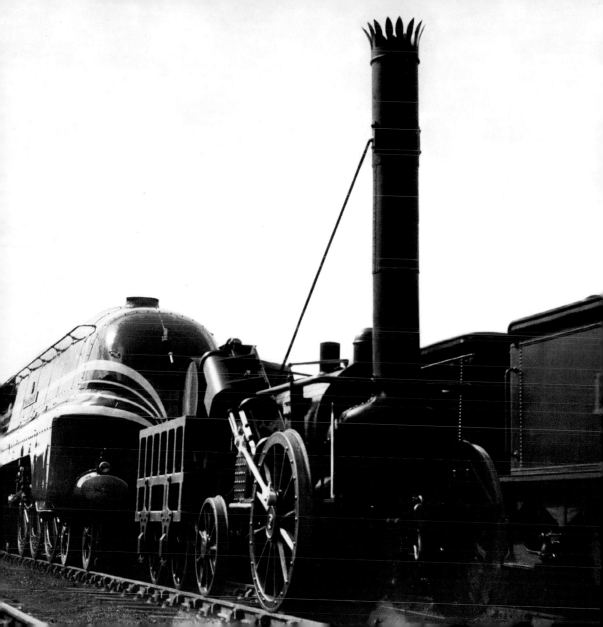

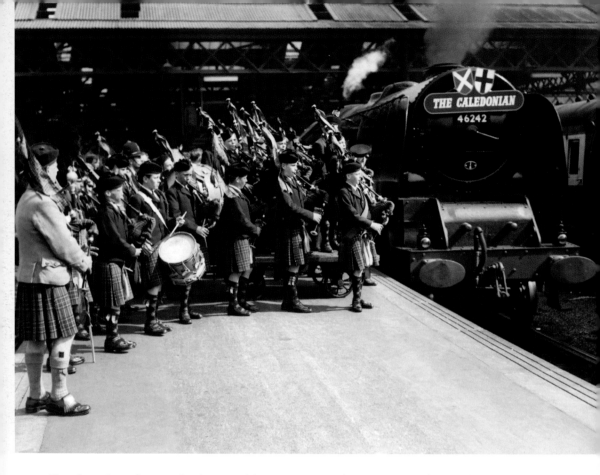

The first day of a new high-speed luxury express between London and Glasgow. *The Caledonian* was scheduled to complete the 401-mile (640km) journey in 400 minutes, faster than any West Coast main line service since the Second World War. The train is headed, appropriately, by *City of Glasgow*, a Coronation Class Pacific. 17th June, 1957

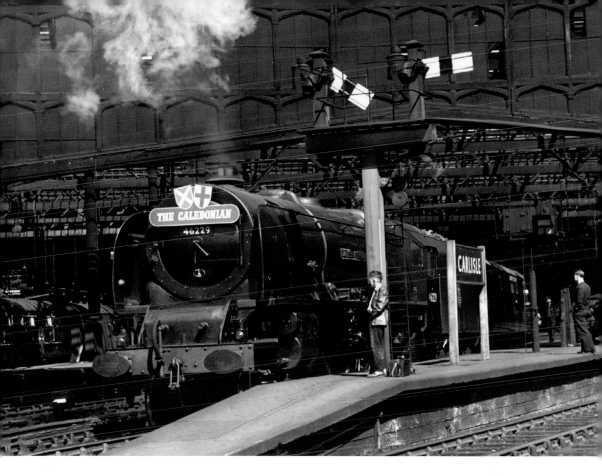

The Caledonian pulls out of Carlisle Station.
17th June, 1957

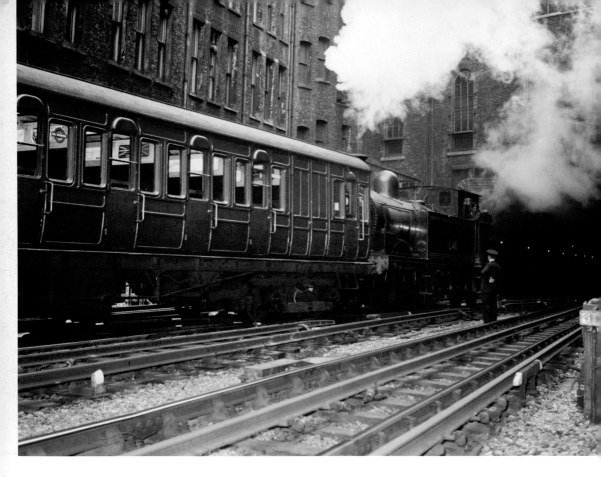

As a reminder of what the London Underground was like before electrification, an L46 tank heads an enthusiasts' special around the Circle Line.
23rd September, 1957

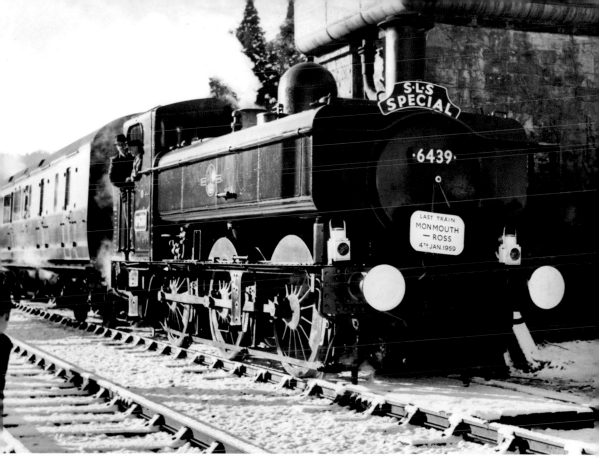

The last passenger train on the Wye Valley Railway
between Ross-on-Wye and Monmouth, a Stephenson
Locomotive Society special, hauled by ex-GWR Class
6400 No. 6439. Part of the line remained opened for
goods traffic until complete closure in 1965.
4th January, 1959

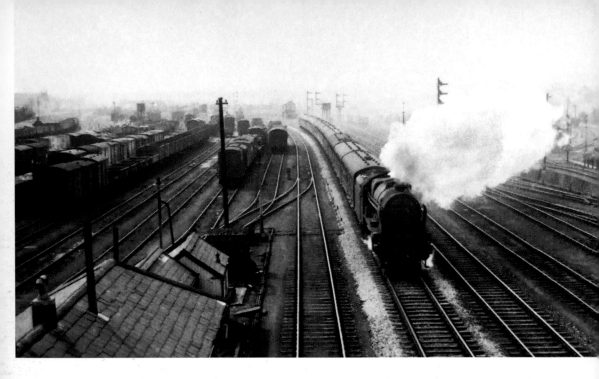

A passenger express roars
past the busy goods yard
at Bescot in the West
Midlands.
13th March, 1959

Right: Special excursion trains ran throughout the 1950s.
Here 'aged members' of Nuneaton Sports Club pose in
front of the ex-LMS Stanier Black Five that took them for
an Easter holiday in Blackpool.
17th April, 1959

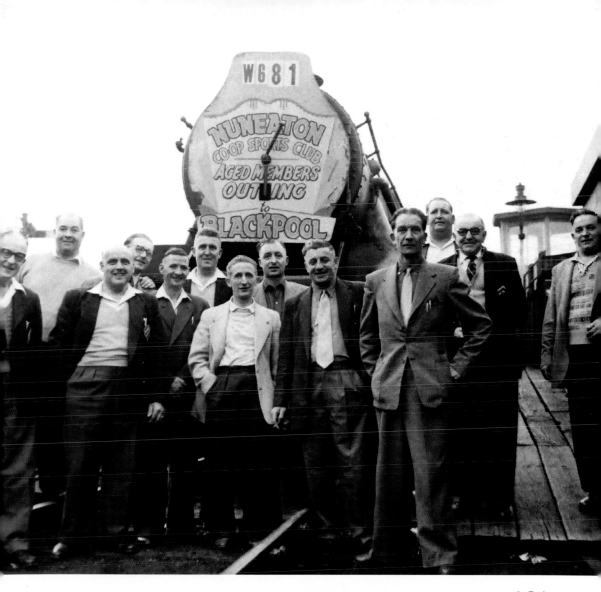

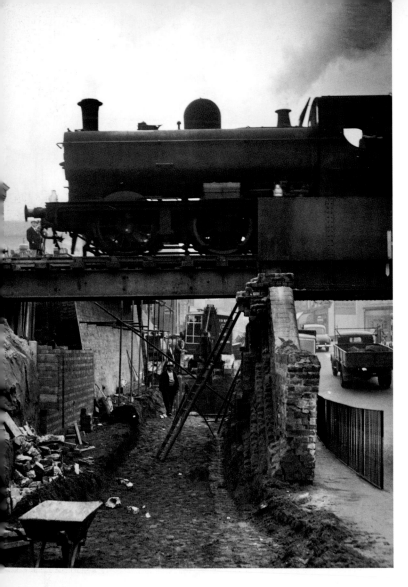

A goods train makes its way across Foster Street Bridge in Stourbridge. Currently under reconstruction, the span across the road was later demolished altogether.
11th October, 1959

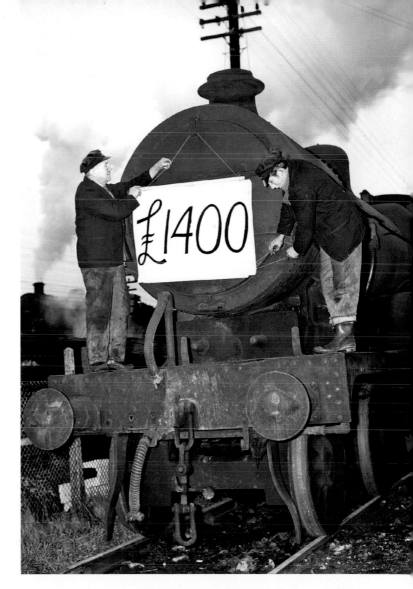

This is the way the world ends: as British Railways bring in new diesel and electric power units, the old steam locomotives are sold off or scrapped.
15th December, 1959

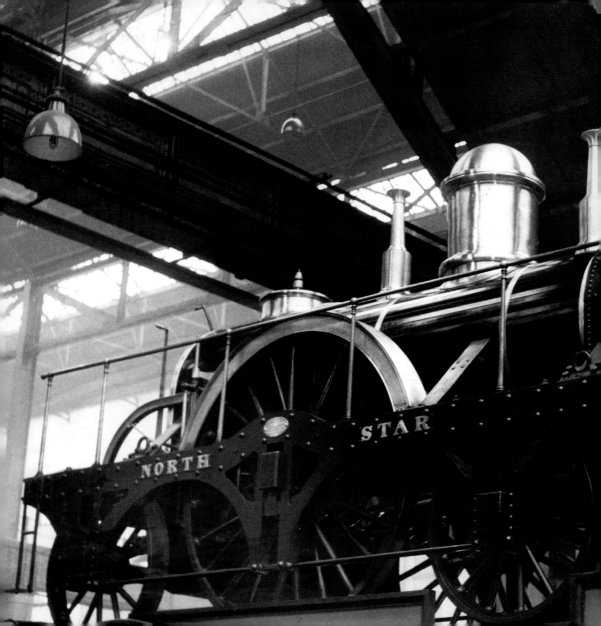

Stephenson's *North Star*, which in 1837 pulled the first GWR passenger train, on static display at the Great Western Railway Museum in Swindon.
March 1960

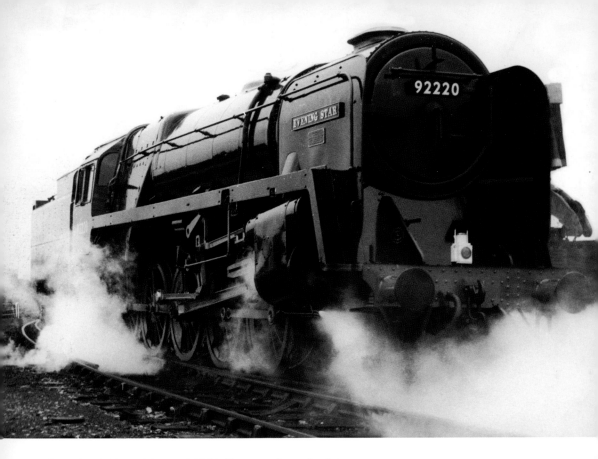

Standard Class 9F No. 92220 *Evening Star*, the last
steam locomotive to be built by British Railways, leaving
Swindon Works after its naming ceremony.
March 1960

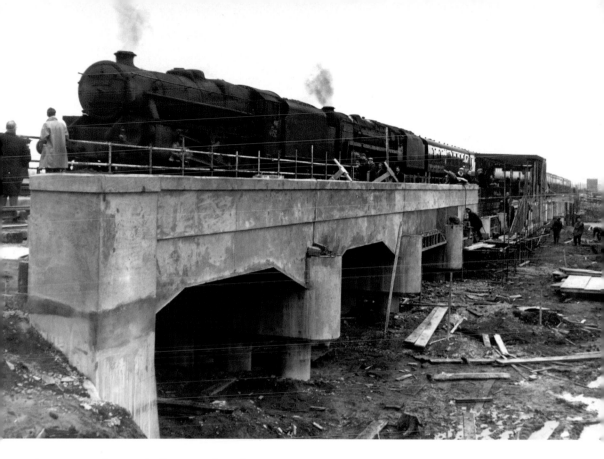

A new goods marshalling yard under construction in Carlisle. When completed, this mechanised centre for sorting trucks would have the capacity of seven old-style yards.
16th March, 1960

On 9th May, 1904 *City of Truro* reached a record speed of 102.3mph (164.6km/h) while hauling the *Ocean Mails* special between Plymouth and Bristol. Here the Churchward 4-4-0 is displayed at Old Oak Common Depot near Paddington, London. **25th April, 1960**

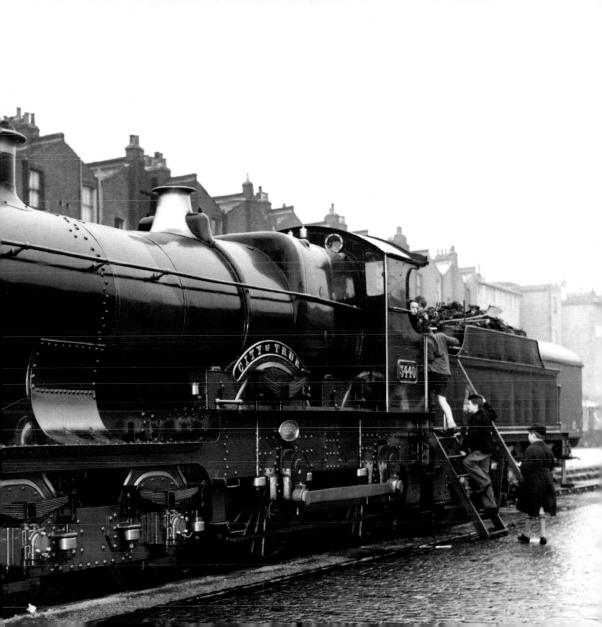

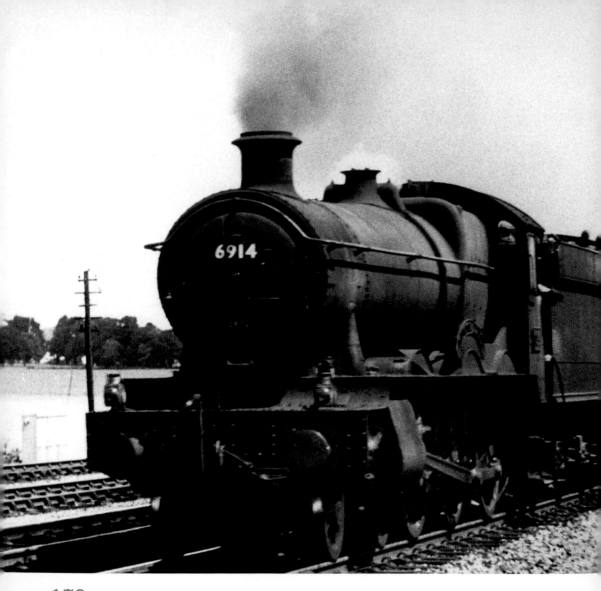

WR 4-6-0 Class 4900 No. 6914 *Langton Hall* passes Twyford with a semi-fast passenger train. The Halls were so powerful and reliable that they became the workhorses of the GWR.
July 1960

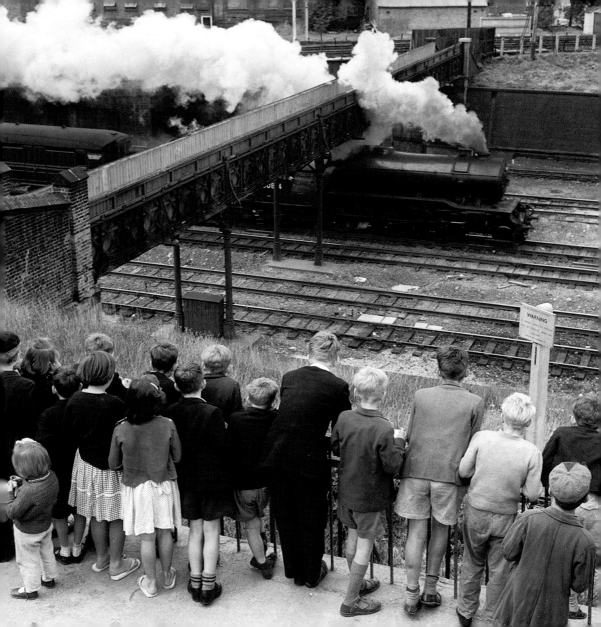

Left: Trainspotters crowd a specially erected viewing platform along the side of the East Coast main line near Finsbury Park, North London. The passing locomotive is a Gresley V2.
24th July, 1960

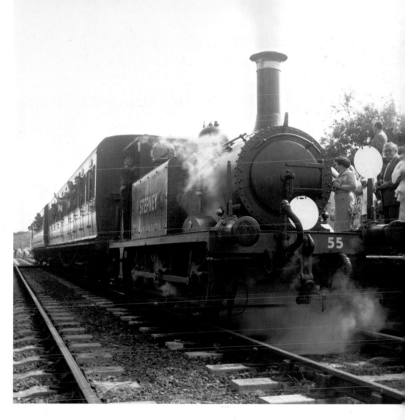

Shortly after its acquisition by the preserved Bluebell Railway, ex-LBSCR locomotive No. 55 *Stepney* pulls in to Horsted Keynes Station.
8th August, 1960

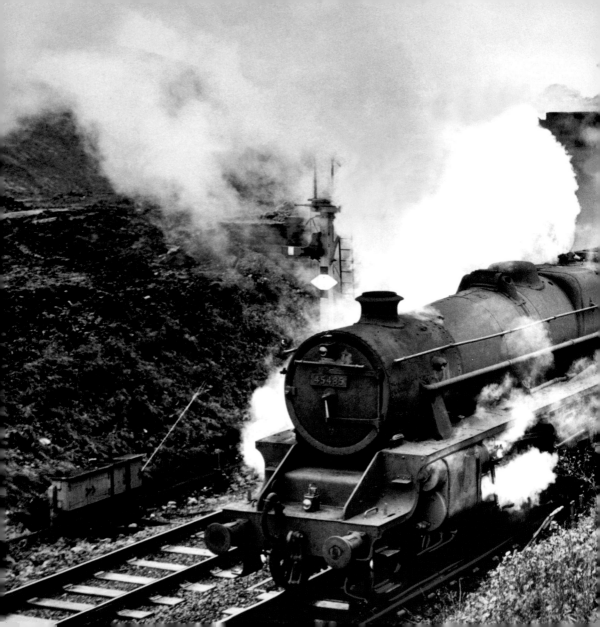

Wreathed in smoke, an ex-LMS Stanier Black Five passes beneath the road bridge at Kingstown, Stainton Road, Carlisle, which is in the process of being demolished and replaced by a new viaduct.
17th October, 1960

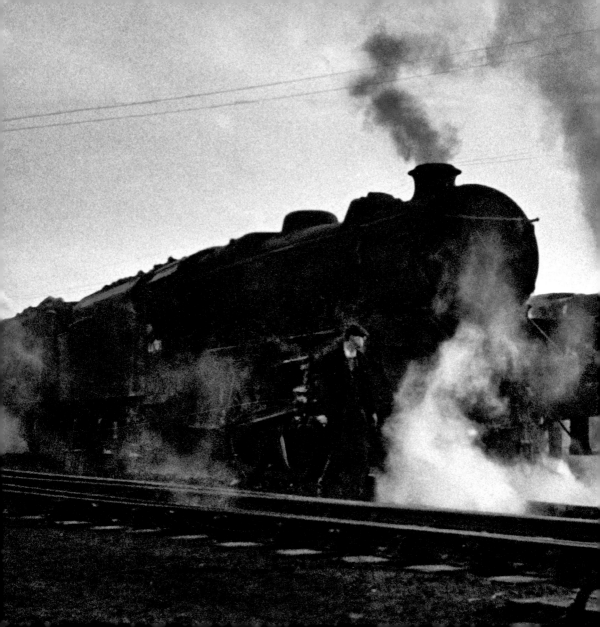

The lights go down on
steam traction: near
Birmingham.
c.1960

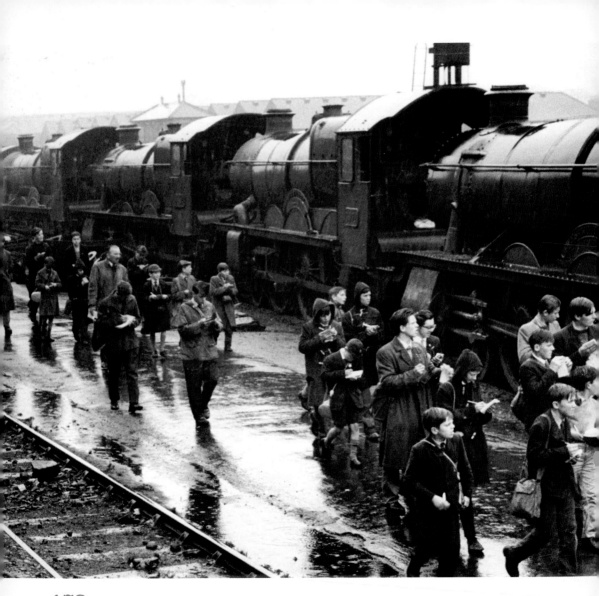

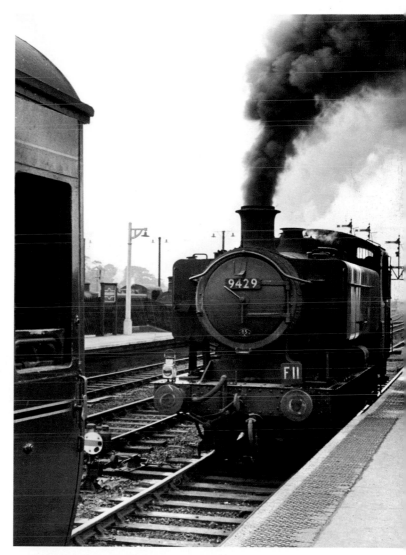

Left: Last chance to see... the imminent end of the Steam Age inspired ever-increasing numbers of enthusiasts to see as many of their old favourites as possible before they disappeared forever.
April 1961

Great Western Railway Class 9400 No. 9429, which is here about to act as a banker to help the leading loco up a steep gradient.
October 1961

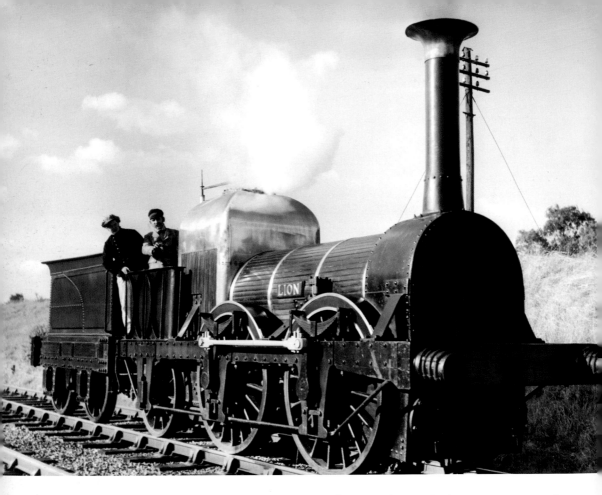

Aged 123 years, *Lion*, a stalwart of the Liverpool & Manchester Railway, comes out of retirement in the museum at Crewe to drive up and down the Rugby-Leamington line at Dunchurch, with driver and fireman both wearing period costume.
18th October, 1961

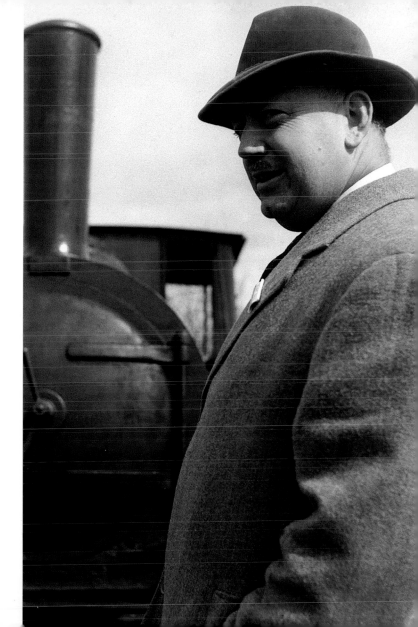

Dr Richard Beeching, whose 1962 report to the government proposed the closure of more than 2,000 stations and 5,000 miles (8,000km) of lines. The conventional wisdom of the time was that trains had been outmoded by cars and lorries. But what if the roads became too crowded to cope: would there still be railways to take the strain?
2nd April, 1962

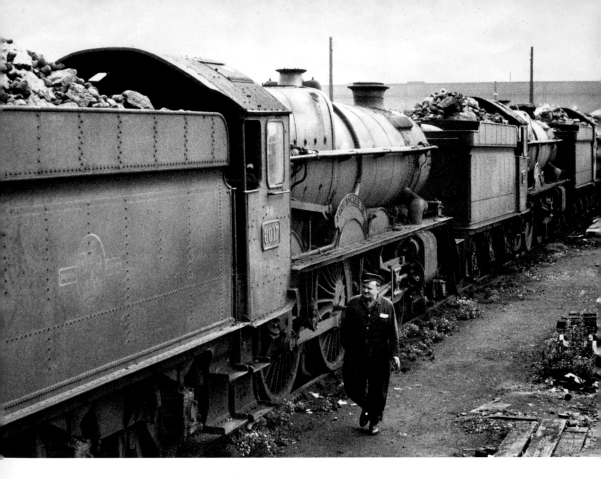

Multiple regicide: decommissioned King Class locomotives line up for the breaker's ball at Stafford Road Depot in Wolverhampton.
September 1962

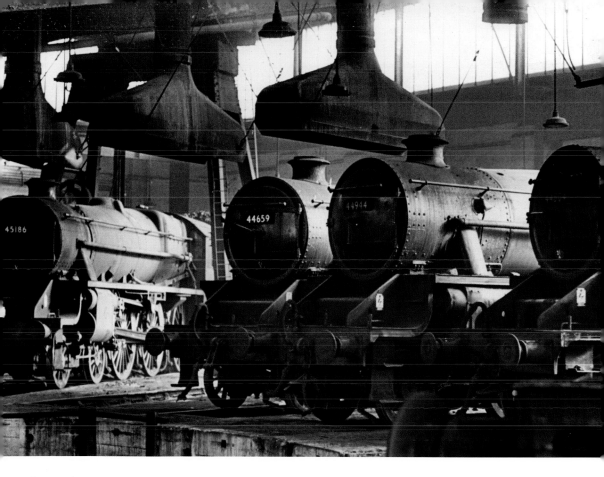

Steam locomotives
at Saltley Shed near
Birmingham.
October 1962

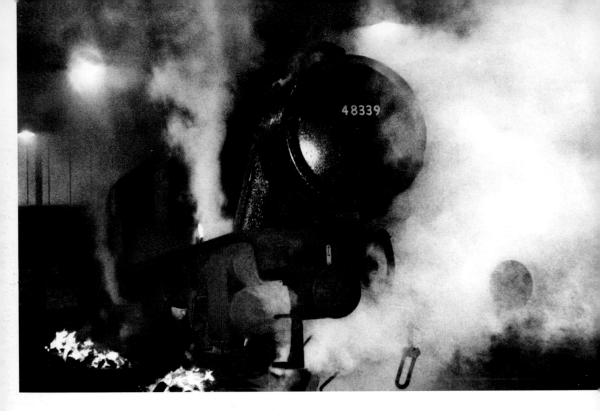

During a particularly hard winter, an ex-LMS Class 8F Stanier 2-8-0 is de-iced by lighting coal fires around it at Saltley Shed.
January 1963

Right: No. 4472 *Flying Scotsman* got a new lease of life when it was purchased from BR for £3,000 by Alan Pegler, who restored it to its pristine state and set it to work on enthusiasts' specials. Here the historic loco prepares to leave Paddington with 350 members of the Ffestiniog Railway Society on their way to their AGM in Porthmadog, North Wales.
20th April, 1963

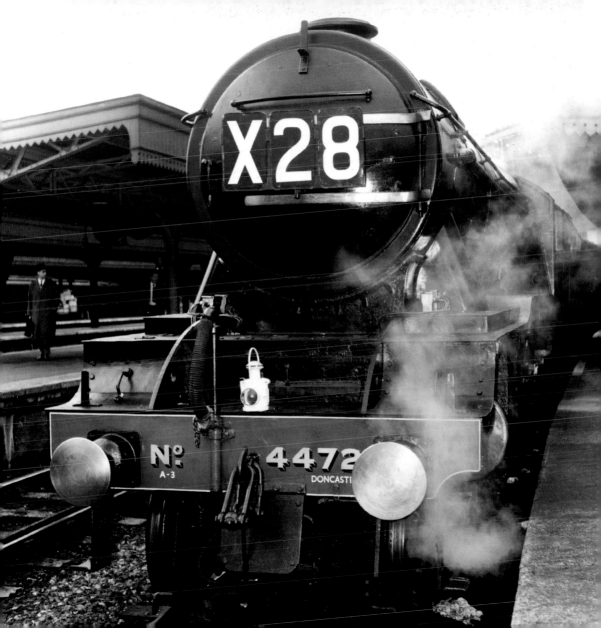

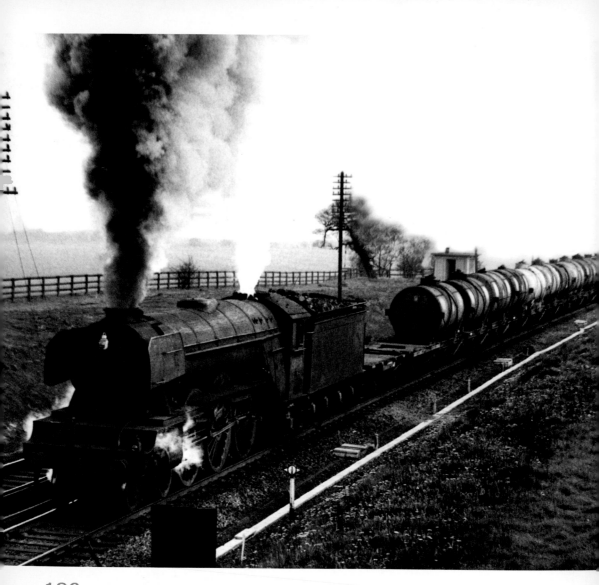

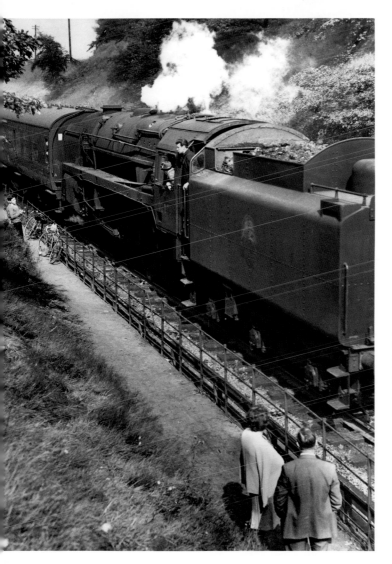

Far left: One of the rapidly diminishing number of steam engines still operating is seen here hauling a freight train north of Newcastle.
18th May, 1963

BR Class 9F 2-10-0 No. 92079 pushes hard up from Bromsgrove Bank at the rear of a heavy Bristol-to-Newcastle express.
August 1963

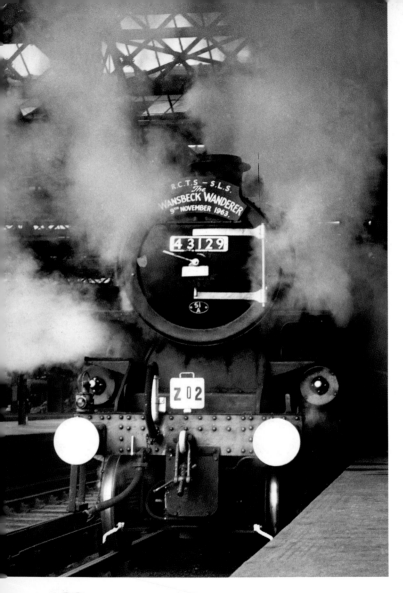

Left: In a flurry of steam, ex-LMS Ivatt Class 4F-A No. 43129 pulls a six-car train, with 300 members of the Stephenson Locomotive Society and the Railway Travel and Correspondence Society aboard, on the last trip to Morpeth, Scots Gap, Rothbury, Reedsmouth and Bellingham before the line closes.
11th November, 1963

The *Regency Belle* leaving London Victoria with six well-dressed hostesses who will wait on passengers en route to Brighton.
28th March, 1964

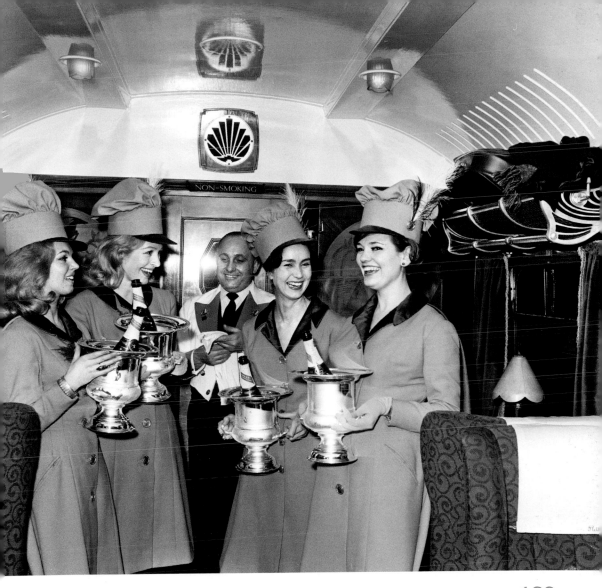

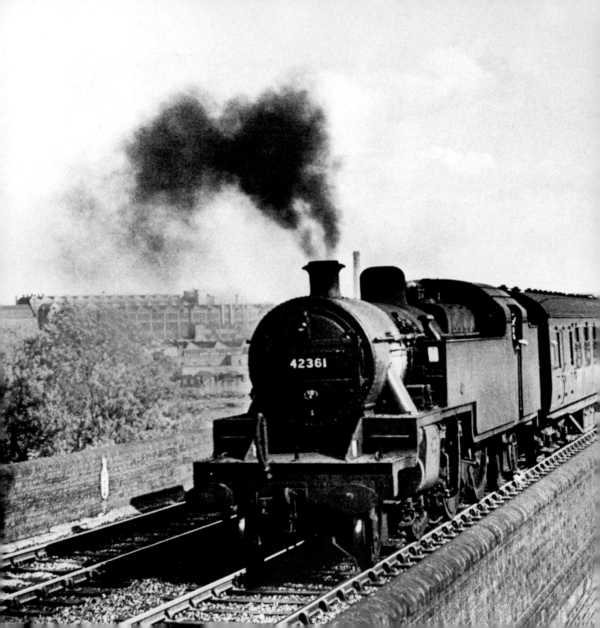

A Leicester-based tank
engine heads for home
over the viaduct at Rugby.
c.1964

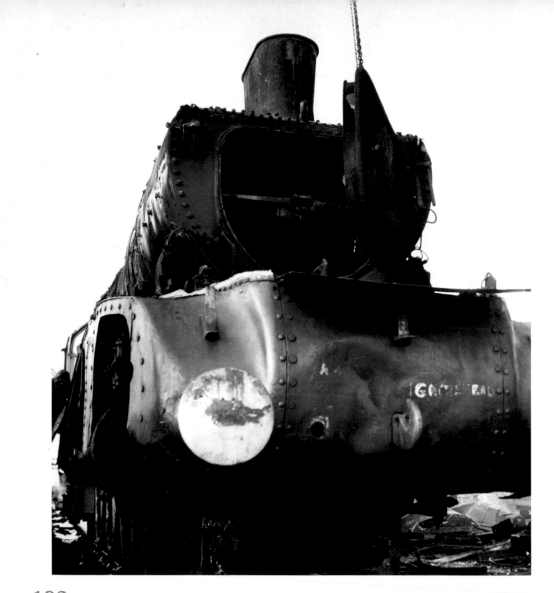

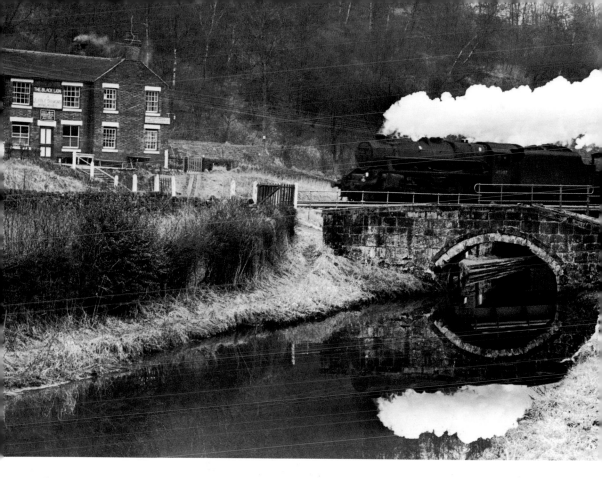

Left: How are the mighty fallen: stripped of its outer casing, a once-great steam locomotive awaits the coup de grace at a breakers' yard in North Blyth.
5th January, 1965

A goods train passes The Black Lion at Consall Forge near Leek, Staffordshire.
February 1965

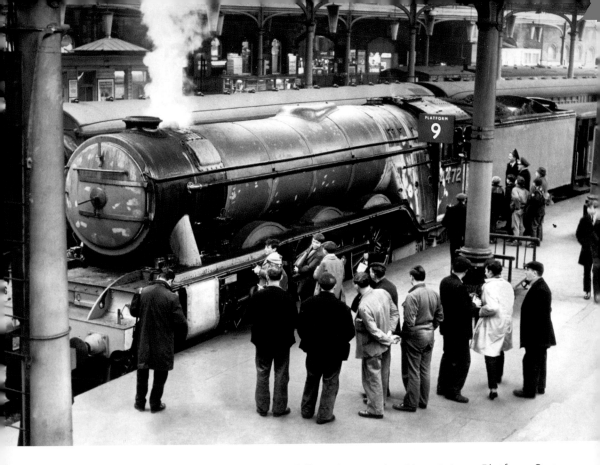

Flying Scotsman was hard to maintain in full working order. Here it is on Platform 9 at Newcastle Central Station on a trial run from Darlington during one of its increasingly frequent refits.
23rd February, 1965

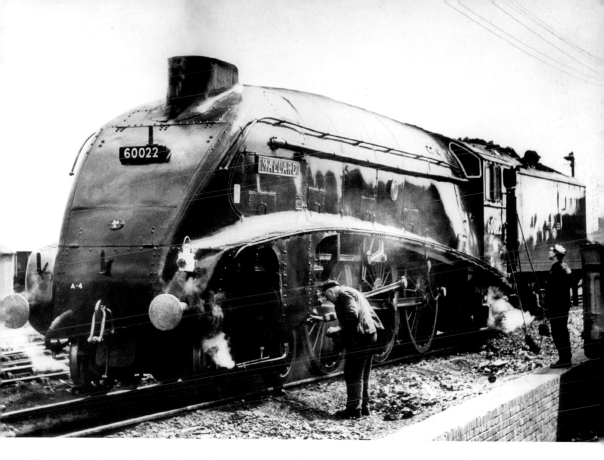

Simmering in a shed yard, *Mallard* gets a check from its crew just prior to withdrawal by British Railways after 1.5 million miles of service. The holder of the world speed record is now on static display at the National Railway Museum in York.
March 1965

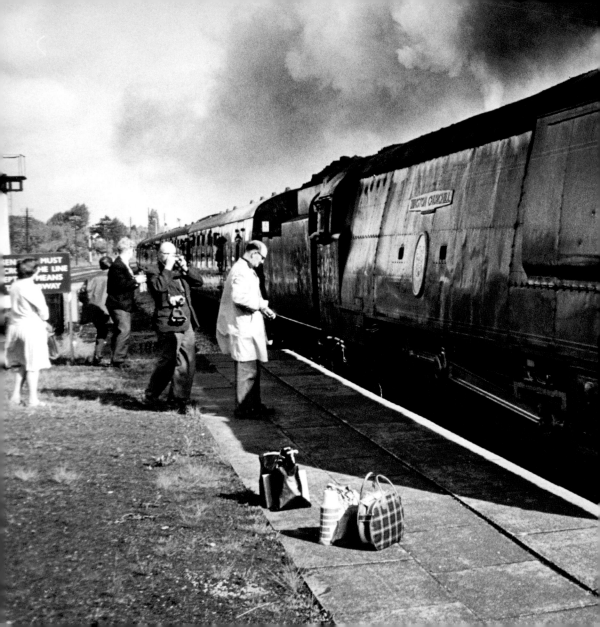

Battle of Britain Class 4-6-2 *Winston Churchill* arrives at Solihull on a Stephenson Locomotive Society excursion. In its Southern days, the locomotive would never have been seen so far north, but once preserved it would go wherever there was business.
23rd May, 1965

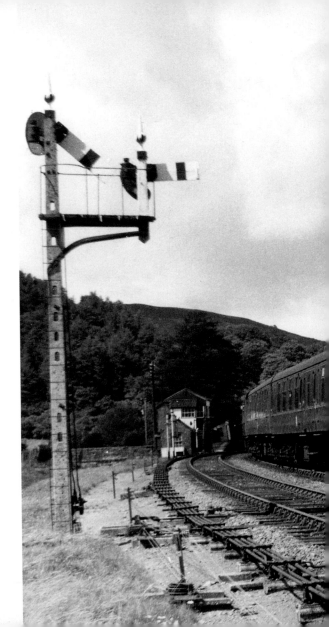

The *Cambrian Coast Express* ran from Paddington to Aberystwyth and Pwllheli. Here is one of the last steam-hauled workings near Talerddig in Powys.
c.1965

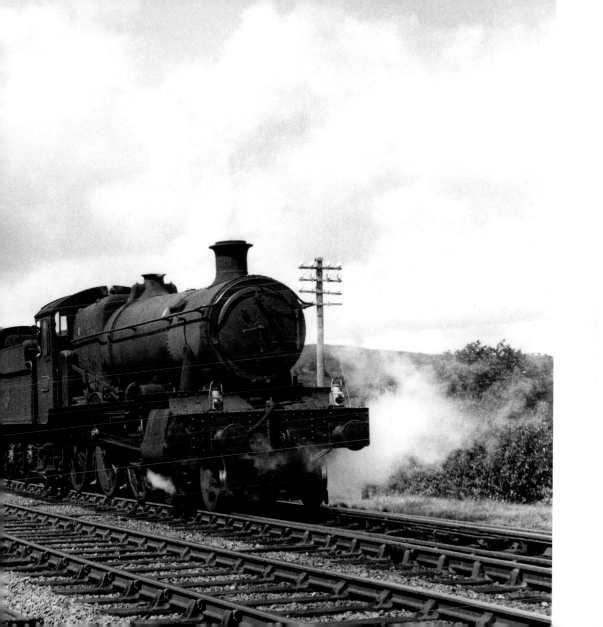

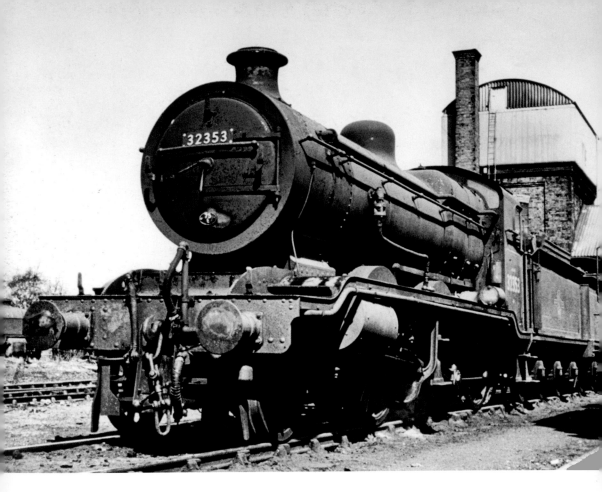

The K Class were powerful 2-6-0s built between 1913 and 1921 for the London Brighton and South Coast Railway. This is one of the last surviving members. c.1965

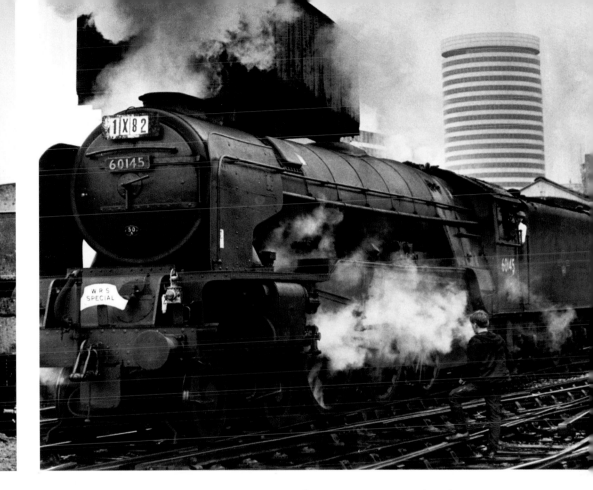

Ex-LNER A1 Pacific *A.H. Peppercorn* heads an enthusiasts' special at Birmingham Moor Street. c.1965

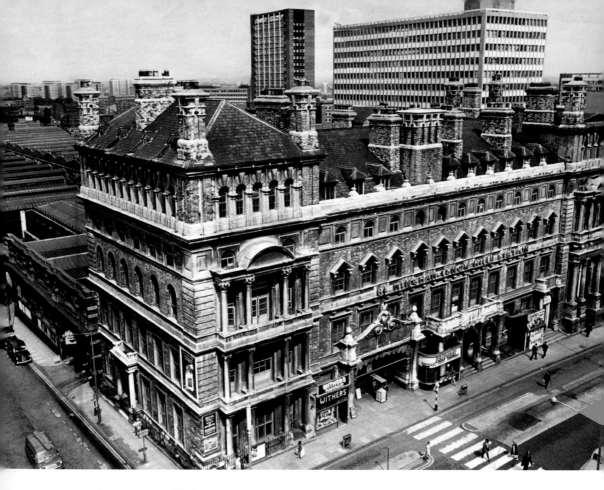

Birmingham Snow Hill: the station was closed but the buildings were listed so they escaped the Beeching axe. 1967

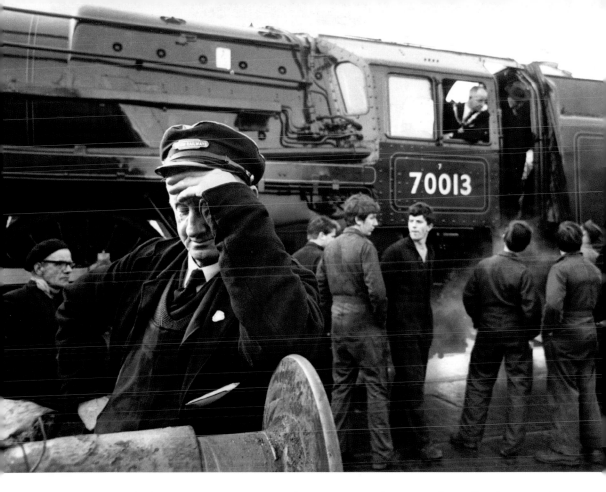

It's all too much for driver Charles Carter, who turns away from watching the departure from Crewe Works of the last steam locomotive to be overhauled by British Railways, Britannia Class 7P Pacific No. 70013 *Oliver Cromwell*, here driven by Herbert Vernon, Mayor of Crewe.
February 1967

Railway enthusiasts crowd the platform at Leamington Station to witness the passing of the last steam-hauled passenger train in the area – the *Birkenhead Flyer* headed by No. 4079 *Pendennis Castle*, resplendent in its original Great Western Railway livery.
6th March, 1967

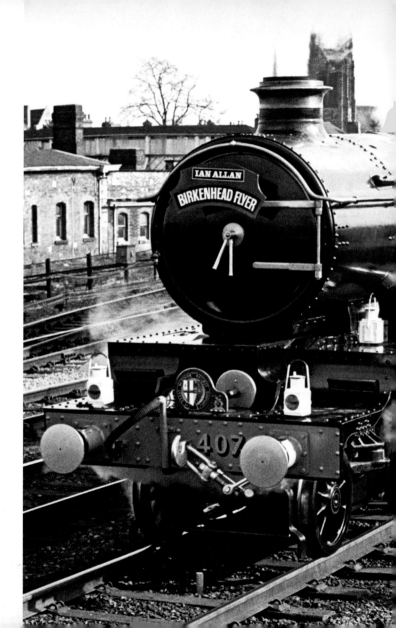

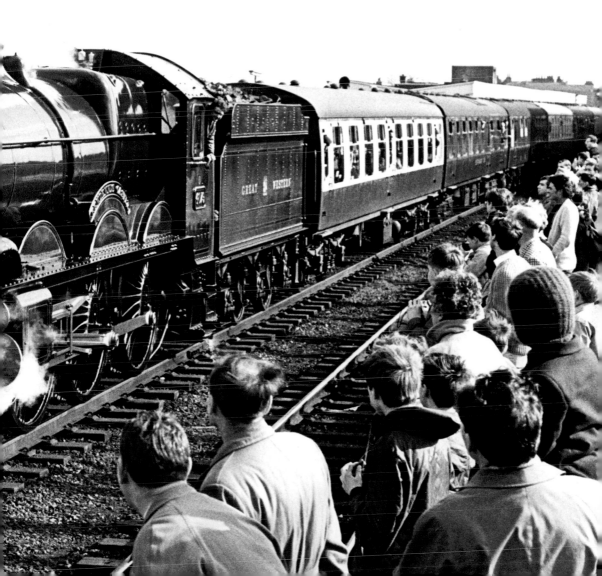

Shorn of her brilliant plumage and even her nameplate, Gresley A4 Pacific *Kingfisher* awaits her fate in the breakers' yard.
4th June, 1967

207

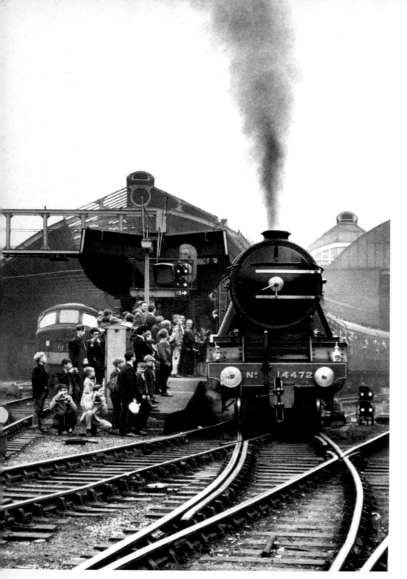

Once more refurbished, *Flying Scotsman* attracts an admiring audience on the platform of Newcastle Central Station.

9th September, 1967

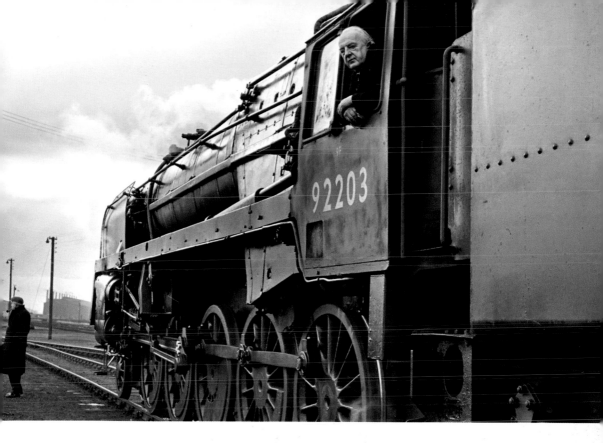

BR Standard Class 9F No. 92203 pulls the last steam-hauled iron ore train from Bidston Docks, Birkenhead, to John Summer's Steelworks at Shotton, Deeside, with Sir Richard Summers on the footplate. The locomotive was later bought by artist David Shepherd and named *Black Prince*.
10th November, 1967

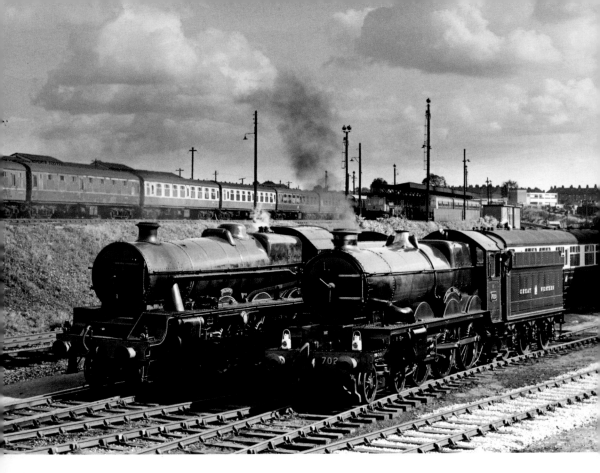

Ex-GWR Castle Class No. 7029 *Clun Castle* with ex-LMS Jubilee Class No. 5593
Kolhapur at Tyseley Locomotive Works in the West Midlands before both locos were
appeared in a BBC adaptation of *The Railway Children*.
1968

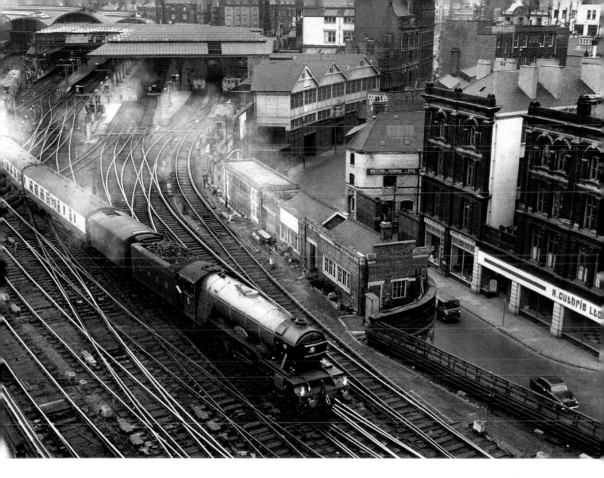

Flying Scotsman at Newcastle on a London–Edinburgh special. Though scheduled as a non-stop service, the locomotive slowed to a crawl through the station so that Geordie fans could get a good look as it passed.
1st May, 1968

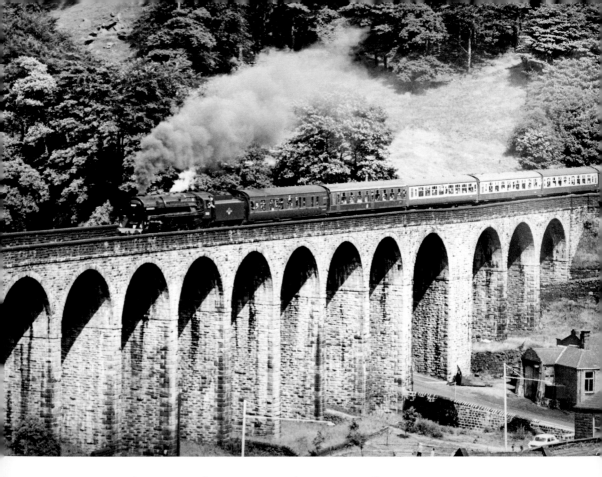

BR Britannia Class 7P Pacific No. 70013 *Oliver Cromwell*
crosses Lydgate viaduct between Todmorden and
Burnley with a Roche Valley Society special to Southport.
21st July, 1968

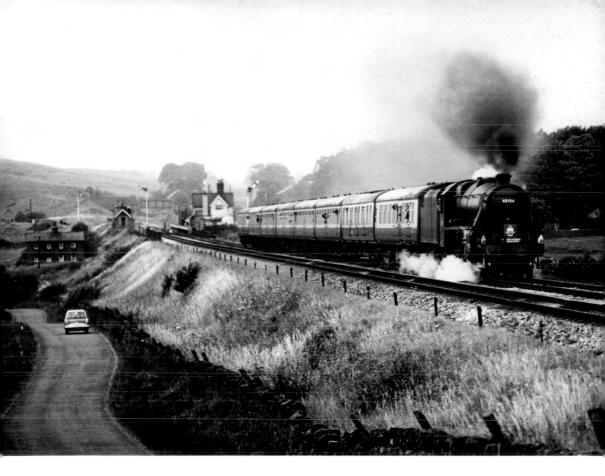

Ex-LMS 4-6-0 Stanier Class 5 No. 45156 heads a GC
Enterprises special through Clapham between Carnforth
and Settle.
4th August, 1968

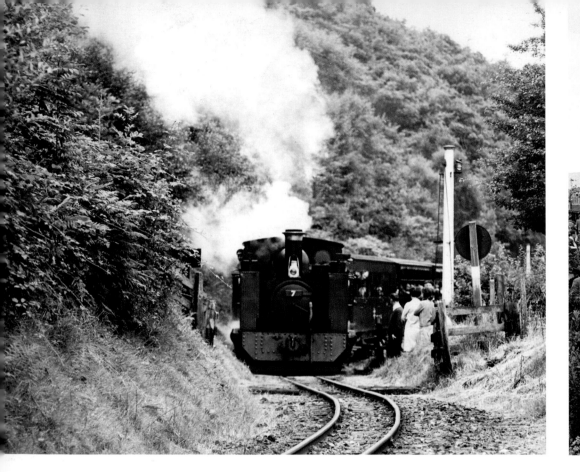

The Vale of Rheidol Railway was British Railways' only narrow gauge line. Here loco No. 7 *Owain Glyndwr* leaves Aberffrwyd with the 10 am from Aberystwyth to Devil's Bridge.
7th August, 1968

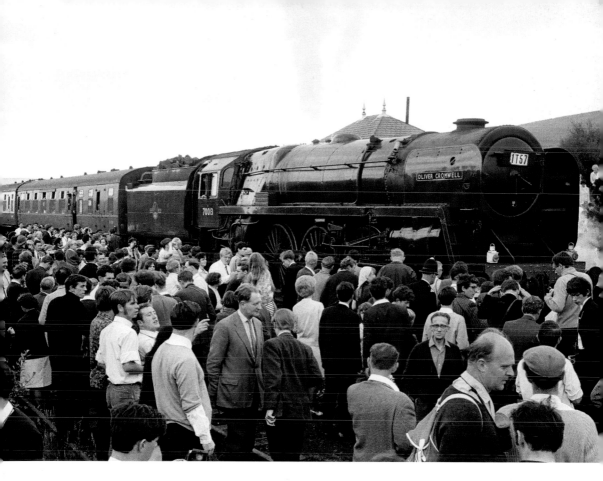

Oliver Cromwell's last journey was at the head of the *Fifteen Guinea Special* from Liverpool to Carlisle. Here it makes a stop en route at Ais Gill signal box, at the summit of the Settle and Carlisle Railway.
14th August, 1968

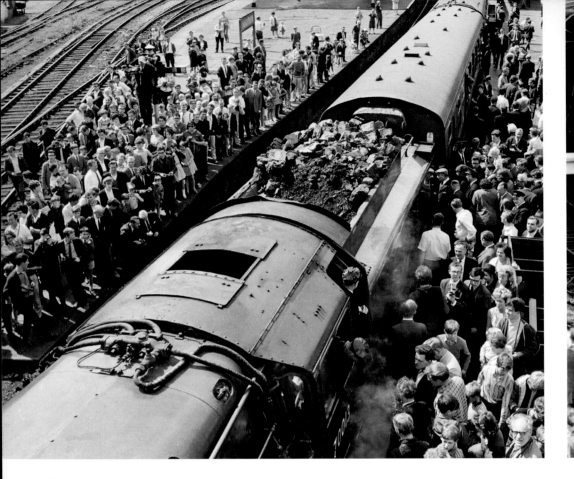

The *Fifteen Guinea Special* took a roundabout route to enable as many people as possible to say their farewells to steam. Here it is in Manchester.
14th August, 1968

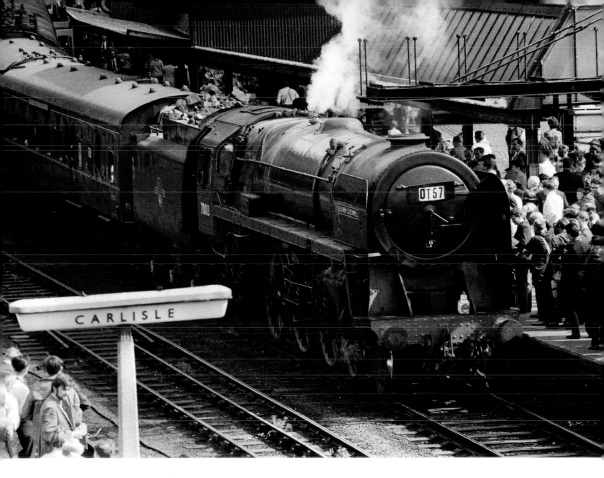

Oliver Cromwell reaches journey's end. From Carlisle the locomotive travelled light under its own steam to Norwich, and was thence transported by road to Diss, Norfolk, where it is now on static display at Bressingham Steam & Gardens.
14th August, 1968

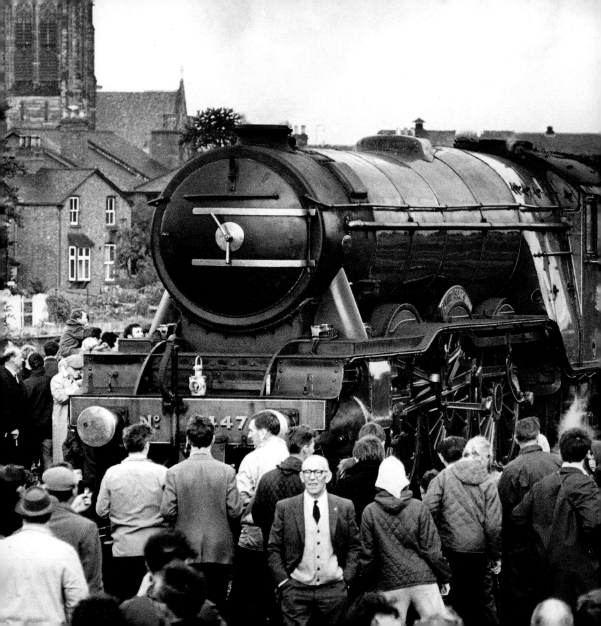

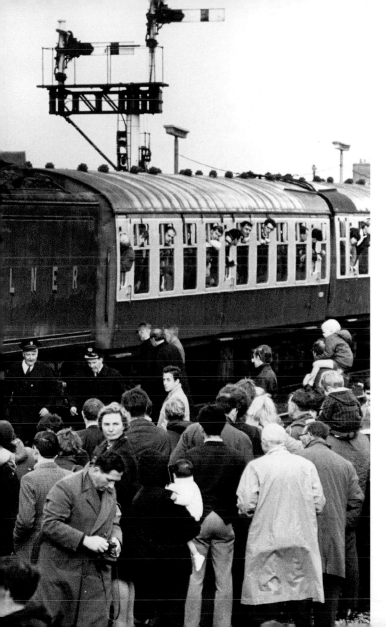

Although British Railways officially finished with steam power on 11th August, 1968, Alan Pegler's contract allowed him still to run *Flying Scotsman* on the mainline. As the sole remaining steam locomotive on BR, a good crowd turns out to see it here at Leamington Spa. **30th September, 1968**

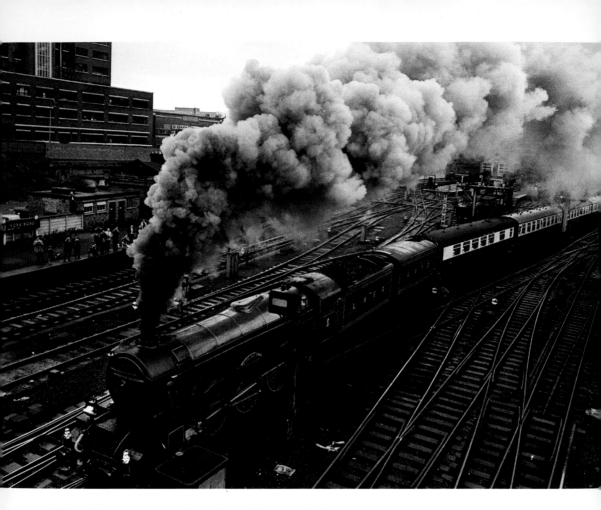

Flying Scotsman on yet another of its nostalgic returns
to the East Coast main line. Here it is seen leaving King's
Cross for Edinburgh.
2nd January, 1969

This Stockton &
Darlington Railway
boundary stone was
recovered from the moors,
with official permission,
by Richard Martin and his
son and was re-erected
right on their doorstep in
Jesmond, Newcastle.
14th August ,1969

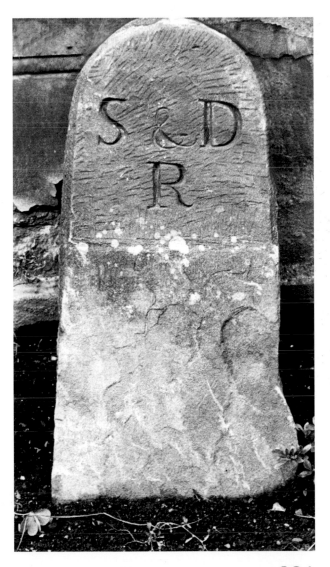

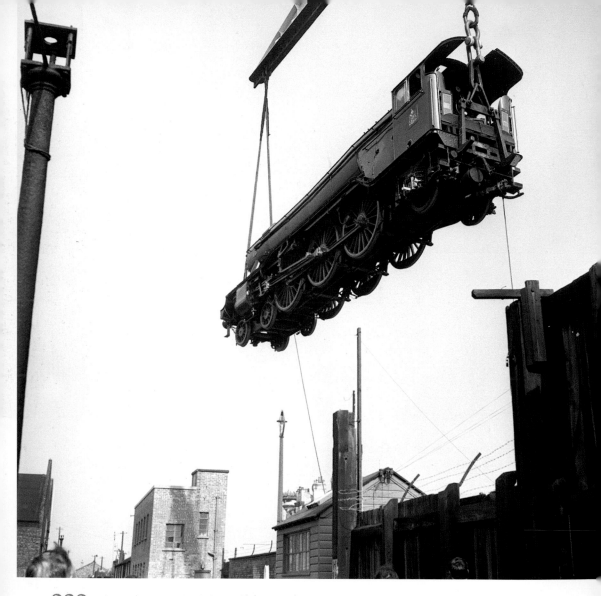

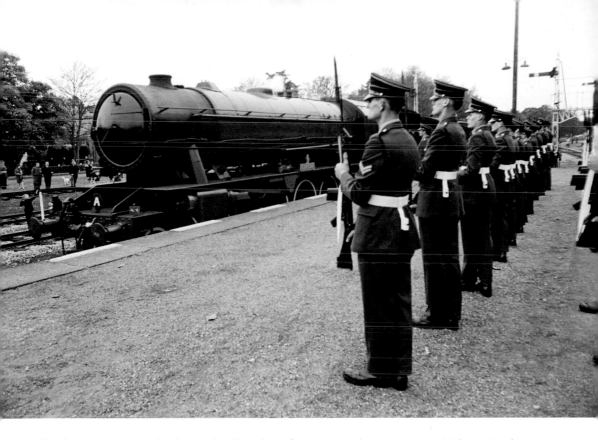

Left: *Flying Scotsman* had global appeal: here the locomotive is winched onto the *Saxonia* at Liverpool Docks at the start of its historic trip to the United States.
19th September, 1969

The last day of steam on the Longmoor Military Railway, a line in Hampshire that was built by the Royal Engineers in 1903 to train soldiers in railway construction and operations.
2nd November, 1969

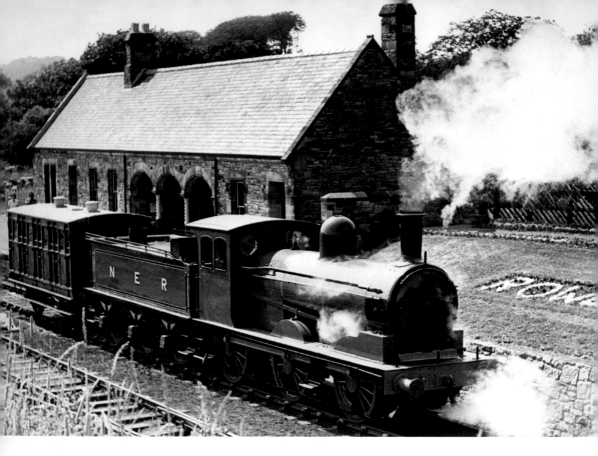

The last J21 locomotive in the world gets up steam
at the rebuilt Rowley Station in the Beamish Museum,
County Durham.
1970

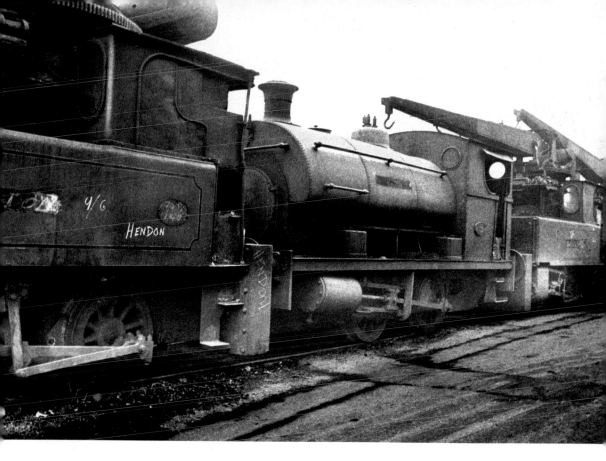

This Pallion 0-4-0 tank engine, which had been in service since 1902 at the Doxford and Sunderland Shipbuilding and Engineering Company, was saved from the scrapheap and may now be seen on the Foxfield Light Railway near Stoke-on-Trent.
14th January, 1971

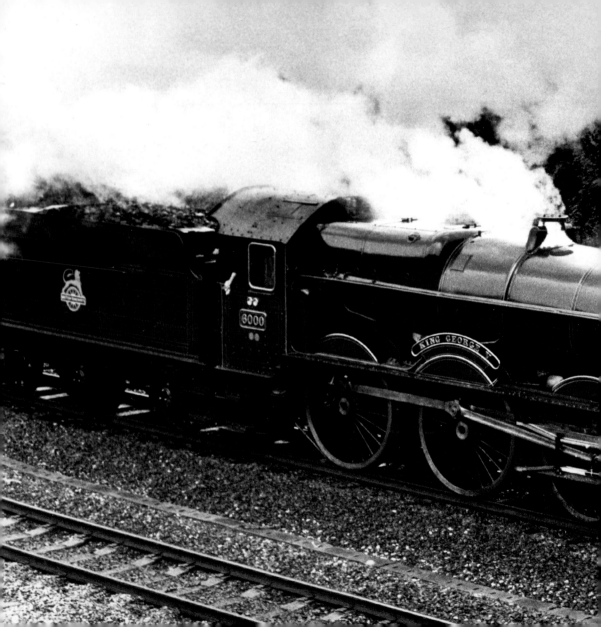

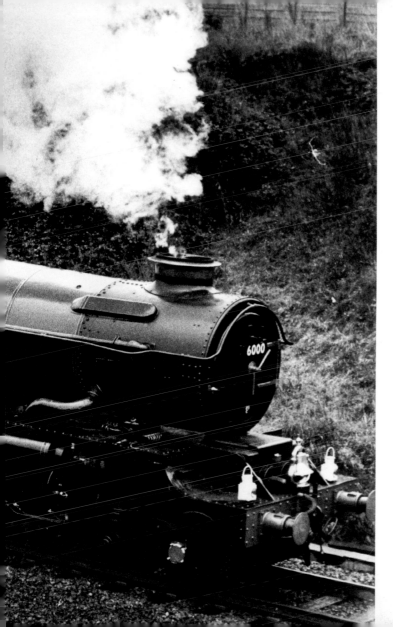

GWR 6000 Class *King George V* in steam at an open day at Tyseley depot. *King George V* was officially preserved and restored to main line running order and based at Bulmer's Railway Centre in Hereford. In 1971 it became the first steam engine to break the mainline steam ban that had been enforced since 1969. Its restoration to main line service is often credited with heralding the return of steam to the main lines of the UK. **October 1971**

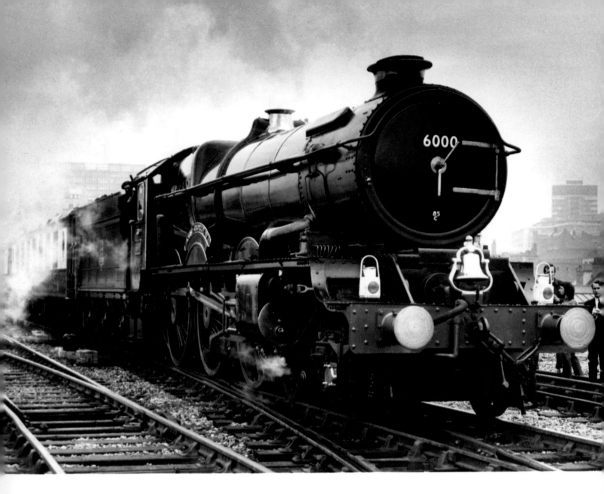

King George V at the head of a set of Pullman stock.
October 1971

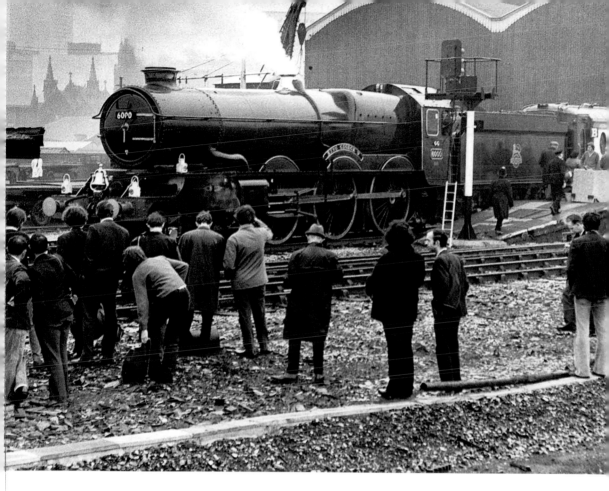

King George V leaving Moor Street Station, Birmingham, at the head of a London-bound special. This locomotive – the first of the GWR King Class – is now preserved at the National Railway Museum in York.
2nd October, 1971

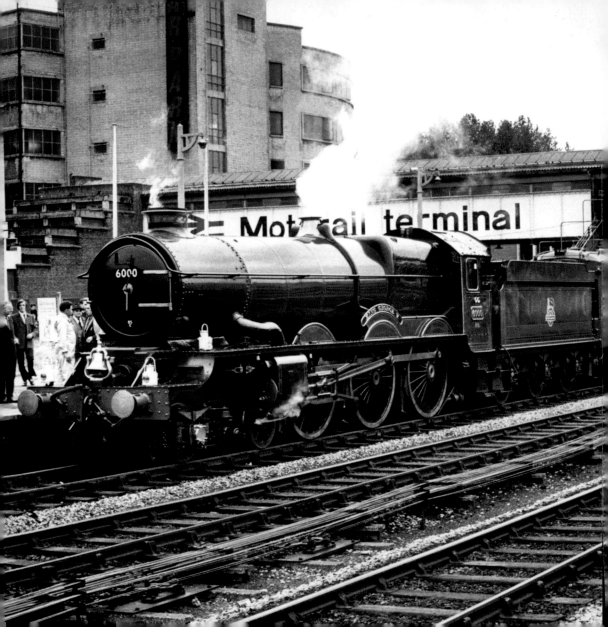

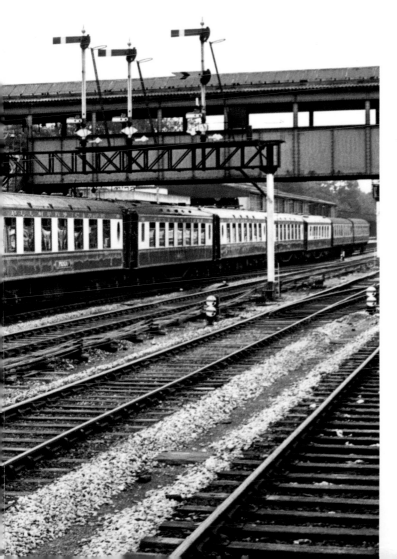

King George V drew a big crowd on arrival at London's Olympia. The following coaches contained an exhibition mounted by the locomotive's owners, The Bulmer's Cider Company. 4th October, 1971

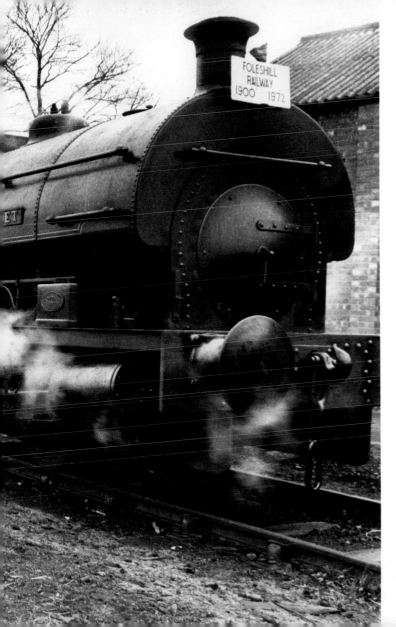

Saddle tank *Rocket* on its last journey through Courtaulds at Coventry, watched by dozens of rail enthusiasts before a ceremony to mark the end of the Foleshill Industrial Railway.
April 1972

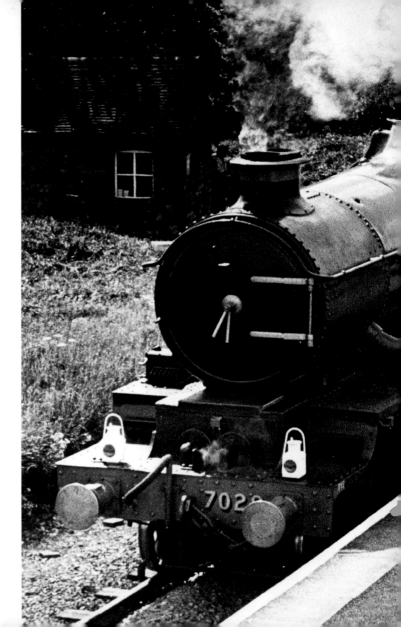

A moment of nostalgia for rail enthusiasts at Hatton near Warwick as *Clun Castle* steams into the station on a trial run preparatory to an open day at Tyseley.
8th June, 1972

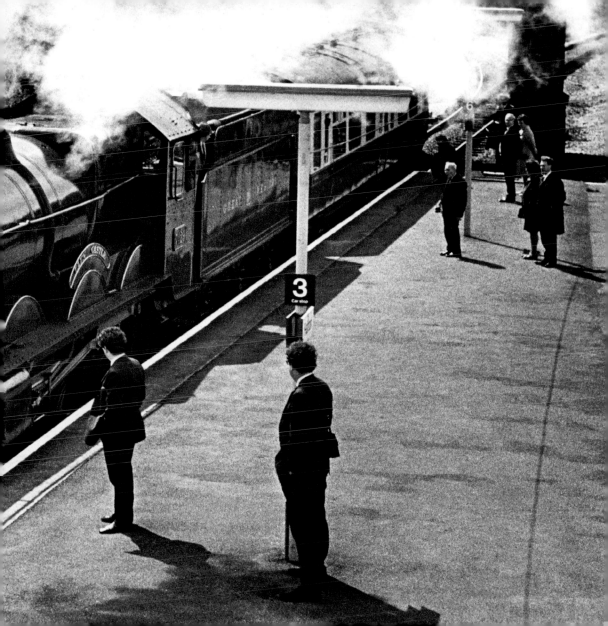

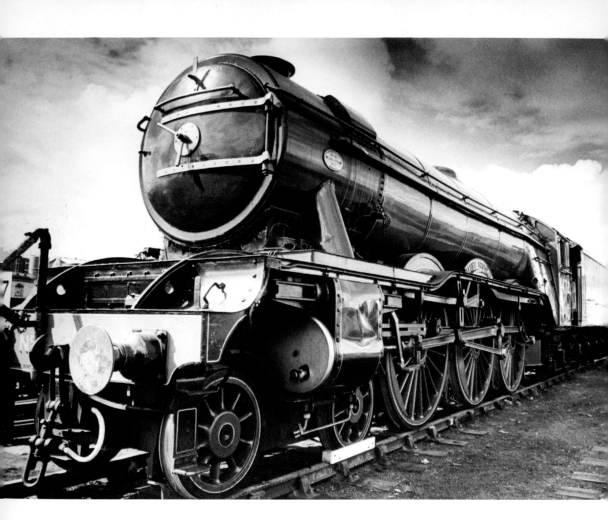

No. 4472 *Flying Scotsman* in sidings at Shildon, County Durham.
22nd August, 1975

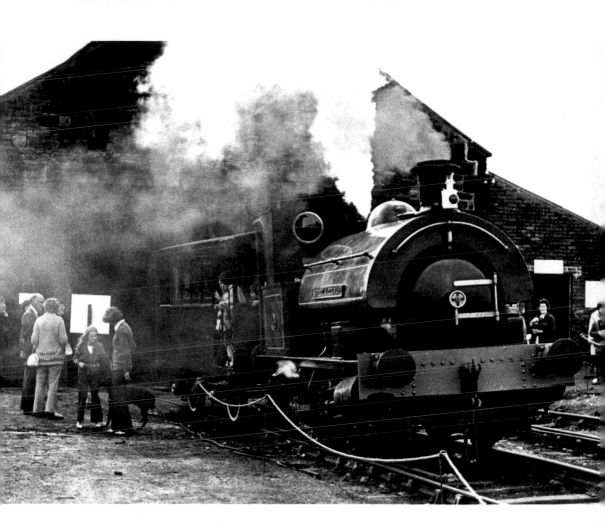

Railway enthusiasts get a blast from the past as the 0-4-0 saddle tank *Sir Cecil A. Cochrane* returns to service after a refit on the Tanfield Railway in County Durham. 24th August, 1975

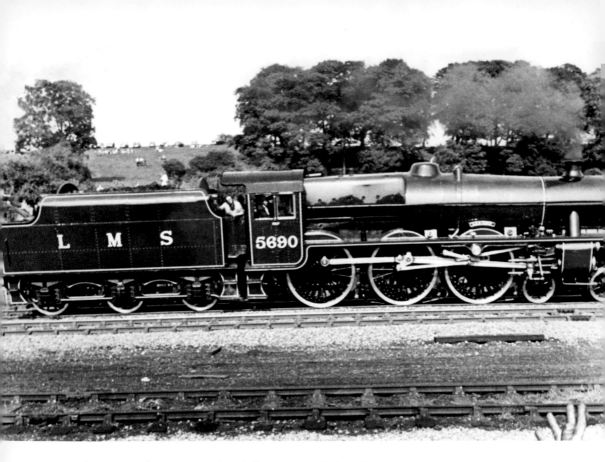

More fortunate than many of its fellow LMS Jubilee Class 4-6-0s, *Leander* was preserved and found a new lease of life on the Severn Valley Railway and elsewhere. The locomotive is currently with the West Coast Railway Company at their base in Carnforth.
31st August, 1975

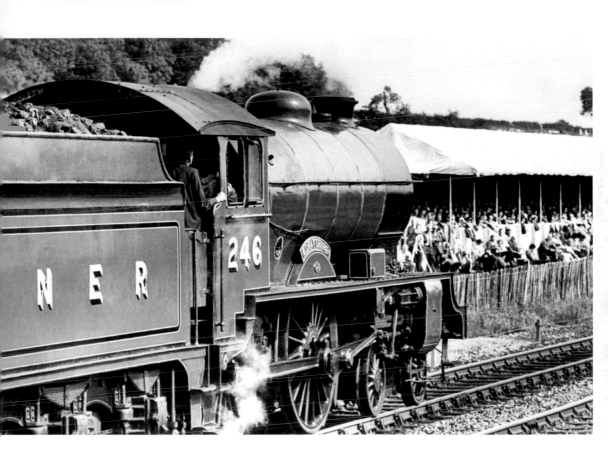

LNER D49 Class 4-4-0 No. 246 *Morayshire* making its way
past crowds gathered to celebrate the 150th anniversary
of the Shildon to Darlington line.
31st August, 1975

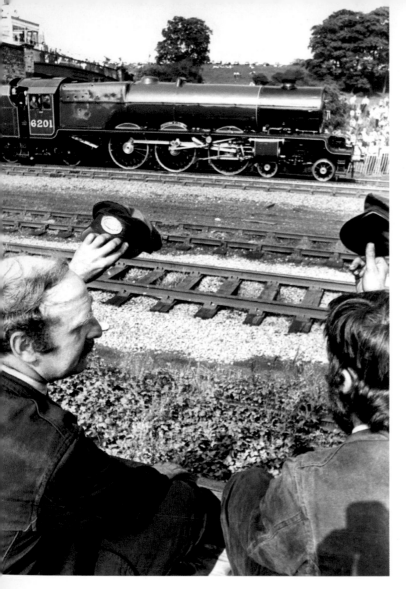

Railway enthusiasts Pete Reid (L) from Kent and Dave Wescott from Derby salute *Princess Elizabeth* as it passes during the 150th anniversary celebrations of the Shildon to Darlington line.
31st August, 1975

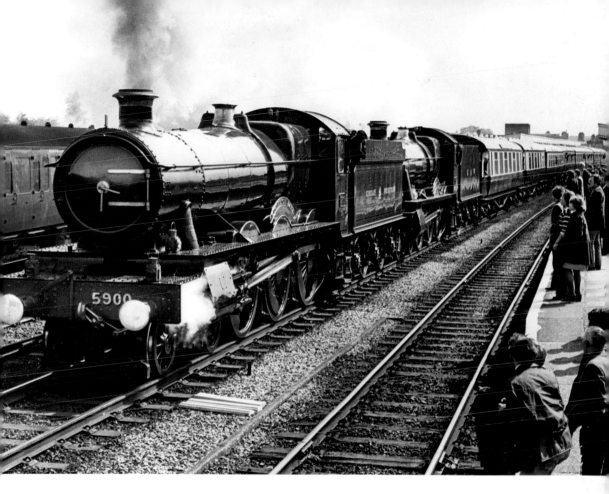

Restored to its original condition, Class 4900 4-6-0 No. 5900 *Hinderton Hall* heads another unidentified ex-GWR locomotive through Leamington Station on a special journey from London to Birmingham and Derby.
May 1976

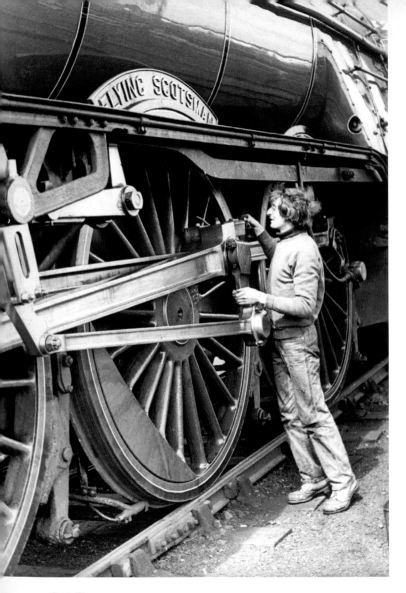

Steve Sandever, job creation supervisor at Steamtown Railway Museum in Carnforth, Lancashire, checks the lubrication of *Flying Scotsman*.
12th May, 1977

Right: The Ravenglass & Eskdale Railway, a 15-inch (381mm) gauge line that runs for 7 miles (11.3km) through the beautiful Lake District, shows off its latest locomotive, *Northern Rock*, a 2-6-2 passenger engine.
26th May, 1976

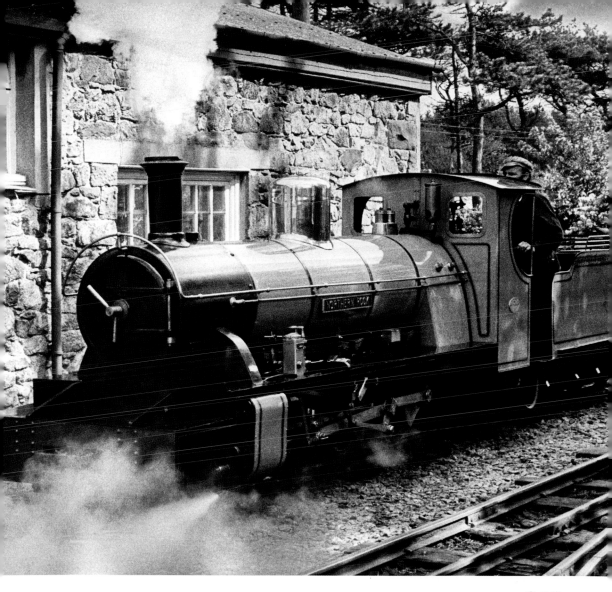

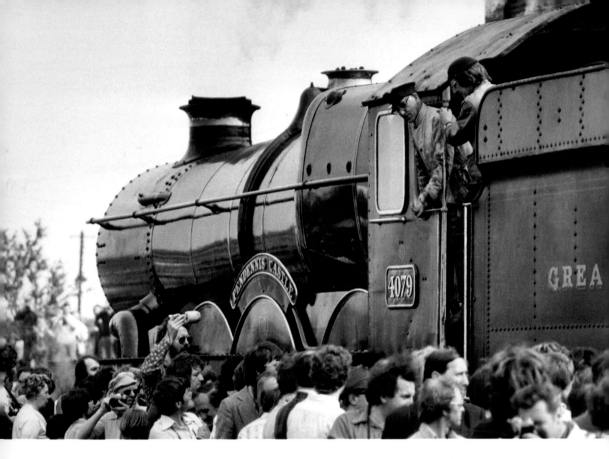

Pendennis Castle was sold to Australian iron ore producers Hamersley Iron, but before leaving the United Kingdom went on a short farewell tour at the head of *The Great Western Envoy* excursion from Birmingham to Didcot and back. The following day, the locomotive travelled to Avonmouth, the port for Bristol, where she was loaded aboard the cargo vessel *Mishref* and departed for Sydney on 2nd June, 1977.
29th May, 1977

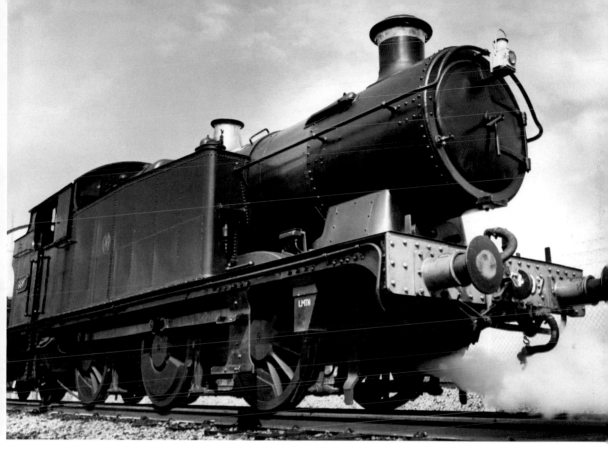

Ex-GWR 0-6-2 tank engine No. 6697 being prepared for
action at the Didcot Railway Centre, Oxfordshire before
taking part in a Great Western Society open day.
17th September, 1977

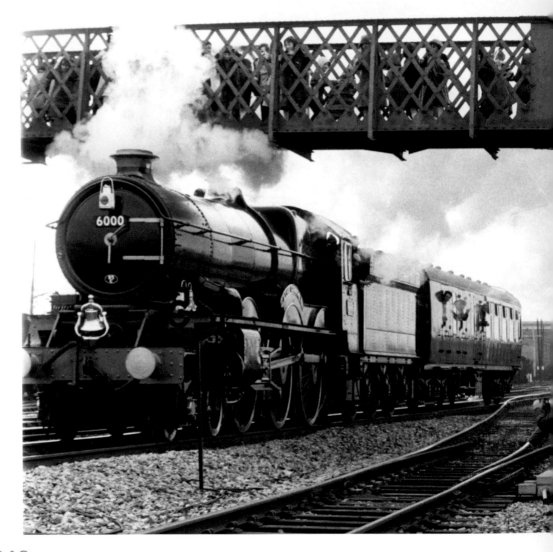

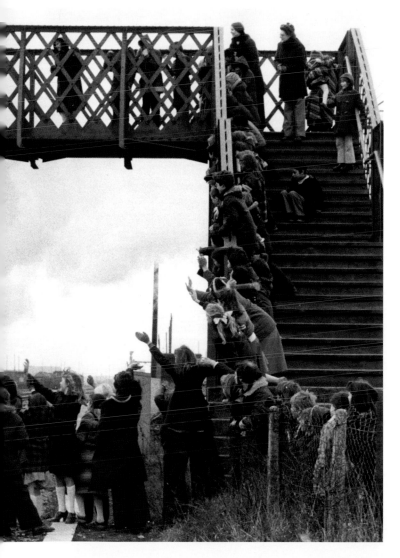

Spectators cheer the doyen of the GWR's King Class, No. 6000 *King George V*, as it storms past on its way from Swindon (where it was built in 1927) to London for celebrations marking the 125th anniversary of Paddington Station. Note the bell, which was presented during the locomotive's trip to the Baltimore & Ohio Railway in the US on the occasion of its centenary celebrations in 1927.
1st March, 1979

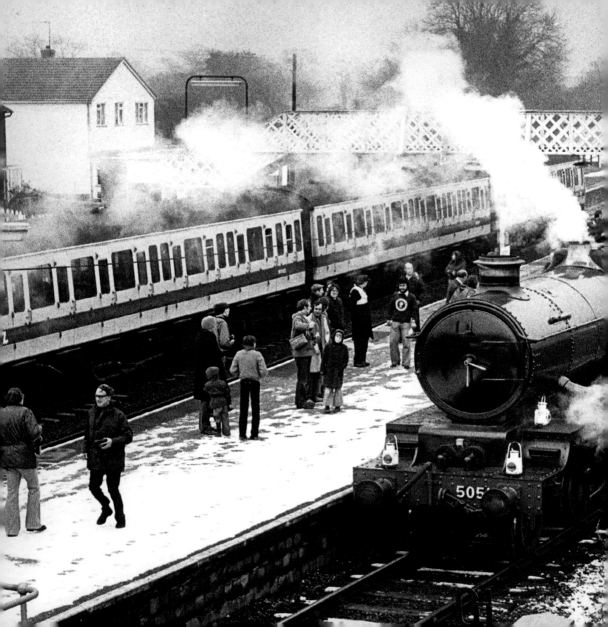

Collett Castle Class No. 5051 *Drysllwyn Castle* rolls into Hatton Station on the former GWR London Paddington–Birmingham main line. This was the loco's first run in 17 years after being restored from a scrapyard wreck following its withdrawal in 1963. It is hauling the Great Western Society's vintage carriage rake back to its HQ at Didcot, Oxfordshire, where loco and coaches still reside.
19th January, 1980

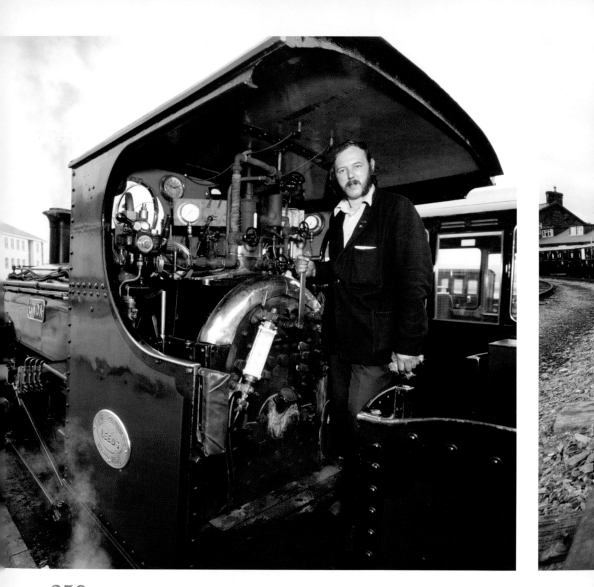

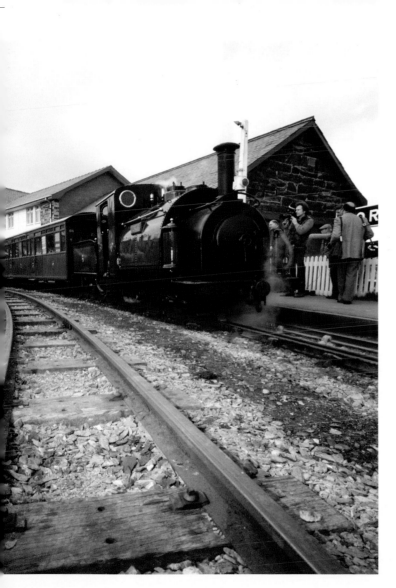

Far left: Driver on the footplate of *Linda*, one of two ex-Penhryn Quarry Railway Hunslet 2-4-0s that now operate on the Ffestiniog Railway, a 1 foot 11½ inch (597mm) line that runs for 13½ miles (21.7km) between Porthmadog and Blaenau Ffestiniog in North Wales.
24th April, 1980

Ffestiniog Railway No. 2 *Prince* at Porthmadog Station. Built in 1863, this 0-4-0 is the oldest locomotive still in operation on the line.
24th April, 1980

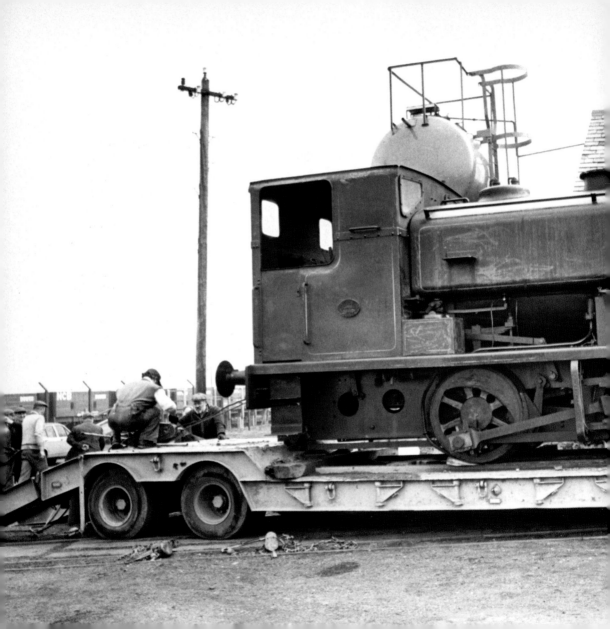

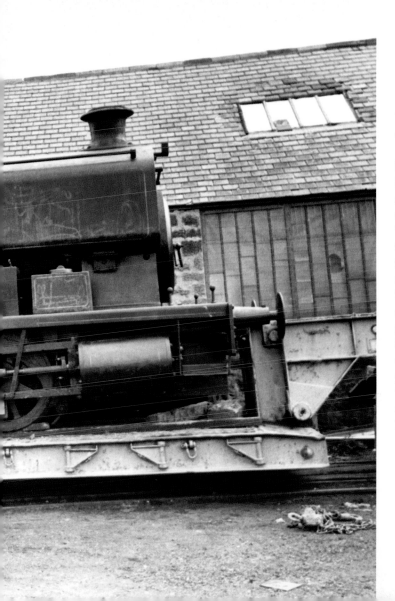

This 0-4-0 saddle tank engine *William Steuart Trimble* No. 22, built by Andrew Barclay of Kilmarnock in 1954, arrives at the Bowes Railway depot at Springwell Village, Gateshead, where it will be restored to full working order. The railway, built by George Stephenson in 1826 to carry coal from Durham pits to docks on the River Tyne, is now the only preserved standard gauge railway in the world that was originally cable-operated.
7th May, 1981

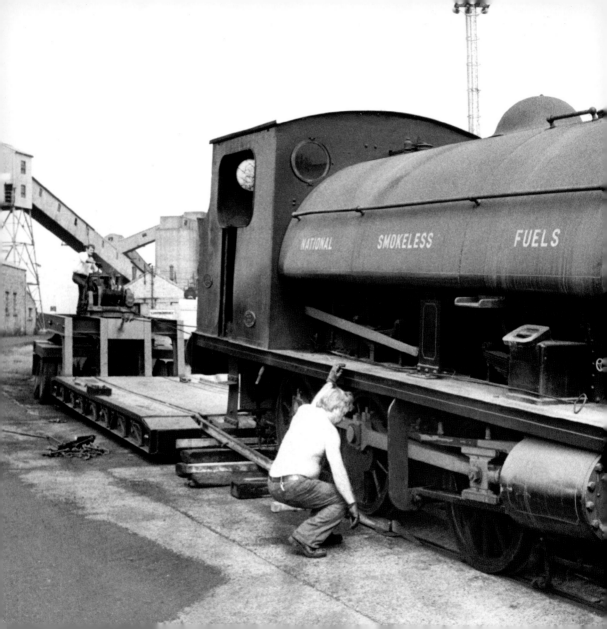

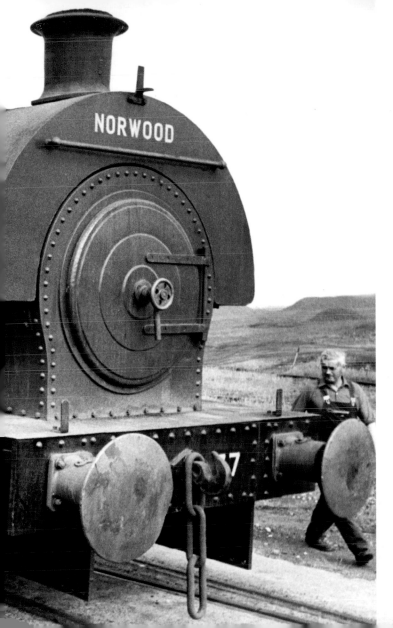

Another elderly saddle tank engine, GNR 0-6-0ST J52 class No. 1247, built in 1899 by Sharp Stewart & Co., is rolled off the low loader at the Bowes Railway depot in Gateshead. When restored the locomotive was taken to the National Railway Museum in York, where it is still on display. **7th May, 1981**

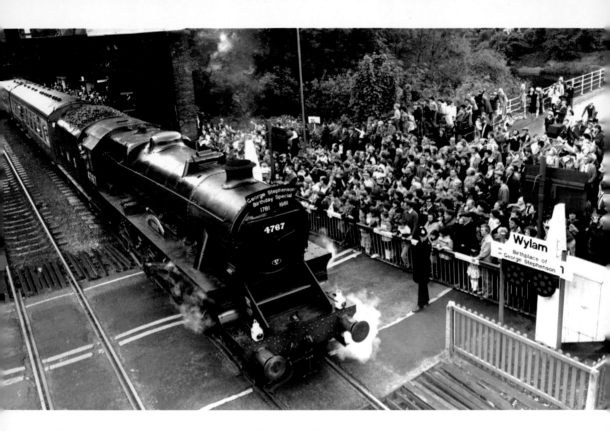

This Black Five was simply No. 4767 in its LMS days but under preservation it was named *George Stephenson*. Here it heads a special into Wylam, Northumberland, the engineer's birthplace, around the 200th anniversary of his birth.
6th June, 1981

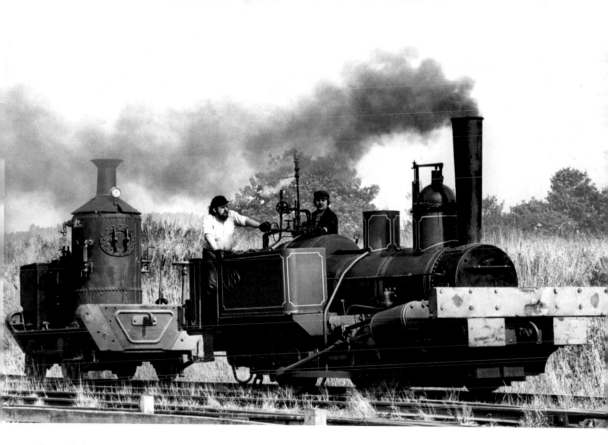

Two 19th-century locomotives – a Lewin tank (R) and
a 'coffee pot' design – were the stars of the show at a
Steam Day at the Beamish Museum in County Durham.
10th September, 1981

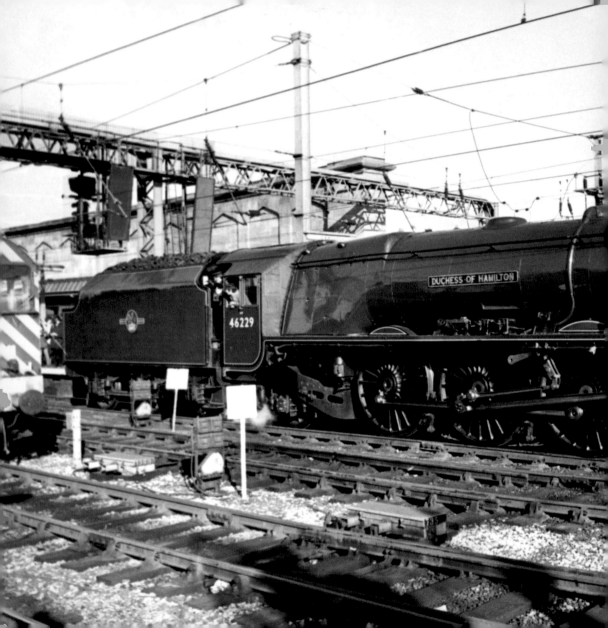

Ex-LMS Princess Coronation Class Pacific No. 46229 *Duchess of Hamilton* was preserved thanks to the generosity of Billy Butlin, founder of the holiday camps that bear his name *(see page 92)*.
1st October, 1981

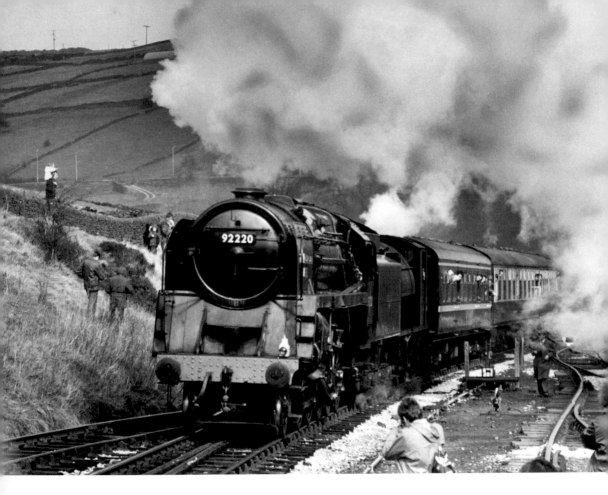

Evening Star, the last British Railways steam locomotive, pulls in to Oxenhope Station during the Keighley & Worth Valley Railway's annual open day for enthusiasts.
December 1982

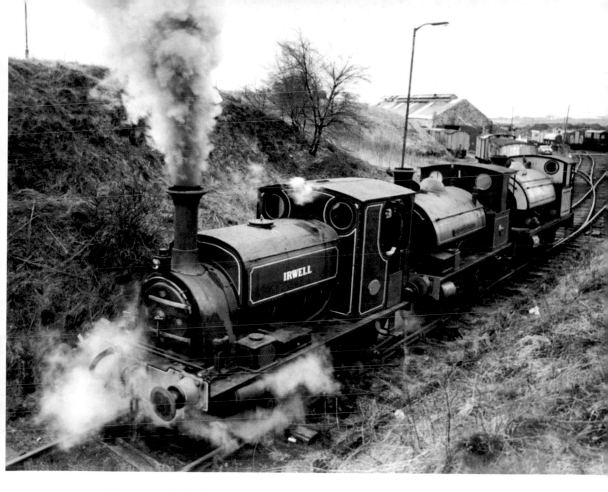

Irwell, a 1937 Hudswell Clarke 0-4-0 saddle tank. Shown in steam here, at the time of writing the locomotive was under overhaul in the sheds of the Tanfield Railway in Gateshead, County Durham.
28th March, 1983

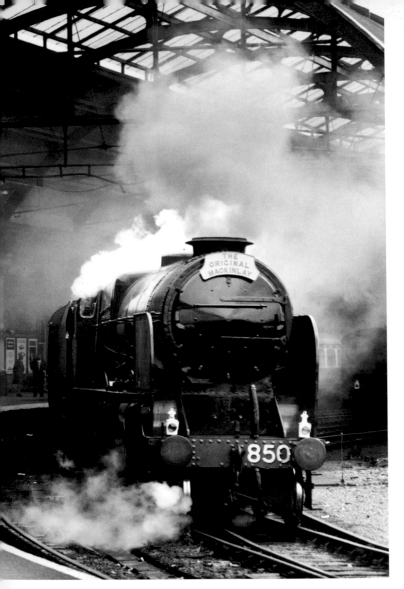

Ex-SR No. 850 *Lord Nelson* leaves Newcastle Central at the head of a Pullman train containing more than 170 Northeast licensees on a whisky distiller's special.
23rd July, 1985

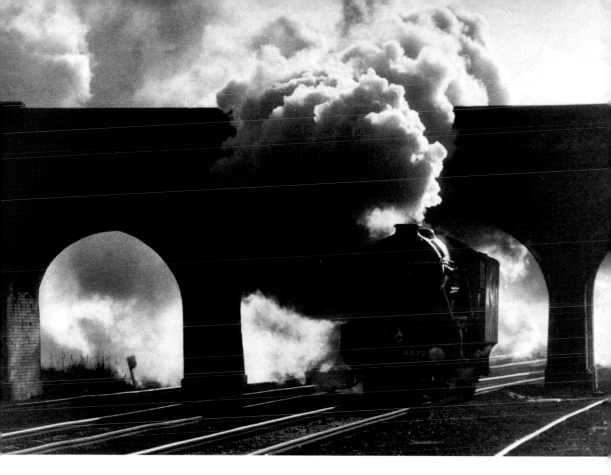

In its LNER days, *Flying Scotsman* would no more have travelled on GWR lines than sailed to the United States. As a preserved locomotive, it did both: here it is running light into Banbury Station in Oxfordshire.
December 1985

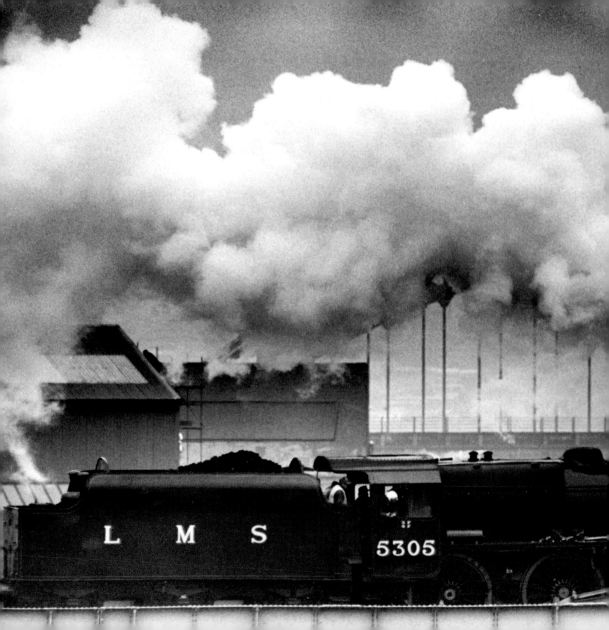

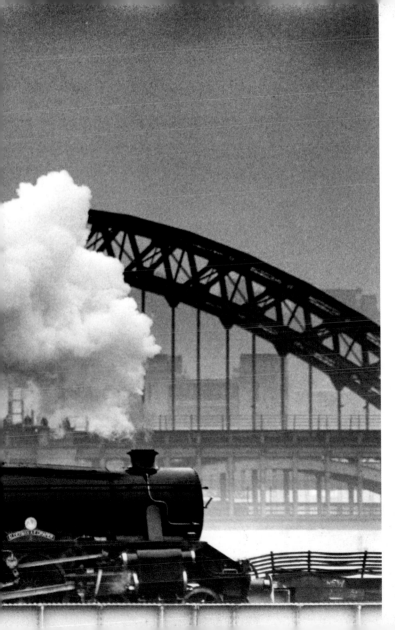

Black Five No. 5305 crosses the River Tyne as it enters Newcastle en route to Scotland. Like No. 4767 *(see page 256)*, this locomotive had no name under the LMS or BR, but in 1984 was dubbed *Alderman A.E. Draper* after the Mayor of Hendon.
14th March, 1987

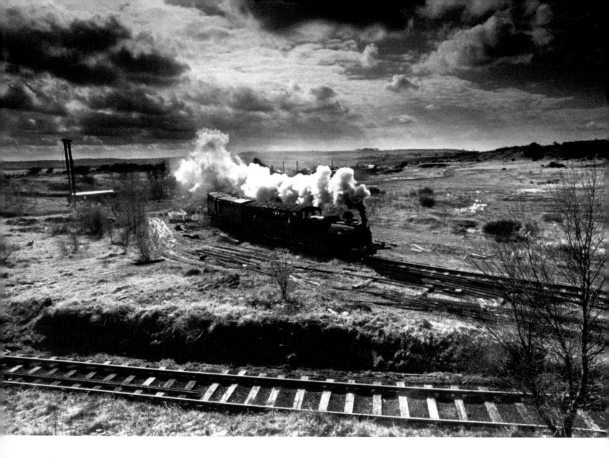

The Tanfield Railway extends for 3 miles (4.8km) between
East Tanfield and Sunniside, Gateshead, County Durham.
It claims to be the world's oldest railway still in operation.
3rd April, 1988

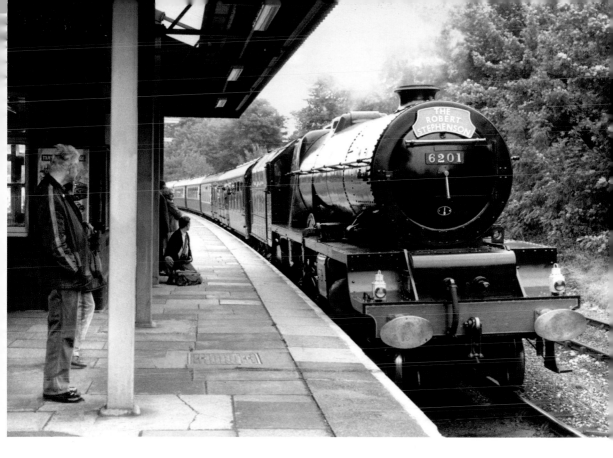

Ex-LMS Princess Royal Class No. 6201 *Princess Elizabeth* enters Dorridge Station in the West Midlands at the head of a special to mark the 150th anniversary of the London to Birmingham Railway.
17th September, 1988

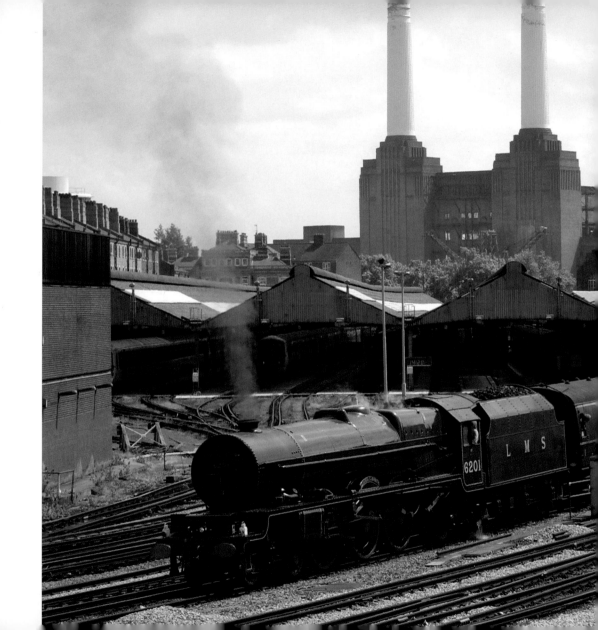

Contrasting giants of the Steam Age: in the shadow of Giles Gilbert Scott's Battersea Power Station, Stanier's *Princess Elizabeth* approaches London Victoria at the end of a circuitous journey from Liverpool Lime Street.
1st June, 1990

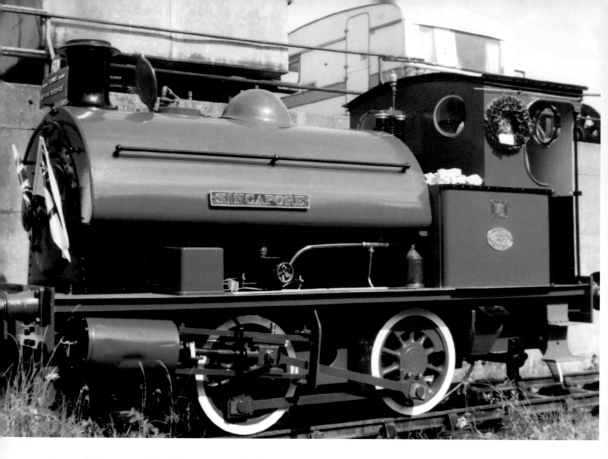

One of the prized exhibits at Rocks by Rail: The Living Ironstone Museum (aka the Rutland Railway Museum) near Oakham, this steam locomotive helped the British Army liberate Singapore from the Japanese at the end of the Second World War.
3rd February, 1992

Right: *Mallard* on its way by road to the Severn Valley Railway.
16th April, 1993

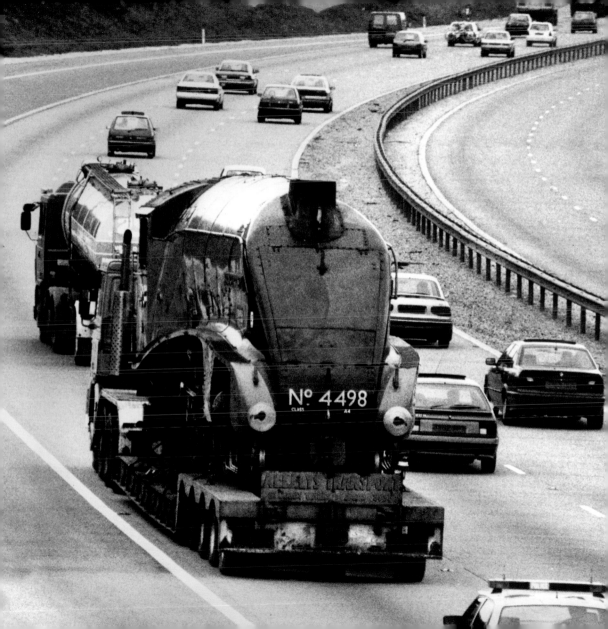

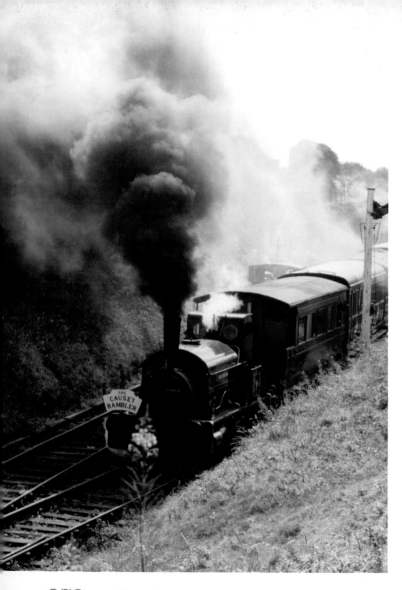

0-4-0ST *Wellington* hauls *The Causey Rambler* along the Tanfield Railway in Country Durham.
4th September, 1994

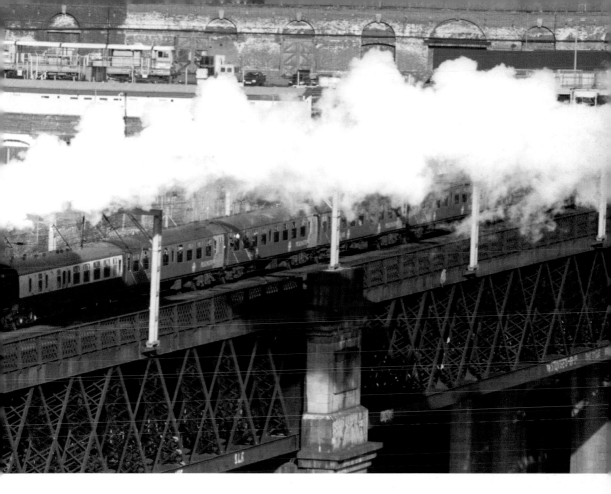

No. 44767 *George Stephenson* leaves Newcastle over the King George Bridge on a trip to Manchester. Note the green ex-SR coaches, seldom if ever before seen north of the Trent.
18th March, 1995

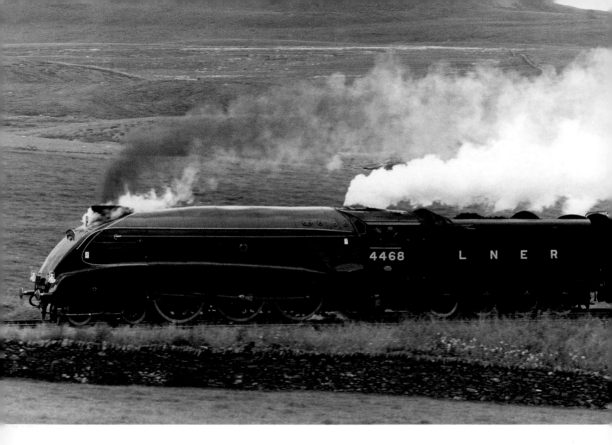

Framed by the distinctive slope of Pen-y-Ghent in the Yorkshire Dales, Gresley A4 class No. 4468 *Mallard* in garter blue livery works the Settle & Carlisle line. Restored to working order in 1988 to celebrate the 50th anniversary of its world speed record, the loco later returned to static display in the National Railway Museum in York.
16th September, 1996

Fireman Andrew Arnold stokes up one of the locos at
the Tanfield Railway for the journey between Tanfield
and Sunniside, Gateshead, County Durham.
28th August, 1997

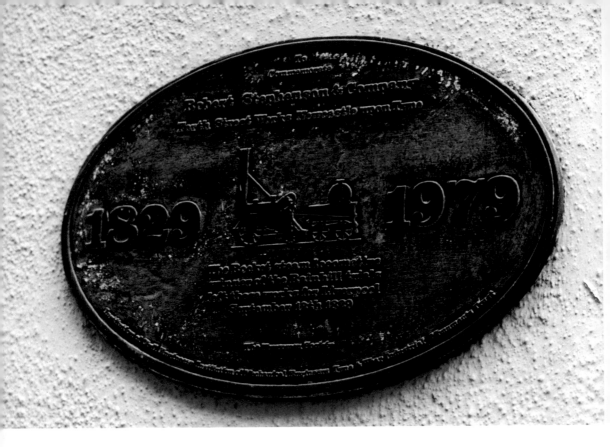

Plaque on George Stephenson's South Street Works in
Newcastle, newly unveiled to mark the centenary of his
Rocket leaving there for the Rainhill Steam Trials.
9th June, 1998

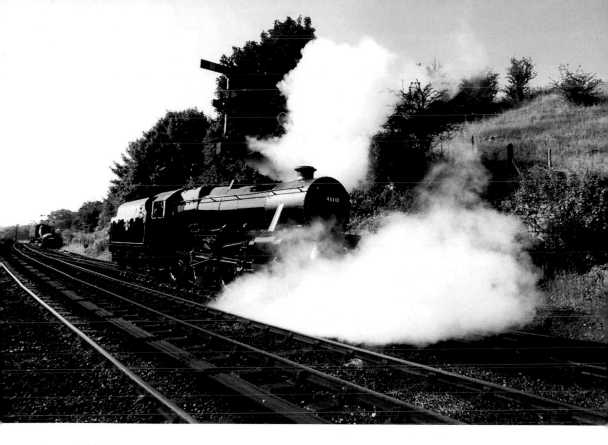

Stanier Black Five No. 45110 on a test run over the
Severn Valley Railway at Bridgnorth, Shropshire at the
end of a 10-year refurbishment project.
11th August, 1998

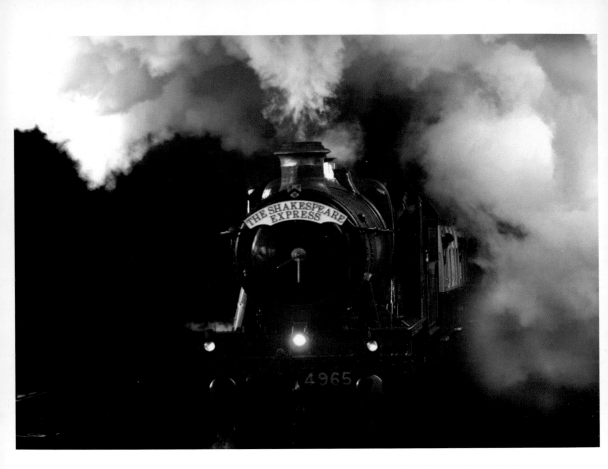

GWR Hall Class No. 4965 *Rood Ashton Hall*, newly restored by Birmingham Railway Museum at Tyseley Works, hauls *The Shakespeare Express*, a regular Sunday working between Birmingham Snow Hill and Stratford-upon-Avon.
20th December, 1998

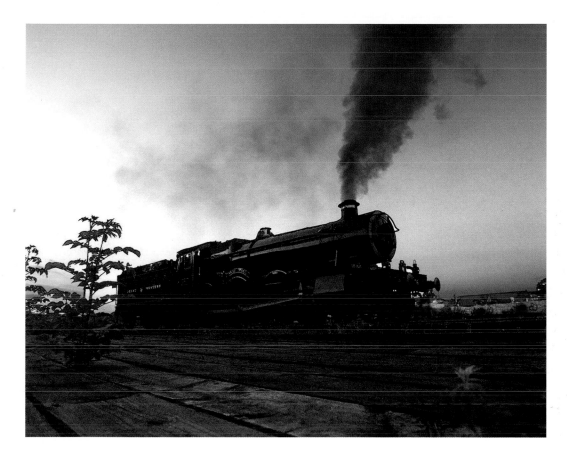

GWR Hall Class No. 4963 *Kinlet Hall* being made ready
at Worcester Shrub Hill for a journey to Birmingham
Snow Hill.
2000

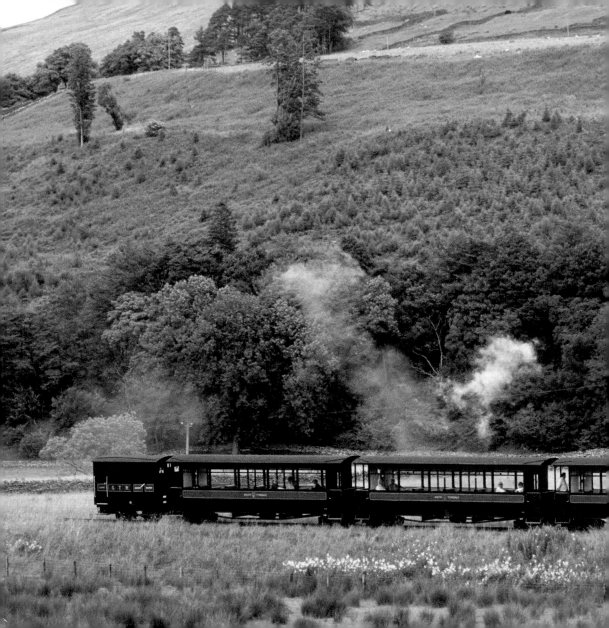

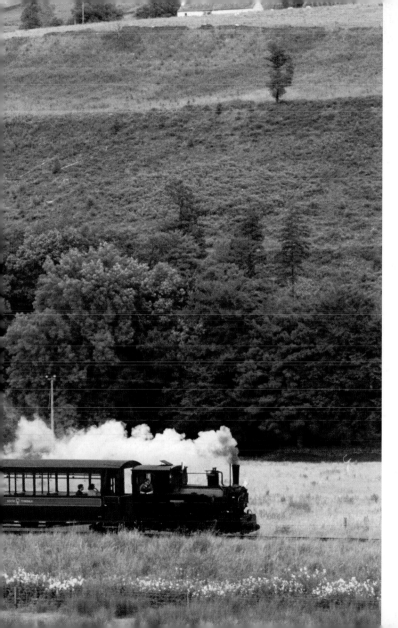

Full steam ahead on the South Tynedale Railway, a 2 feet (610mm) gauge line between Alston, Cumbria and Lintley, Northumberland, a distance of 3¼ miles (5km). 2000

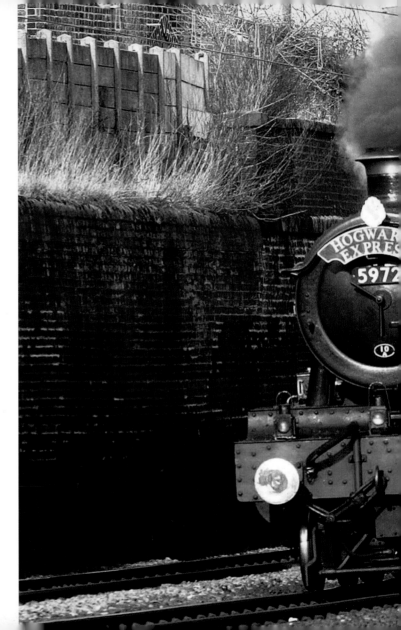

Saved from the scrapheap in 1964, ex-GWR Hall Class No. 5972 *Olton Hall* (seen here passing through Norton Bridge, Staffordshire) was just an ordinary preserved steam locomotive until the start of the 21st century, when it shot to worldwide fame at the head of *The Hogwarts Express* in the Harry Potter films.
1st June, 2001

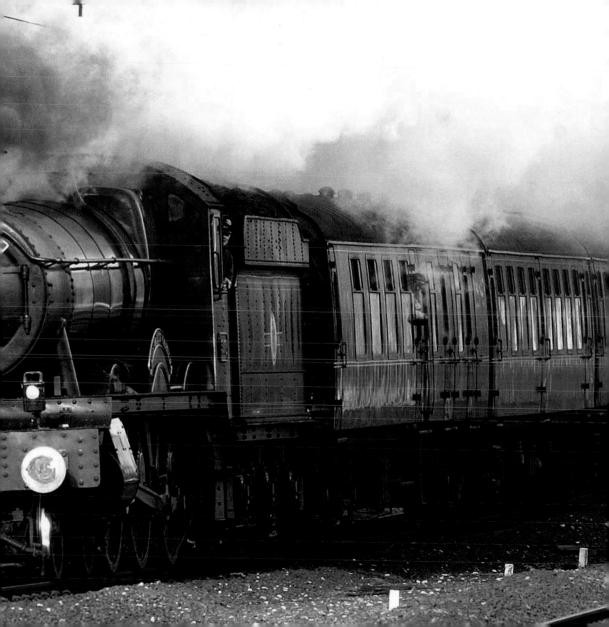

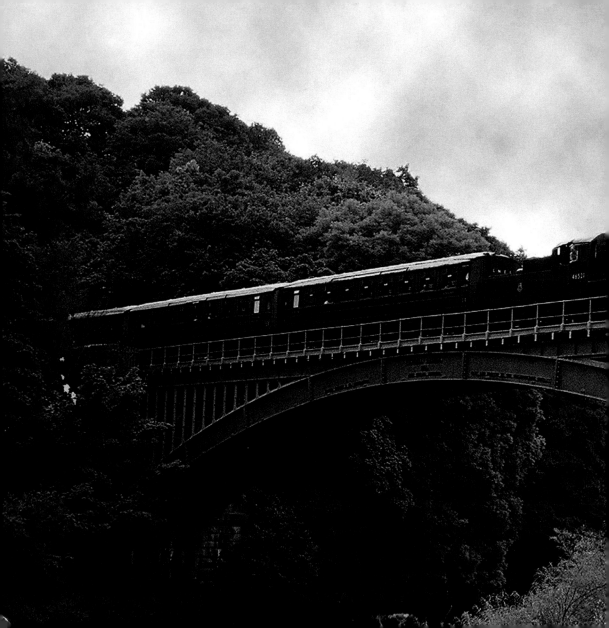

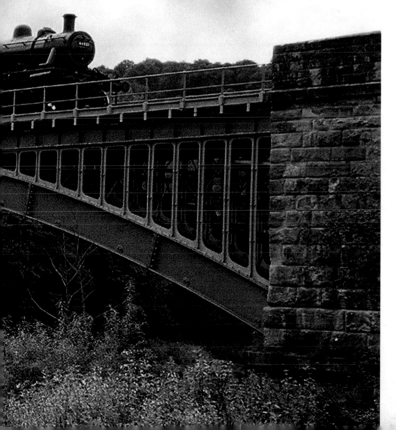

Ex-LMS Ivatt Class 2MT
2-6-0 takes a Severn Valley
train from Kidderminster
to Bridgnorth across the
cast-iron Victoria Bridge
over the River Severn.
15th July, 2001

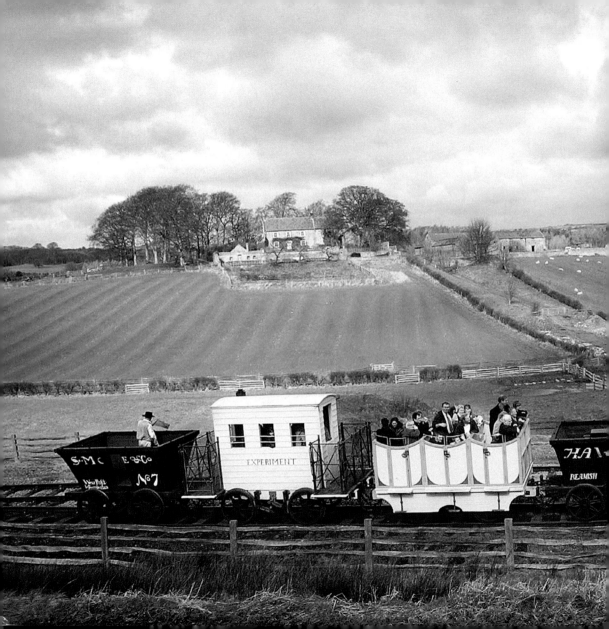

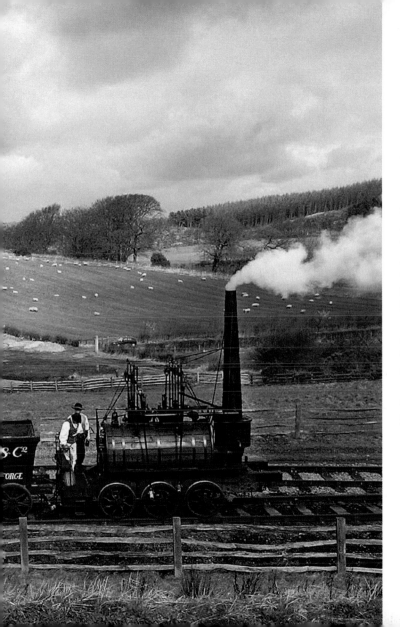

The original *Steam Elephant* is thought to have been a creation of George Stephenson – although some considered that it was designed by John Buddle and William Chapman for Wallsend Colliery on the north bank of the River Tyne in 1815 – but it survived only in paintings until the Beamish Museum in County Durham built this replica, seen here on its first official run.
21st March, 2002

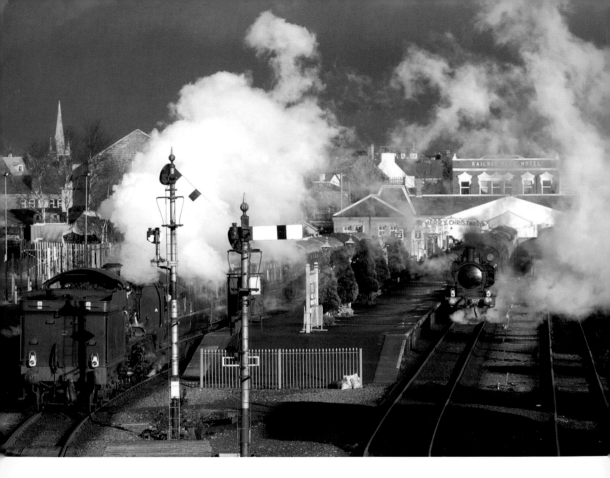

A busy Boxing Day on the
Severn Valley Railway at
Kidderminster.
26th December, 2002

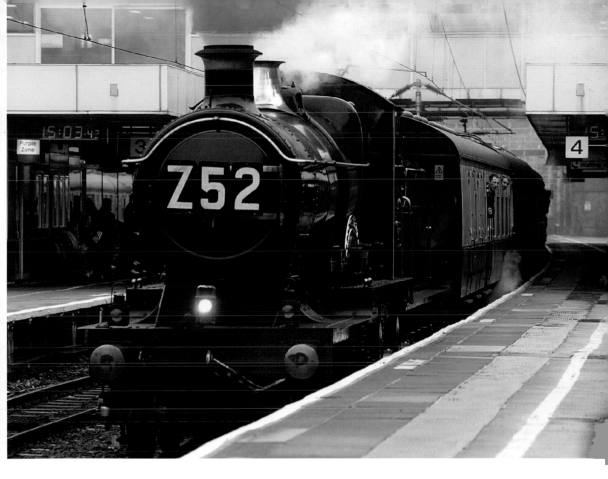

City of Truro passes
through Coventry en route
to Warwick.
29th December, 2004

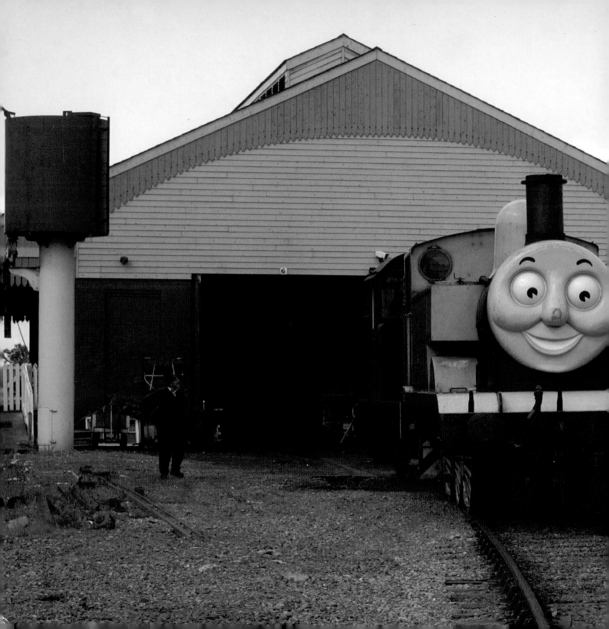

Rev. W.V. Awdry's Thomas the Tank Engine books gained a new lease of life with Britt Allcroft's animated TV series voiced by ex-Beatle Ringo Starr. This led to Thomas events around the United Kingdom, including this one on the Vale of Glamorgan Railway, Barry, Wales. Since none of the E2 Class locos on which Thomas was based survive, various other classes have been adapted to resemble him.
27th May, 2005

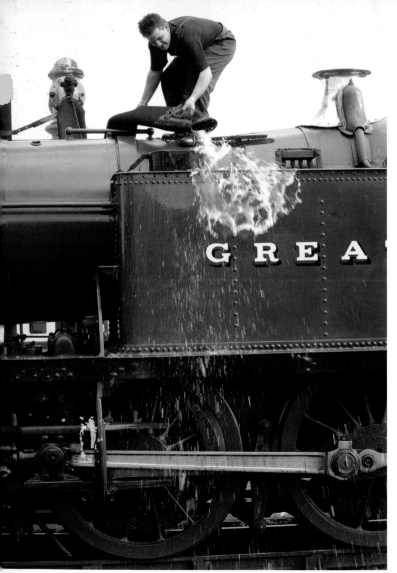

A locomotive gets splashed as it is refilled with water at Kidderminster Station during the Severn Valley Railway Autumn Steam Gala.
19th September, 2008

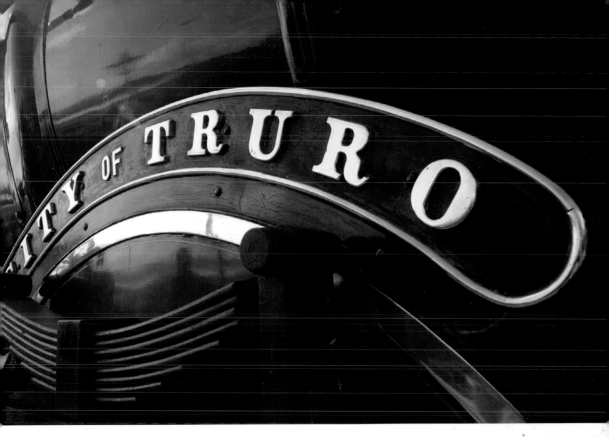

Generally regarded (though never officially confirmed) as the first railway locomotive to top 100mph (160km/h), *City of Truro* spends most of its time on static display in Swindon, but is brought out occasionally for special workings such as this on the Severn Valley Railway.

19th September, 2008

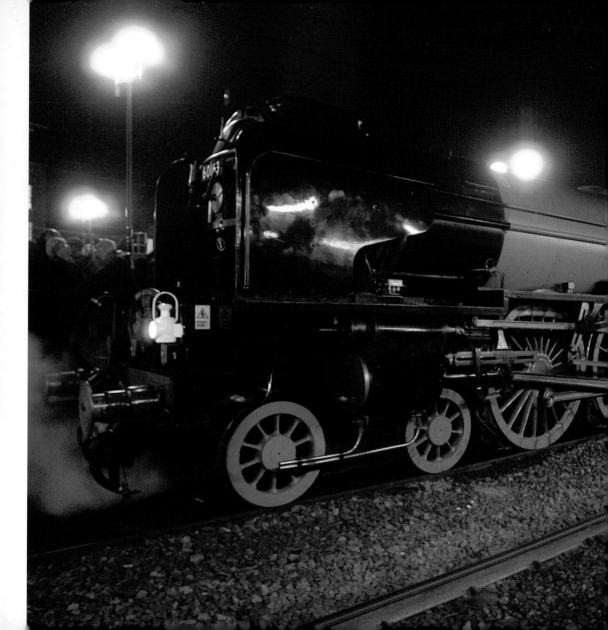

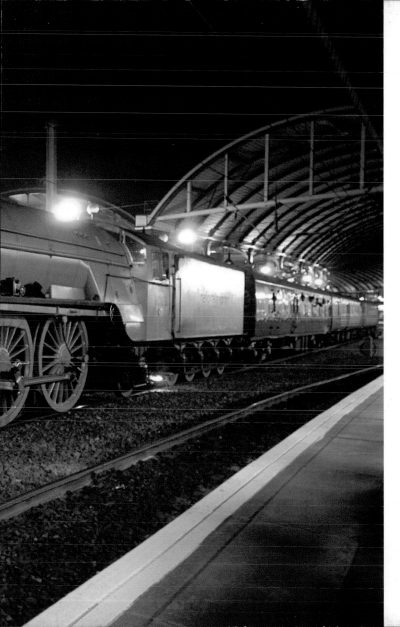

They may have thought it was all over but it wasn't: in 2008 *Tornado* – based on the LNER A1 Pacifics – became the first completely new steam locomotive to enter service on the mainline railways of Britain since *Evening Star* in 1960. Here the newcomer is seen at Newcastle Central.
18th November, 2008

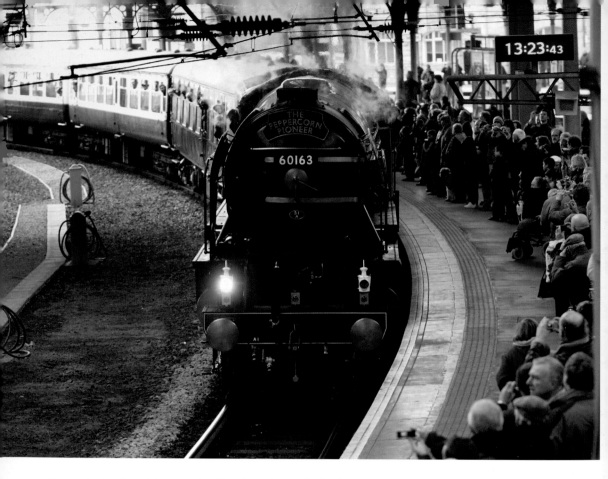

Tornado back at Newcastle. The headboard alludes to
the designer of the LNER locomotives on which it was
modeled, *A.H. Peppercorn (see page 201).*
31st January, 2009

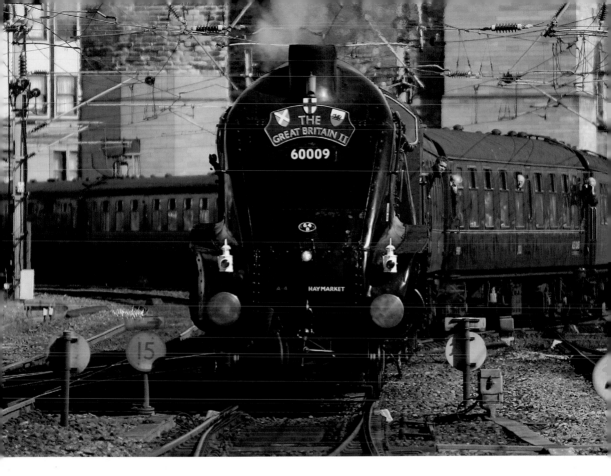

Over the years, steam rail charters have become more ambitious, few more so than the Railway Touring Company's annual *The Great Britain* week-long tour, which starts and ends in London and takes in Penzance and northern Scotland. Here Gresley A4 Class No. 60009 *Union of South Africa* coasts into Newcastle Central with the second of these excursions.
13th April, 2009

The Brecon Mountain Railway in Merthyr Tydfil, Wales, is a 1 foot 11¾ inch (603mm) gauge line that was opened in 1980 along the bed of an abandoned standard gauge route. Remarkably (and for the operators, annoyingly), although it is situated within three miles (5km) of a working opencast mine, it is compelled by regulations to import the coal it needs: supplies currently come from Russia.

17th September, 2009

The publishers gratefully acknowledge Mirrorpix, from whose extensive archives the photographs in this book have been selected.

AMMONITE
PRESS